RED LIGHT

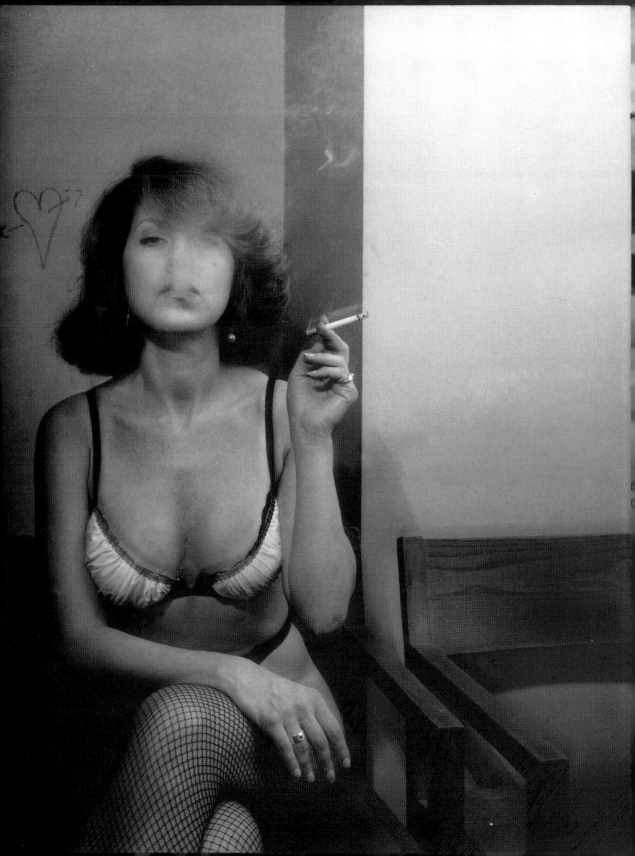

RED LIGHT

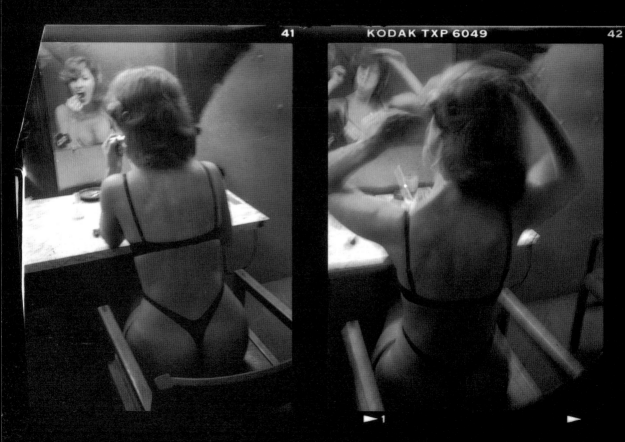

PHOTOGRAPHS BY SYLVIA PLACHY TEXT BY JAMES RIDGEWAY

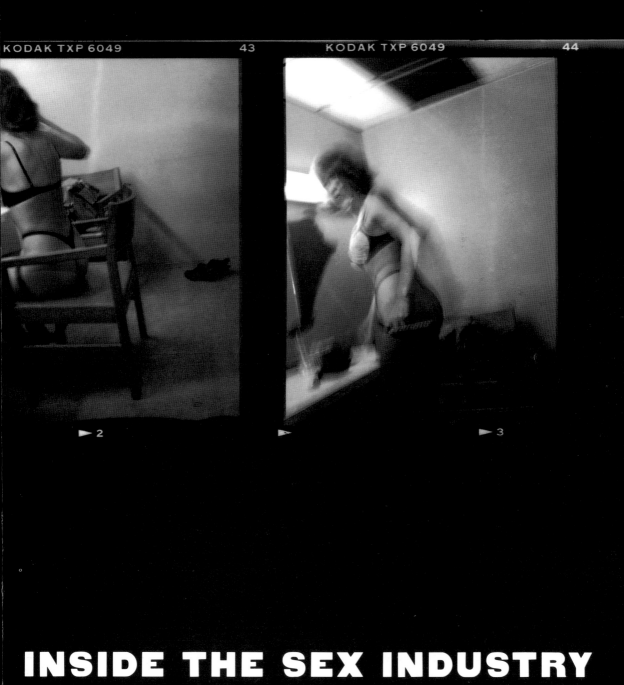

INSIDE THE SEX INDUSTRY

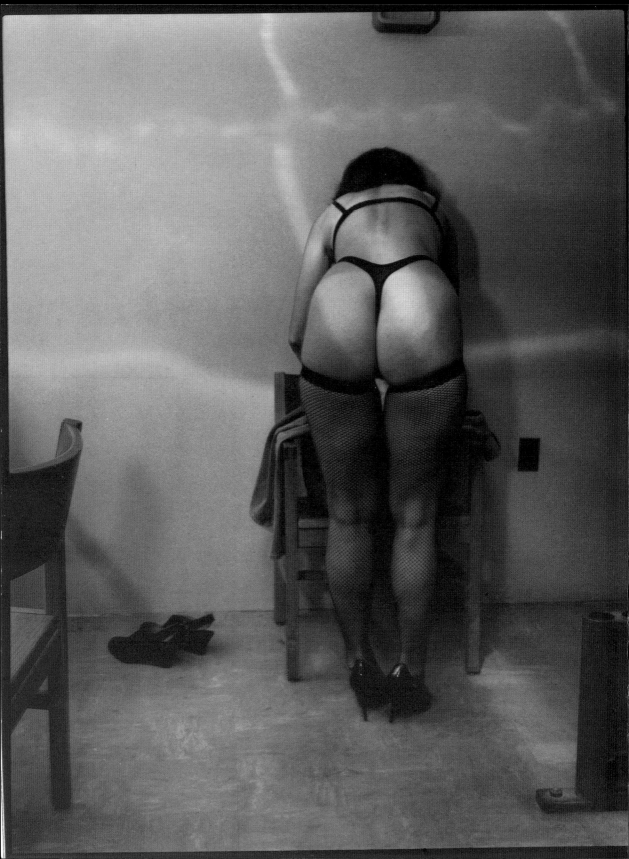

CONTENTS

PREFACE

Although they are alternately romanticized as glamorous sex goddesses or whores with hearts of gold, or reviled as purveyors of disease and sin, sex workers are, first and foremost, working people. Like other working people, they show up for work on time, perform their jobs in accordance with their employers' and clients' wishes, and collect their pay.

Our intention in this book is to show something about the lives of the women and men engaged in the broad variety of work that falls under the umbrella of the sex industry. We do not pretend, however, that this book is an exhaustive or comprehensive survey of sex work in America. Most of the workers we interviewed live and work in the New York metropolitan area (where just about every kind of service can be found, but where the work undoubtedly has its own local characteristics). Most are women performing services for heterosexual men (which also remains the case in the industry at large). Certain types of workers—for example, undocumented immigrants working in tightly controlled brothels—remain unrepresented here because they are so strictly isolated from outsiders. Some workers wanted to be interviewed but not photographed; others were photographed but not interviewed. Readers should also be aware that throughout this book we have used the names that the sex workers asked us to use: full names, first names only, stage names, false names, or no names at all.

Although we have spent over three years visiting the lives and worlds of sex workers, talking with them and photographing them on their own turf, we cannot in any way pretend ourselves to be "insiders." We have tried to provide a kind of inside story by allowing the sex workers to speak in their own voices and to pose on their own terms. But in the end we—like most of you who are reading and looking at this book—can never claim to be more than visitors in their world (or perhaps, unavoidably, voyeurs).

Our guide through much of this work was Susan Walsh, who has written about the sex industry for *Screw* and *The Village Voice*, and has also worked on

and off as a go-go dancer to support herself and her son. With admirable perseverance and considerable skill, Susan helped us to understand the many facets of the industry, gain access to various places, and establish a rapport with sex workers; we are grateful for her invaluable contribution to the book.

This book could not have been done without the cooperation of the many women and men inside and outside of the sex industry who agreed to be interviewed and photographed, supplied crucial information, and often showed us incredible patience and kindness; we owe our thanks to all of them. We are especially grateful to Michelle Manafy, Jane Sherry, Jesse Torres and the staff of Sally's Hideaway, the managers and dancers at Dubonnet, Joey and the staff at After Dark, Jill Morley, Greg Easley, Tiarra Mukherjee, Aaron Fineman, Judy Cinciata, Mary Nolan, Glenn Kenny, Melissa Hines, Ace, Tony Sokal, Denny, Mistress Shane, the Vault, Michael Salem, Dr. Joyce Wallace and the staff at Frost'd, Mark Walsh, Rob Hardin, Eileen Callinan, Eamon Lynch, the staff at Crazy Nanny's, Julie Tolentino and the staff of Jackie 60, Ron Athey and his troupe, the late William Duffy of Bottom's Up, Pilar, Eric Swenson, Ivana and the Russian dancers in Queens and Brooklyn, Bob Richter, Trash, Annie Sprinkle, Veronica Vera, Miss Kelly Webb, Tara Ball, Rebecca Rand, the staff at Rick's, Al Goldstein and the staff of *Screw*, Karen English, Dynomite and Ivory, Hennessey, Carter Stevens and his staff, and Karin Assmann and her film crew from Spiegel TV. Our special thanks go to Charlotte and her friends on the Lower East Side.

Several books and publications were especially valuable to us. These include Frederique Delacoste and Priscilla Alexander's collection *Sex Work: Writings by Women in the Sex Industry* (Pittsburgh and San Francisco: Cleis Press, 1987); Lawrence A. Stanley's "The Child Porn Myth" in *Cardozo Arts & Entertainment Law Journal* (7:2, 1989); Marjorie Heins's *Sex, Sin, and Blasphemy: A Guide to America's Censorship Wars* (New York: The New Press, 1993); Nadine Strossen's *Defending Pornography: Free Speech, Sex, and the Fight for Women's Rights* (New York: Scribner's, 1995); Pamela Church Gibson and Roma Gibson's collection *Dirty Looks: Women, Pornography, Power* (London: British Film Institute, 1993); reports by Human Rights Watch's Free Expression Project; and especially *Girls Lean Back Everywhere: The Law of Obscenity and the Assault on Genius* (New York: Random House, 1992) by Edward DeGrazia, who also kindly shared with us his unparalleled knowledge in this field.

Finally, we want to extend our special thanks to several individuals involved in the publication of *Red Light*. Their contributions to the book extend far beyond the call of duty, and we are grateful for their commitment to the project and for their outstanding work.

Faith Childs, our agent, has stood by us and by this project through many sometimes difficult years, and we are enormously grateful for her support.

Daniel Power, publisher of powerHouse Books, took up this complicated and controversial project without hesitation. He played a crucial role in the editing and organization of the book, and we are grateful for his input and support. Thanks also to Paula Curtz of powerHouse Books and to the staff of D.A.P. for their enthusiasm and their valuable work.

Yolanda Cuomo, the book's designer, and her assistant, Francesca Richer, deserve our special thanks for their skill and artistry in turning this project into a book.

Jean Casella helped to conceptualize the text and edited it with insight, intelligence, and skill, and we want to thank her for her dedication and for her critical role in the creation of this book.

—James Ridgeway and Sylvia Plachy
January 1996

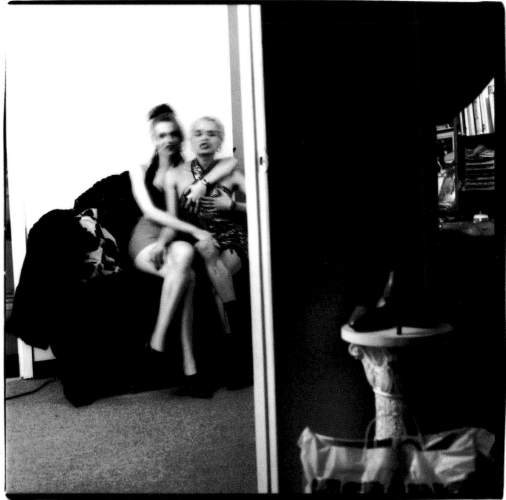

Alter Image, Manhattan

Park Avenue South and 23rd Street, Manhattan

"Shit, you're not a cop," the girl said, "you're a newspaper reporter. 'How'd you get into this? How much do you make? Does your mother know you ball?' Cop, you know where you stand. Newspaper reporter, he's got a dirty mind, wants you to say dirty things he can't write in the paper anyway. No, I'm sorry, I'm not answering any questions at all today about anything."

ELMORE LEONARD, 52 PICK-UP

Why struggle, waiting is good enough, since everything is bound to end up in the street. Basically, only the street counts. Why deny it? It's waiting for us. One of these days we'll have to make up our minds and go down into the street, not one or two or three of us, but all. We stand on the brink, we simper and fuss, but never mind, the time will come.

**LOUIS-FERDINAND CÉLINE,
JOURNEY TO THE END OF THE NIGHT**

THE BUSINESS OF SEX

Paulie is sitting at a table in the corner of the bar. He has thick glasses and wears a rumpled suit, and has just arrived from the floor of the New York Stock Exchange, where he is a trader. The remains of his lunch, in a brown bag, lie on the table. Across the table is a thin, pale, blond woman. She is dressed in Day-Glo tights and a skimpy white blouse. The bar is in a midtown Manhattan hotel, and at 4:30 in the afternoon there aren't many people around. In the corner three businessmen are talking on a cellular phone. Two German tourists are trying to trace a subway route on a map. In the lobby a tall, middle-aged woman is talking to a bellboy as she waits for someone.

Paulie rises to shake hands. "This is not such a great place to do this," he says, laughing a little.

Paulie has agreed to talk about his experiences as a buyer of sexual services. In Paulie's case, this has consisted primarily of paying women to participate in sexual scenarios that he directs—"role playing" to his tastes. He begins by describing how he first got into it.

"I don't know. One day I felt like spanking somebody. I went to Catholic school. We always got hit. And I guess that's where it began."

He turns to the woman, whose name is Sherri. "Remember Nancy, the girl with black hair? I went over to her friend's house. Her friend Lauren lives on East 12th Street. I made one of them kiss the other one's feet while I tongue kissed with her. So, in other words, me and Lauren would tongue kiss while Nancy kissed Lauren's feet, then mine; then they'd switch. But I'd never get down and kiss their feet. Then I'd spank one while with the other one, I kissed her tits and stuff and…"

"But Paulie," Sherri breaks in, "every now and then you like to be spanked, don't you?"

"Yeah," he laughs. "Every now and then. Like tomorrow or the next day when I feel mischievous. When I gamble or drink too much."

He changes the subject. "I like it on the phone. She can tell you," he says, nodding at Sherri. "We've had some real explosive ones on the phone. Oh, major sex! Sometimes twice or three times, right, Sherri? I also do that with my friend Bill. Like tonight I might call him, and we'll fantasize. So we'll pick this girl he used to live with or I lived with, some girl we know in common. Like we might say we're going to the Waldorf Astoria and meet her in the lounge, have dinner, take her upstairs and do…" His voice trails off. "Whatever. You know what I'm saying. Sometimes we get off if his wife and kids aren't bugging him."

Forty years ago, Jean Genet described a world where men could pay to act out their fantasies. His play *The Balcony* is set in a whorehouse, where an assortment of middle-class patrons don the garb of bishops, judges, or generals, and play out scenarios that, in Genet's words, "conform to the liturgies of the brothel." The gateway to each man's fantasy life is a woman who, for a price, enables him to fulfill his dream for a few moments. One woman becomes the penitent thief before whom the judge must crawl. Another woman is the general's plunging steed, carrying him from one conquest to another, her mouth dripping blood from the master's bit. Yet another becomes the Virgin Mary, defiled twice weekly by a bank clerk. In this world, the possibilities are limitless; but more often than not, the whores' task is to enable small men to live out grand fantasies of virility and power.

It's the same game for Paulie, only not so grand. He pays the price—usually $100 for each girl—and rents a hotel room. Together, as a couple or as a three-some, they restore the mythical order of a lost world, where the woman may be the girl next door, the subservient coquette, the slut, or the mistress—but seldom an economically, emotionally, and sexually autonomous equal. In Paulie's dream world, the men hold the power, just as love in the whorehouse is conditioned on the orders of the man. The man may get a spanking, but only because he wants to get a spanking. Women may kiss other women, but only on his terms. It's Paulie's game; Paulie is paying the bill. So the women's sexual pleasure—feigned as it may be—is controlled by Paulie.

Refreshed from their trip into this fantasy world, Paulie and his pal Bill get off, sometimes with each other. Later they pick up the hotel phone and play the horses. When it's over, they go home—Paulie to his mother in the Bronx, his pal to a wife and kids.

The next day Paulie will call Sherri and discuss the night's activities. Sometimes he forgets and acts as if Sherri is his girlfriend. She reminds him of reality by mentioning money, complaining that he only paid $180, not the $200 they had agreed upon. Paulie always promises to make it up the next time.

FANTASIES
AND FAMILY VALUES

Today's whorehouse remains an arena where male fantasies can be played out for a prenegotiated price. The charades acted out within its confines are a measure of the times, and these are times of great insecurity and confusion, particularly for men.

The last few decades have witnessed an erosion of the traditional American concept of family—the governing patriarchal institution of modern life—and of the woman as social servant. The decline of U.S. economic power abroad, and eviscerated economic opportunities for Americans at home, have all but eliminated the "head of household" status once held by most middle-class men. As women have entered the workplace, they have achieved a new degree of economic independence. At the same time, the feminist movement—besieged as it may be—has resulted in increased emotional and sexual autonomy for many women. The relations between the sexes are undergoing profound change, and men's unquestioned control of society's economic and sexual life is being challenged in new—and, for many men, disturbing—ways.

So today's trip to the whorehouse, whatever form it may take—escort service, strip joint, dungeon, video tape, computer, or phone sex line—becomes a pilgrimage, an emotionally charged step towards re-enacting one more time the rituals of a down-at-the-heels patriarchy. The whorehouse is a simulacrum of the past; the whores artful magicians, employed in a sprawling theme park that caters to the nostalgic fantasies of a threatened masculine culture.

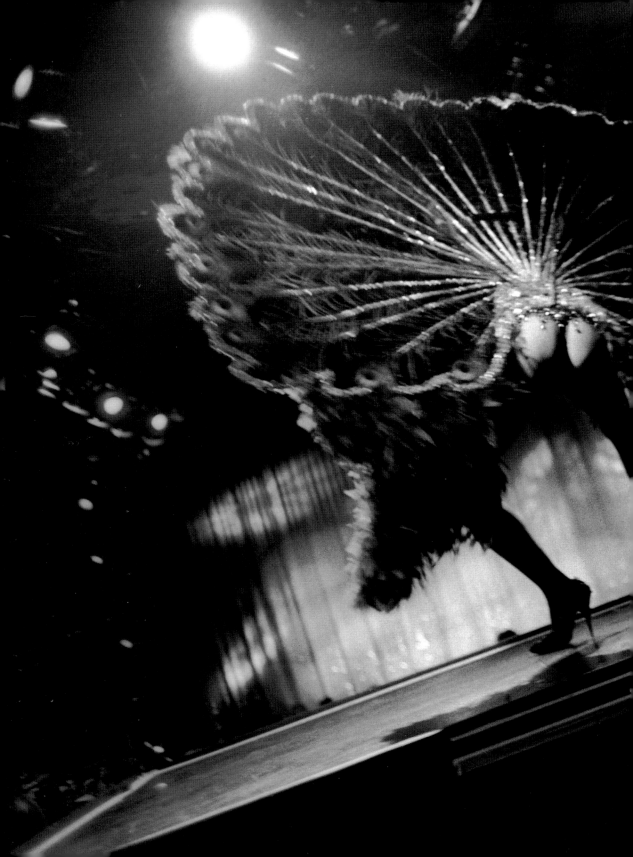

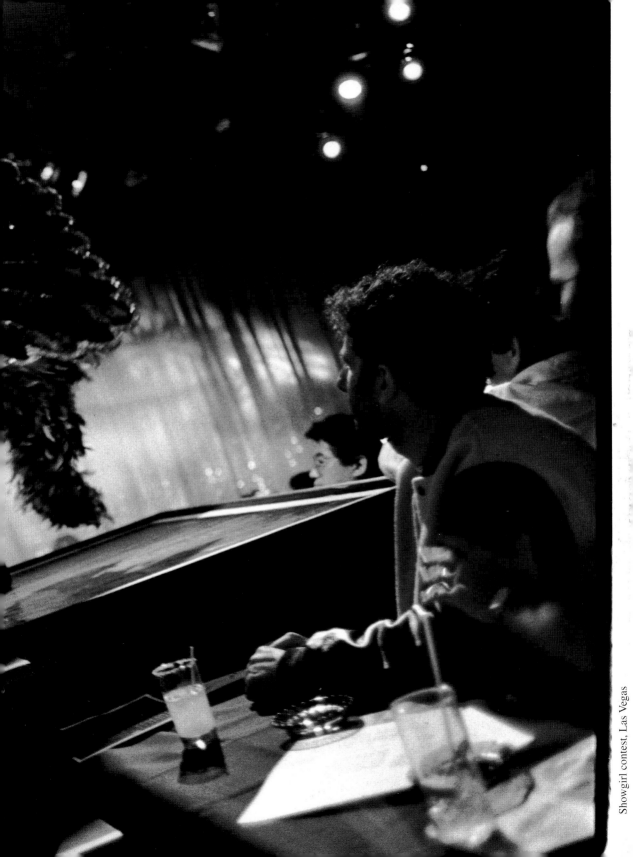

Showgirl contest, Las Vegas

Although the sex business is often portrayed as antisocial, it in fact functions as an agent of social control. It takes the human hunger for sex and power and objectifies it, splitting it up and repackaging it as a commercial product—a product that incorporates the worn-out fantasies of a prefeminist world view, where men are in control, and women are idealized objects of desire. Even the so-called transgressive sides of the industry, involving sadomasochism or gender bending, uphold the mainstream social order by providing a place where unacceptable sexual appetites can be sated safely and secretly.

At times, the sex industry has also been depicted as a "liberating" force in society, on the front lines of the battle against sexual repression. In this view, sex workers are tantric helpmates, catalysts who can propel their clients toward sexual freedom, personal transformation, and even better relationships. But most of what happens in the sex industry does little to expand the human capacity for sexual expression or emotional communion. Instead, it operates as a closed circle—commodifying existing patterns without transforming them, and perpetuating desires without satisfying them. A trip to the modern fuckery does not surrender the client to the world of flesh and blood and feeling, but turns him back on himself, into a virtual world of fantasy and onanism. And it seems unlikely that society will be freed from repressive prudery by activity which remains, for most participants, a raw commercial transaction and a dirty little secret.

In fact, by serving as a kind of safety valve for a repressed and confused patriarchal culture, the sex business preserves, rather than threatens, the mainstream social order. And by remaining a dirty little secret, operating on the sidelines of "normal" society, the industry actually protects and perpetuates another, all-important fantasy, dear to the hearts of church and state: the idea of the family as the only legitimate forum for sex.

In his *History of Sexuality*, Michel Foucault outlines the state's longstanding efforts to control the sexuality and sex practices of its citizens. At the opening of the 17th century, Foucault notes, there was "a certain frankness" about sex. Sexual practices were not secret; discourse about sex was open, bodies were displayed and transgressions exposed. But with the birth of the modern state came vastly expanded government involvement in the everyday lives of citizens. The control of sexuality, Foucault suggests, became a primary tool of state control, wielded via the approved social unit—the family. The

"procreative couple laid down the law…" and "enforced the norm"; "a single locus of sexuality was acknowledged in social space as well as at the heart of every household, but it was a utilitarian and fertile one: the parents' bedroom."

Kate Millet, in *Sexual Politics*, notes that the family has been the "chief institution" of male-dominated culture, "serving as an agent of the larger society." The traditional, male-headed family serves to uphold the status quo, economically as well as socially. It "serves as a citadel of property and traditional interests. Marriages are financial alliances, and each household operates as an economic entity much like a corporation." And like the corporation, the socially sanctioned nuclear family enjoys the support and protection of the state.

Today it is more obvious than ever that sex (along with race) is among the real organizing principles of contemporary society, increasingly central to our social and political identities. Clearly, whether we are born male or female has a profound impact on our lives. It also true that what we do with our bodies—whom we choose to sleep with (black or white, gay or straight, rich or poor) and when, the circumstances of our bearing children, our living arrangements and family constituents—all work to determine our status within society. These factors can dictate whether we get tax breaks, whether we qualify for a social assistance program or medical care, how we are treated by the justice system, and whether, in current jargon, we are given equal access to opportunity. In venues as diverse as the welfare office and the corporate board room, "traditional" sexualities are rewarded. The struggle for control of sexuality is also at the center of the current debates over abortion, AIDS, gay rights, pornography, school curricula, and what is shown on television. Sex, not the IRS, occupies the center of the state's encroachment into every citizen's life.

During the 1980s and early 1990s sex became, more than ever, the driving force in American political life. The reassertion of patriarchal society's hegemony over women's bodies, and over sexual behavior in general, was an endless topic for political debate, nowhere more evident than at the Republican Party's presidential nominating convention in 1992. It was by using the passions and fears surrounding sexual politics that the Christian Right was able to overcome its opponents inside the party. And once again, the family was appointed executor of state control over sex and sexuality. "Family values represent a great dividing line between the parties," William Bennett, the former secretary of Education and a New Right theoretician, has said. To Bennett and his allies, the

traditional "Christian" family model, with the man at the head of the household, is the only acceptable social unit. It is the family that should get the tax breaks and run the schools. It is the family that should determine what people can see, hear, and read; the family that should decide who can have sex, when, where, and with whom. The family, in short, is a smaller, better government. "This is a free country," Bennett said. "Within very broad limits, people may live as they wish. And yet we believe that some ways of living are better than others.... Marriage and parenthood should be upheld."

Right-wing Republicans knew that expanding the state's control over sex and sexuality was the key to reorganizing American culture along lines more pleasing to them. And by 1995, the new Republican-controlled Congress (with little resistance from moribund Democrats) had taken these principles as the basis for a vast transformation of social policy.

High on the agenda, of course, was limiting access to abortion. By severing the tie between sex and procreation, abortion and birth control liberate women from the fear of unwanted pregnancy, and free them to make their own sexual, reproductive, and ultimately, economic choices—a reality highly threatening to the family values crowd. Equally threatening is single motherhood, which represents a woman's right not only to have sex, but also to raise children, outside of the sanctified realm of the male-dominated family. In response to this threat, Republicans promoted a new welfare policy, designed to punish women who have sex and bear children out of wedlock by denying them state support.

These attacks on women's sexual and reproductive freedoms go hand-in-hand with the ever-growing attack on the basic civil rights of lesbians and gay men—who represent, perhaps, the greatest threat of all to the traditional order. All such attacks are clearly predicated upon the idea that the state should define "legitimate" sexual activity—and revile and punish all transgressors. This punishing view toward all "antisocial" expressions of sexuality was present even in Bill Clinton's dismissal of Surgeon General Joycelyn Elders over the seemingly ludicrous issue of advocating masturbation. A clearly harmless activity (and in terms of teen pregnancy and AIDS, a healthy one), masturbation nonetheless threatens the social order by acknowledging the possibility of sexual pleasure, without negative consequences, outside the domain of the procreative family.

Proponents of so-called family values have also declared their enmity toward the sex industry. Yet ironically, the sex industry not only upholds but also

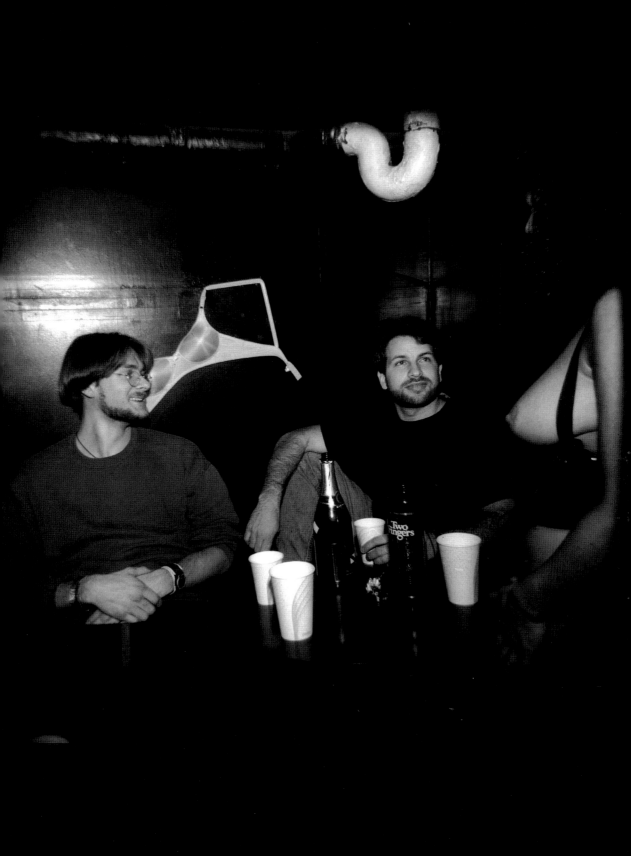

reflects the traditional social order. It is within this secret world—circumscribed by law, public moralizing, and obscuring fantasy images—that a virtual microcosm of society can be found. It is here that the relationships between money, sex, and power—the triad of forces that drives so much of contemporary life—appear in uniquely sharp relief.

The commercial sex business is, after all, a business—a business charged with emotional and political significance, but a business nonetheless. People are making money on the business of sex—not only (not even primarily) the women whose bodies are sold, but also an assortment of others, from pimps to club owners to pornographers to long-distance telephone companies.

In *Sex Work: Writings by Women in the Sex Industry*, Priscilla Alexander of the prostitutes rights organization COYOTE (Call Off Your Old Tired Ethics) notes: "Prostitution also involves an equation of sex with power: for the man/customer, the power consists of his ability to 'buy' access to any number of women; for the woman/prostitute, the power consists of her ability to set the terms of her sexuality, and to demand substantial payment for her time and skills."

Such interchanges, of course, take place against a backdrop of lingering gender inequality, where women's social and economic power remains, despite some progress, relatively limited. Men still have much of the buying power; what women have to offer in exchange is sex. In fact, it is the exchange of men's money for women's bodies which, in one sense, forms the very foundation of the traditional family, and of traditional relations between the sexes.

In the sex industry, this age-old, implicit exchange is made resolutely manifest. In *Sex Work*, sex-worker advocate Rachel West writes: "Given the economic status of women, how many of us are forced to rent our bodies, stay in marriages we want to get out of, make deals with the landlord, the shop keeper, put up with sexual harassment on the job, smile when we don't want to, put out or get fired, etc.? How many wives put in a greater effort at being sexy when they need extra money from their husbands? How many women choose the man who has better career prospects over the man who is a heartthrob? How much do we all have to prostitute ourselves because women internationally have so little to show for the tremendous amount of work we do? Perhaps in thinking over these things, non-prostitute women can see that they are really not so very far apart from the rest of us."

THE SEX POLICE

In certain respects, what defines the sex industry are these forces arrayed in opposition to it. The state and mainstream society have found the sex industry useful not only as a safety valve, but as a convenient and reliable public enemy. For years, politicians and law enforcement agencies have used the sex industry to justify their own jobs, bolster budgets, and win political prominence. Often in league with conservative family-value groups and anti-pornography activists, these state officials have created a booming industry in vilifying, regulating, and prosecuting the sex industry.

In fact, laws against commercial sex—even prostitution—are by no means universal or timeless. Most European countries have "decriminalized" prostitution—a policy called for by the United Nations over 45 years ago—and most of the U.S. laws prohibiting prostitution were not enacted until the 20th century; many, in fact, were passed just prior to the ratification of the women's suffrage amendment in 1920.

These new laws, and the latter-day social puritanism which spawned them, proved a boon to local, state, and federal police forces. The Federal Bureau of Investigation, for example, got its start enforcing the Mann Act, passed in 1910, which banned the interstate transportation of prostitutes. Stanley Finch, then the Bureau's chief, invoked the purportedly ever-present threat of the white slaver as reason enough for Congress to finance an expanded federal detective force. As Max Lowenthal notes in his book *The Federal Bureau of Investigation*, Congress wasn't anxious to spend the money, but Finch shrewdly argued the enormity of the task confronting the G-men: "Unless a girl was actually confined in a room and guarded," Finch said, "there was no girl, regardless of her station in life, who was altogether safe....There was need that every person be on his guard, because no one could tell when his daughter or his wife or his mother would be selected

as a victim." The G-men then invented the concept of the dragnet to catch whores in their hidden lairs, and also began the practice of using informers by hiring one madam to rat out another. (Under J. Edgar Hoover, both of these techniques would be transferred to political dissidents of every sort.)

Prostitutes rights advocate Priscilla Alexander notes that present-day laws against prostitution are often enforced in a highly discriminatory fashion. Citing statistics from the 1980s, she reveals that only 10 percent of those arrested have been customers. Arrests have also disproportionately targeted street prostitutes and women of color. The extent to which the police arrest and prosecute illegal sex workers also varies enormously from state to state and from locality to locality—and, even within a single area, from month to month or year to year. Pre-election periods often seem to yield an increase in arrests. Politicians—especially local politicians—can always use a well-timed and well-publicized crackdown on the sex industry for a quick political boost.

The most high-profile target of the sex police—as well as one of the most controversial political and social issues of the day—is pornography. Contained in this controversy, too, is the states' battle to wield selective control over the sexuality of its citizens. As Walter Kendrick points out in *The Secret Museum: Pornography and Modern Culture*, the very concept of pornography as a separate category of materials did not emerge until the 19th century, when it was shaped by regulatory efforts to keep sexually explicit materials out of the sight of women, children, and the lower classes—purportedly, for their own "protection," but actually as a means of social control.

As First Amendment attorney Edward DeGrazia outlines, in his book *Girls Lean Back Everywhere: The Law of Obscenity and the Assault on Genius*, the legal basis for declaring materials "obscene" (and for prosecuting pornography, which has no distinct legal definition) has evolved considerably over the years. U.S standards drew for some time upon the 1868 British ruling that judged books by their "tendency to deprave and corrupt those whose minds are open to such immoral influences" (i.e., "impressionable young girls"). Later, works were assessed according to their "capacity to arouse lust in the 'average person'" (in this case, "the judge himself, and two friends, whom he privately consulted").

When in 1964 the Supreme Court, led by Justice William J. Brennan, Jr., liberalized anti-obscenity standards on First Amendment grounds, DeGrazia writes, "the Court's critics found in the Brennan doctrine grounds to blame the Court for

Dubonnet Newark, New Jersey

the 'tides of pornography' that were now 'seeping into the sanctity of the home.' "
Current obscenity standards are still based upon Court decisions rendered in the
early 1970s, which deny First Amendment protection to materials that are
deemed offensive to "local community standards" and are without "serious liter-
ary, artistic, political, or scientific value." As always, these definitions remain
controversial and vague, and prosecutions are sporadic and often capricious.

In seeking to resolve the "pornography question," President Lyndon Johnson
appointed a panel of experts to study the issue of pornography. To the surprise of
many, the commission's 1970 report found "no evidence of harm" caused by
pornography, and called for the repeal of existing obscenity laws, except those
concerning children.

In 1985, President Ronald Reagan directed his attorney general to convene
another commission to study pornography. Both the chair and the staff director
of the so-called Meese commission were men known for their zealous anti-
pornography prosecutions; the parade of witnesses, also heavily weighted in
favor of "tighter controls" on pornography, included law enforcement officials,
representatives of anti-pornography organizations, politicians, psychologists
and researchers, and dozens of women—both former sex workers (including
Deep Throat star Linda "Lovelace" Marciano) and victims of rape and sexual
abuse—who told of how their lives had been damaged by pornography.

The FBI agents and other researchers working for the Meese commission
spent a considerable amount of time and taxpayer dollars studying and synop-
sizing a vast and eclectic collection of pornography. "The Meese commission,"
writes DeGrazia, "dedicated more than 300 of its *Final Report*'s 1,976 pages to
detailed descriptions of the plots, images, and ideas disseminated by 725 books,
2,325 magazines, and 2,370 films of the hard-core pornographic type."

Nevertheless, the commission did not recommend any new legislation
against pornography; instead, it urged that enforcement of existing laws be
stepped up. One of the effects of this effort, DeGrazia notes, was "to heighten
collaboration between federal and state sex-police prosecutors and citizens'
anti-pornography groups, including those led by right-wing religious leaders
Charles Keating, Jerry Kirk, James Dobson, and Donald Wildmon," for whom
the anti-pornography crusade has long served as a highly effective organizing
tool within a broader challenge to liberal sexual expression and to the rights of
women and gays.

In recent years, the forces of sex police have been joined by some feminist anti-pornography activists, most prominent among them University of Michigan law professor Catharine MacKinnon and writer Andrea Dworkin. MacKinnon and Dworkin have taken the position that pornography does not qualify as speech, entitled to protection under the First Amendment. Instead, it is both an incitement to discrimination and violence against women, and a form of discrimination in itself. Pornography, writes MacKinnon in *Toward a Feminist Theory of the State*, "is more like saying 'kill' to a trained guard dog, and the training process itself."

In 1983, MacKinnon and Dworkin drafted a model anti-pornography ordinance that differed substantially from any existing obscenity laws in that it created a "cause of action" (a right to sue) to ban the production, sale, distribution, or exhibition of any work of pornography deemed to degrade or dehumanize women. The ordinance also gave crime victims who claimed pornography had provoked their attackers the right to sue the creators and distributors of the pornography.

This model became the basis for a local ordinance in Minneapolis (which was vetoed by the mayor) and one in Indianapolis (which passed, but was later overturned by federal courts), as well as for the proposed federal Pornography Victims Compensation Act, also called the "Bundy Bill" after the serial killer who claimed that porn made him do it. (The act died in the Senate in 1992, but still has many supporters.)

The theories of MacKinnon and Dworkin also influenced the enforcement of much stricter censorship laws in Canada. In 1992, the Canadian Supreme Court's decision in *R v. Butler* upheld the government's right to restrict materials it found obscene if the material involved sex coupled with violence, or sex that was "degrading" or "dehumanizing." The court ruled that it was unnecessary to prove that the pornography in question caused actual harm; this could be inferred by a judge from the mere existence of the material. MacKinnon declared Canada "the first place in the world that says what is obscene is what harms women, not what offends our values." The *Butler* decision was hailed as a victory by anti-pornography campaigners in the U.S.

Ironically—but, perhaps, predictably—the primary targets of censorship after *Butler* have been feminist and gay and lesbian publications. As ACLU president Nadine Strossen recounts in her book *Defending Pornography*, imme-

diately after the case was decided, the owner and manager of Toronto's Glad Day Bookshop, a gay and lesbian bookstore, were arrested after police confiscated copies of *Bad Attitude*, a magazine of lesbian erotic fiction. In deciding in favor of the prosecution in the case, the court found that the combination of sex and violence met the requirements of obscenity despite the appearance of consent. Citing *Butler*, the judge concluded that "The consent…far from redeeming the material, makes it degrading and dehumanizing." According to Strossen, when Glad Day was again charged with obscenity based on seizures of gay publications, the court found them all to be "degrading and dehumanizing" in some cases merely for depicting sexual encounters "without any real meaningful human relationship."

Canadian Customs has also expanded its lists of prohibited materials, delaying or preventing delivery of many books and journals, particularly those headed for small gay, political, and women's bookstores rather than mainstream commercial stores. According to Human Rights Watch's Free Expression Project, customs has censored such classic authors as Oscar Wilde and Langston Hughes, while "Madonna's widely controversial book *Sex*, a book that includes a photograph of a school yard rape scene, [was allowed to sell] freely."

The Canadian experience seems to confirm feminist writer Ellen Willis's observation that "in a male supremacist society, the only obscenity law that will not be used against women is no law at all.…How long will it take oppressed groups to learn that if we give the state enough rope, it will end up around our necks?" Joining feminists who oppose censorship of pornography on First Amendment grounds are some who contend that the best way to counter pornography that "degrades" women is to produce pornography that doesn't. Susie Bright, former editor of the lesbian sex magazine *On Our Backs*, writes in her introduction to *Herotica 3: A Collection of Women's Erotic Fiction*, "Sexual liberation has always been a cornerstone of modern feminism. One of the oldest feminist challenges is to eliminate the double standard, to move from barefoot and pregnant to orgasmic and decisive. So why isn't the sex field treated by feminists as just another Old Boy's Club that needs to be shaken up and infused with a woman's point of view?"

While few would defend, on any grounds, the use of children in pornography, there is considerable evidence that the child porn issue, too, has been exploited in order to supply a mission of unquestioned importance and merit for

Annie Sprinkle at home, Manhattan

the legions of the sex police. According to Lawrence A. Stanley's essay "The Child Porn Myth," published in the *Cardozo Arts & Entertainment Law Journal* in 1989, the prevalence of child pornography in the United States has been vastly exaggerated since the mid-1970s. Despite evidence to the contrary from government studies and conviction statistics, and despite strict new laws against child pornography, the myth of "a massive underground porn network raking in billions of dollars, alongside a nationwide network of child molesters," continued to grow through the 1980s and 1990s. Child porn rings and pedophiles—some of them operating within secret Satanic sects—were even reported to be behind the disappearances of thousands of missing children.

It was not surprising that the myth of child pornography persisted and grew, since, according to Stanley, "the activities of law enforcement agencies have also grown exponentially in this area. United States Customs, the United States Postal Inspection Service, the Federal Bureau of Investigation…and state and local law enforcement and social service agencies have established special units and inter-agency task forces to combat child pornography and pedophilia." Once this vast network was established, it began to fuel itself, engaging in a variety of ingenious methods to stamp out the mythic underground in child porn.

Operating behind such fake outfits as "Candy's Love Club" and "Heartland Institute for a New Tomorrow" law enforcement agents masqueraded as adults sexually attracted to children or as children themselves (with authentic childlike handwriting) and tried to get their correspondents to send child pornography through the mails. Investigators seeking out potential child pornographers also compiled secret government-owned "target lists" and employed background checks, trash searches, visual surveillance, and wire-tapping.

The real industry here seems to have become the industry of law enforcement, whose main purpose is to perpetuate itself. Stanley notes that "this extensive and very expensive law enforcement activity generates the impression of a large, thriving child pornography underground. Police activities are even cited as 'proof' that such a large underground actually exists.…Today, a person seeking that underground is likely to find only a vast network of postal inspectors and police agents."

By the mid-1990s, this network had taken itself online, in a mission to hunt out child pornographers operating in the relative anonymity of the Internet. In September 1995, more than a dozen America Online customers were arrested

following an FBI-directed sting operation (named "Operation Innocent Images") in which federal agents took to the keyboards to pose as children waiting to be propositioned by adults, or as adults seeking sexual images of children. Based on online conversations, officials received court orders permitting them to open customers' electronic mail. They also, eventually, searched over 125 homes and offices. In a press release following the raids, the FBI expressed its belief that the online services are "rapidly becoming one of the most prevalent techniques by which individuals share pornographic images of minors." The special agent in charge of the last phase of Operation Innocent Images stated that "this investigation embodies a vision of the type of investigatory activity we may be drawn to in the future."

In fact, it seems likely that the Internet—a vast, anonymous, and seemingly uncontrollable means of communication—will rapidly become the new target of choice for the anti-porn patrols in general. In the summer of 1995, the *Georgetown Law Journal* published a study by Marty Rimm, an undergraduate researcher at Carnegie Mellon University, citing massive stores of hard-core pornography on the Internet. The so-called Rimm report inspired a cover story in *Time* magazine, as well as new Congressional efforts to crack down on the Internet by means of the Communications Decency Act (already used to regulate phone sex) and other proposed legislation.

Within months, the study's findings had been largely discredited by revelations that Rimm's research had focused precisely on those segments of the Net where porn was most likely to be found (a methodology one commentator compared to "sitting in at a nursery school and deducing that most of the people in the world are three feet tall"), and that Rimm himself was the author of a privately printed book entitled *The Pornographer's Handbook: How to Exploit Women, Dupe Men & Make Lots of Money.*

These revelations did little to slow down the sex police juggernaut. Instead, efforts to control the amorphous Net have inspired new legal definitions and have reached across national borders. In late 1995, in response to pressure from child porn prosecutors in Bavaria, Germany, CompuServe—the second largest commercial online service in the U.S.—blocked its 4 million subscribers worldwide from accessing all postings on over 200 sex-related UseNet newsgroups. As the Internet enables users to send porn across the world at the touch of a button, the sex police are going global.

In the struggle to reclaim their own images from institutions as pervasive as the sex police and the pornographers, some sex workers and former sex workers have formed organizations of their own. Many of these are involved in such issues as promoting AIDS education among prostitutes; calling attention to rape and other abuse of sex workers, opposing child prostitution, and combating the "whore stigma" that blames women in the sex industry for everything from venereal diseases to the corruption of youth to their own serial murders.

But the various sex-worker groups differ dramatically on many issues—even on the ethics and impact of sex work itself. On one side of the debate are several sex worker-rights organizations, including COYOTE and PONY (Prostitutes of New York), which favor decriminalization of prostitution (rather than legalization, which implies government licensing and regulation of prostitutes). Priscilla Alexander of COYOTE and the National Task Force on Prostitution writes: "Decriminalization...offers the best chance for women who are involved in prostitution to gain some measure of control over their work....Whatever you or I think of prostitution, women have the right to make up their own minds about whether or not to work as prostitutes, and under what terms."

Although positions vary, some members of these organizations have gone beyond advocating legalization and prostitutes' rights to advocating sex work as a socially valuable and personally empowering profession. It is statements to this effect which most anger organizations like WHISPER (Women Hurt in Systems of Prostitution), made up chiefly of former sex workers, and dedicated to abolishing sex work in all its forms. Sarah Wynter, founder of the Minneapolis-based group, writes: "There has been a deliberate attempt to validate men's perceived need, and self-proclaimed right, to buy and sell women's bodies for sexual use. This has been accomplished, in part, by euphemizing prostitution as an occupation. Men have promoted the cultural myth that women actively seek out prostitution as a pleasurable economic alternative to low-paying, low-skilled, monotonous labor, conveniently ignoring the conditions that insure women's inequality and the preconditions which make women vulnerable to prostitution. Men have been so successful in reinforcing this myth by controlling the culture that their central role in the commercial sexual exploitation of women has become invisible."

The reality beyond this debate is that only a tiny minority of sex workers have ever heard of any of these organizations, and that sex workers as a class still have

ONE WAY

ONE WAY

BRUNO
TRUCK SALES CORP.
(212) 965-2000

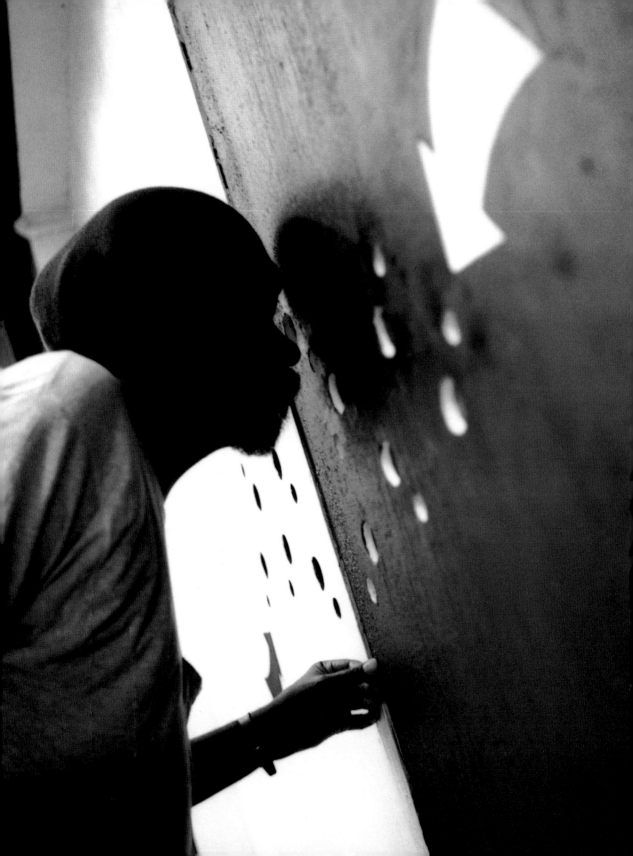

less influence over the policies and attitudes that affect their lives than any other group of working people today. Even the common mission of the sex-worker organizations—a political and social voice for sex workers—is arrayed against enormous odds. Alternately vilified and glamorized, sex workers are seldom seen or heard except through the thick filter of someone else's preconceptions.

THE RED LIGHT INDUSTRY

The business of sex is immense, seldom calculated or measured, and often unnoticed. Today's sex industry spans a burgeoning crop of large and small businesses, which engage in everything from porn videos and phone sex to sadomasochistic role playing, go-go dancing, and prostitution. For some behind-the-scenes owners and operators, the business can be highly lucrative; but small, modestly profitable ventures are the rule rather than the exception. And for all but a few of the workers in the industry, the money never accounts for much more than a bare living wage—just enough to tide them over until their next shift.

The sex industry doesn't really perceive itself as an industry, and both workers and patrons in one segment are, often as not, determined to disassociate themselves from those in other parts. "Like hookers would never be strippers," says Annie Sprinkle, the porn star–turned–sex-worker advocate and performance artist. "Strippers would never be porn stars. Porn stars would never be hookers. There are crossovers, but everyone has things they want to do and things they don't want to do. And each aspect of the business is tailor made for individual needs." One crucial factor that distinguishes work in different facets of the industry is distance—how much distance lies between workers and their clients, between object and subject.

For most workers in the porn industry, for example, the job boils down to creating images in other people's heads—going through the motions of exotic sex for the video camera, talking dirty on the telephone, engaging in cybersex through adult computer bulletin board services or Internet UseNet newsgroups. These workers will never see their clients. Other workers perform at closer proximity in the sort of theater of the absurd that the dungeon and the go-go club

have become. Here, clients can see and sometimes touch the forbidden bodies, but the workers are afforded a degree of protection by a set of rules governing what can and cannot be done. Finally there are the whores, the foot soldiers of American sexual culture, working on the front lines of the sex industry—where the carefully orchestrated rules of striptease and no-sex whipping come undone in the middle of the night on the street; where a fuck is not an idea on the telephone line but a physical and sometimes brutal act.

Fractured and marginalized as it is, the industry has always been adroit at sustaining itself amidst a shifting legal climate and changing client demands. Diversification, as well as adaptability, has been key to its survival. Under various social and economic pressures, the traditional "red-light district" has evolved, over the last century, into a modern, multifaceted industry.

As Richard Symanski describes it in *The Immoral Landscape: Female Prostitution in Western Societies*, cities of all sizes tolerated red-light districts during the post-Civil War period. Although they were against the law in all but three states, actively regulated red-light districts could be found in no less than 50 cities, and at end of the 19th century there may have been upwards of 150 official and unofficial districts. But the Progressivism of the early 20th century brought a crackdown on prostitution—which, opponents claimed, increased cities' rates of crime and venereal disease, led men to immoral behavior, and "promoted education in the abnormal and perverse."

Mobility became the sex industry's key to handling these crackdowns. During the two world wars, prostitutes occupied cabin camps—forerunners to motels—outside army towns, and employed cars (often called "chippie wagons") to solicit and transport customers to them. Other prostitutes followed their customers: At times, they traveled in circuits, in loose confederations sometimes organized by pimps and booking agents, up and down the West Coast, or in circles that stretched out from New York through the old industrial cities of what has become the rust belt, often following the routes of new railroads.

The law of supply and demand has similarly led to the contemporary phenomenon of the weekend sex worker: pink collar workers in Southern California who become Las Vegas prostitutes each weekend, or women who hold down office jobs in New York City but go out to New Jersey on weekends to strip.

Changes in the business have continued to be fueled both by the nature of

legal restrictions and by the nature of the demand for services. According to Symanski, for example, a crackdown on brothels, coupled with the war in Vietnam, helped boost the massage parlor business. Soldiers on R & R in Thailand had experienced the sexual massage, and upon their return became ready customers for American massage parlors—which, unlike brothels, were tolerated because of their "legitimate" fronts and because higher sanitary standards kept them cleaner and less likely to cause disease.

Over the past few decades, the reality of the sex business has moved further and further from the traditional image of the red-light district. Since the early 1980s, in particular, the sex industry has undergone dramatic change, conforming itself to changing tastes, the digital revolution, and the onset of AIDS.

The business of sex in the 1980s and 1990s has increasingly been removed from the realm of the senses—from actual physical contact between bodies— and transferred to the distanced realm of electronic media. The nocturnal visit to the whorehouse has been replaced by a trip to the VCR, the telephone, or the personal computer. The old-fashioned peep show is fast disappearing, but the day when you can dial up a pretend girlfriend on the phone, then see and talk to her on a cable television channel, is just around the corner.

In today's multifaceted business, groups of Wall Street brokers or New Jersey construction workers get together to visit their respective classes of strip joints just as they would to watch Monday night football. For those who find the strip clubs too wholesome, there are the S/M (sadomasochism) clubs, where illicit fantasies and fetishes can be discussed or enacted for a price, and sex workers sometimes talk of themselves as paramedics to psychiatry, facilitators in the faux-psychological role playing of the dungeon. At other venues, people undertake gender illusionism, switching from she-man to he-woman or any number of gradations in between. Even the art world toys at the edge of the business, transforming sex work into theater and performance art.

The sex business is constantly reorganizing and reinventing itself to incorporate these many diverse elements. In the future, what may ultimately replace the old red-light district is something akin to an adult theme park, where you can watch a strip show, make your own porn movie, chat with the online sex group of your choice on computers in the coffee bar, get your hair or nails cut by a topless beautician, sweat with your own jock-strapped personal trainer, and engage in S/M role playing in the basement dungeon.

It is not clear just how much these changes in the industry have to do with AIDS, and so far there are few studies on the topic. For street prostitutes, most of whom are destitute and desperate (and many of whom are now HIV positive), the threat of AIDS seems to have had little influence on sexual practices. But there is some evidence that more middle-class purveyors and consumers of sexual services may be choosing safer sex options. Many higher-priced brothels and escort services, for example, now maintain a "condom only" policy—in theory, at least. Many producers of porn films and videos now require actors to have regular HIV tests—although the majority of these films still fail to depict safe sex practices. Managers and workers in S/M clubs report growing attendance at clubs that are devoted to role playing and ban outright sexual intercourse—though some S/M involves body piercings and other practices that increase risk. Lap dancing, in which clients can get off, but have to keep their pants on, seems also to have gained in popularity. And, of course, phone sex, computer sex, and pornography, which involve no physical contact whatsoever, are the safest of all.

In order to remain a growth industry, the sex business has had to adapt itself to a world where exchanging bodily fluids is potentially lethal. And overall, the industry has been remarkably resourceful in coming up with ways for people to get off without ever touching another human body. Electronically enhanced onanism has become the wave of the future.

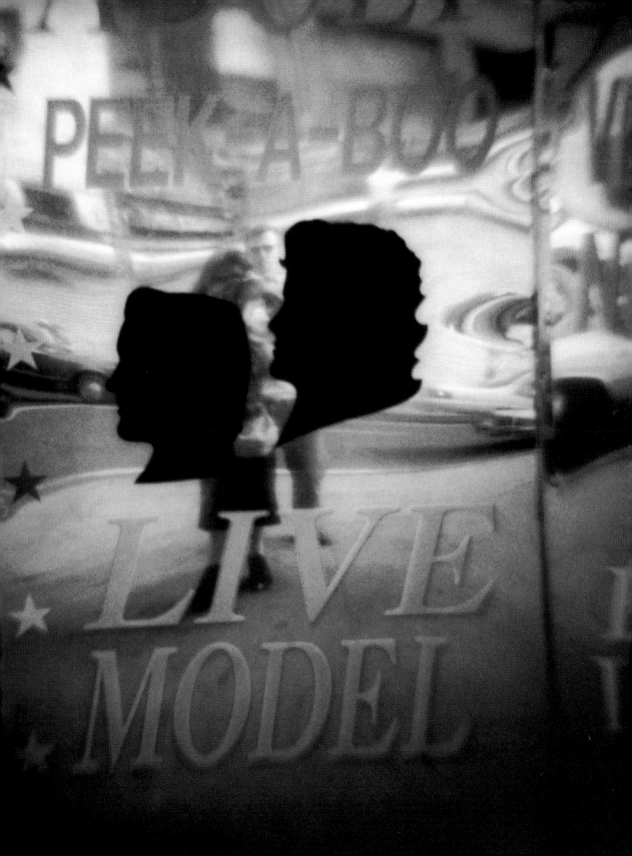

PORN

After more than a century of political and legal controversy, pornography remains the vaguest of concepts. Loosely defined, it consists of words and images calculated to arouse sexual desire. But exactly what people perceive as pornography depends, of course, on what turns them on; so no one has succeeded in providing a more concrete or comprehensive definition than Supreme Court Justice Potter Stewart, who said in a 1964 obscenity case, "I know it when I see it."

For the sex industry, porn is just another way to make money by providing services that get people off, and for the right price, it will supply porn to suit any brand of desire. What distinguishes this part of the business is that the service providers are one step removed from the customers. When porn consumers get off, there is no sex worker in sight—just a well-thumbed magazine centerfold or a flickering image on a screen. And because the service is provided through an interim medium—print, video, or telecommunications—much of the money in porn is being made by middlemen (most of them, indeed, men). The cash flow in porn is controlled not by the individuals whose words and images are sold, but by the producers, publishers, and distributors who sell these words and images to their insatiable customers.

As the multimedia revolution has taken hold, porn has taken full advantage of the new multiplicity of opportunities for mediated sex. No longer limited to the thinly sophisticated men's magazines or the kitschy porn flicks of the past, porn has expanded into the home video market, the 900 telephone lines, the online bulletin board service, the do-it-yourself world of 'zine publishing. As in the rest of the sex industry, small enterprises outnumber large ones, and there are numerous offerings to suit every taste. And despite the concerted efforts of lawmakers, the religious right, or anti-porn feminists, there can be little doubt that pornography in all its flavors has only become more and more popular in recent years. Porn is particularly well suited to an era where, physically as well as emotionally, distance is what many people are looking for.

Mark Davis, actor, on the set of *Memories o' Love*, Malibu, California

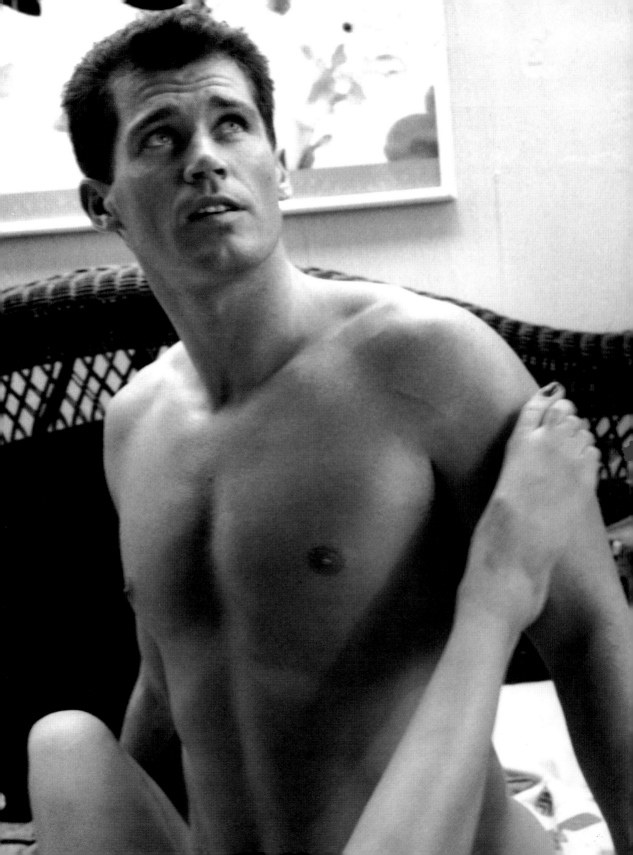

THIS IS FILMMAKING

The 1970s marked the first heyday of porn films, witnessing the release of *Deep Throat* and *The Devil in Miss Jones*. *Deep Throat* cost only $25,000 to make and earned over $50 million. Today, film and video remain lucrative segments of the porn industry. The figures tell the story: In 1989, adult film and video grossed 992 million; by 1993, the figure had risen to 2.5 billion; by 1995, it was up to 3.1 billion.

Southern California—especially the San Fernando Valley on the periphery of Hollywood—remains the production capital for the world in sexually explicit film and video. According to the 1986 report of the Attorney General's Commission on Pornography (the so-called Meese commission), "at least 80 percent of the sexually explicit video tapes, eight millimeter films, sexual devices and paraphernalia that are produced in the U.S. are produced and distributed within Los Angeles County." The commission attributed this trend to the "availability of resources and the temperate climate." Al Goldstein, publisher of *Screw* magazine, is more explicit in describing these "resources": "Nobody is making fuck films in New York," he says, "because all the actresses are living in LA."

As with most businesses, the contours of the modern porn movie business are determined by the bottom line, and are shifting in response to changes in technology and in the marketplace. Movies that once cost anywhere from $30,000 to $150,000 to make on 16mm or 35mm film for theatrical release are being replaced by movies that can be shot on video for as little as $3,000 each and sold to the home video market.

As a result, the adults-only porn theaters are becoming as much a relic of the past as drive-in movie theaters. "I have not shot a foot of film in over four and a half years," explains Carter Stevens, who has built a reputation as a porn film director. "It's too expensive….The last feature film I did, *White Hot*, the budget was about $135,000. We shot it in seven days. Crew of twelve, cast of 20 plus. Hour and a half feature film. Since I came back into the business three years ago, I'd say the budget for all 32 videos I've done doesn't total $125,000.

"A feature film takes three months; a video takes me a week, beginning to end. On a feature film I have a crew of 12 people. On video I have a crew of two or three." According to Stevens, male performers make about $250 per video and females performers about $350, at bottom levels, although stars can garner as much as $2,500 a day.

"The way I understand it," says Al Goldstein, "the budget for a fuck film is $12,000. They aren't actually films. They are videos. They're shot in a day.... I'm going to have a *Screw* line of fuck films. I was told that if I put in $12,000, in about four months I'd get $15,000. Once you have a fuck tape, then you can go to any number of distributors. They are the ones who make the money. They sell 4,000 to 5,000 tapes....I am going with a distributor who offered me an advance of $10,000 for four films. Nothing."

Many porn filmmakers believe their business is swamped with product, and that the future lies in specialty or niche marketing. Candida Royalle, for example, has been trying to open up a relatively untapped market: films, distributed on video, based "on female sexuality and focused on sensuality." "I wanted to do something different. I wanted to create a line of erotic movies that couples could watch together, that women could relate to." She has done eight films, and while it takes her longer than other porn filmmakers to get the money back, her films pull steadily. The most popular, *Three Daughters*, cost $75,000 to make and has grossed $500,000. She tries to hire actors who are lovers in real life or who want to make love to one another, and to "create as natural a situation as possible."

"We shoot very differently from other people," Royalle says. "Most porn people in the mainstream shoot sex act by sex act. They give you a little story, and then you get some sex. It's all formula. You watch one and you've seen them all. It looks mechanical because it's shot sex act by sex act. So we decided to scrap this whole formula....We tried to create as natural a situation as possible." The camera person makes himself inconspicuous, and the sex scenes aren't scripted, Royalle says; they're "choreographed."

Stevens, once celebrated as a hot-selling porn filmmaker, now concentrates on the niche fetishist video market. "Every day I see another company going into fetish because they can't make money in straight porno," he says. "So where is it going? More and more to the mature market and the 'pro-am,' which is professional stuff made to look like amateurs. Because that's the bottom line of what pornography is all about: voyeurism, watching the neighbors next door.

"Amateur stuff is crap. It's setting up a camera and watching two people fuck. But it sells, and it has wiped out most of the rest of the market, and a lot of the fetish market is getting to be the same way. The fetish market is much more limited by law in what we can show, so the amateurs can't really get a toehold, in that you can't show the real thing...."

Bud Lee, director, with actors Mark Davis and Lené, Malibu

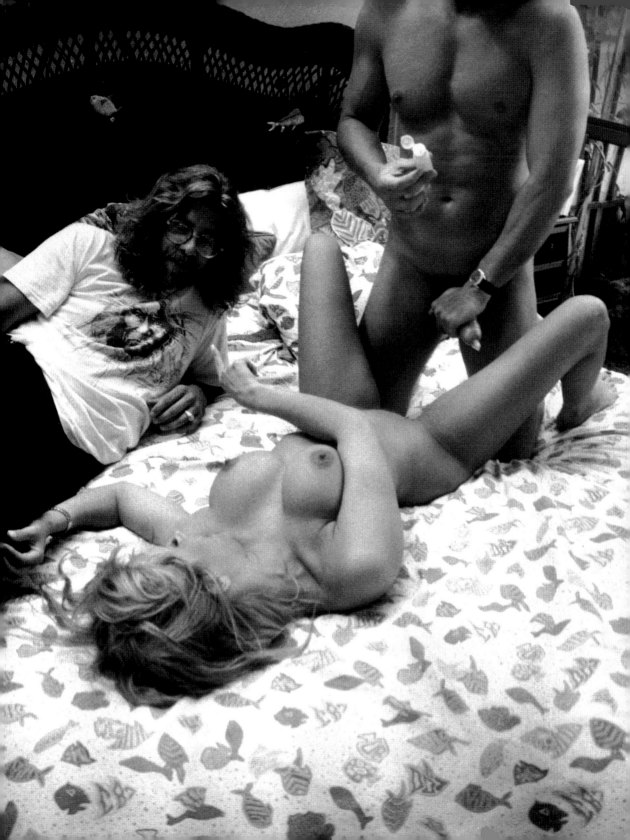

"Everything I do is censored. I do not have any sex in the fetish films, except in the European versions. In the American version we don't show any erection or penetration. Our stuff is R-rated. In fact, you'll see a lot hotter stuff in R-rated films in the regular theaters....I know if I put golden showers in a film I am going to get busted somewhere. You have to understand the mentality of the anti-pornography faction, the prosecutors....If they are half-savvy politicians they know they are not going to wipe out pornography. What they want are convictions, headlines, and votes. Bottom line is that in order to get convictions under the current community standards of hard-core porno, they go after stuff they feel has a high conviction probability—stuff the average person feels is disgusting: scat, enemas, golden showers, fist fucking. It's not everyday screwing. So if a prosecutor goes after a film with enemas and the like in it, he has a better chance of a conviction....

"Fetish films don't have sex. We don't even show the act. That's why I'm still in business and why the amateur films can't run me out of business. Because I can put a golden shower in my film the same way Steven Spielberg makes a movie. I show a golden shower without anybody actually doing it. I do a simulation. It's the same when I do an enema scene. You see the bag. You see the bag being filled. You see the bag emptying. You see the nozzle. You see the ass. You see the face. You see everything but an enema. This is filmmaking."

By catering to a diverse assortment of fetishes, Stevens has achieved a modest success, selling 2,000 to 3,000 copies of each video. "I don't do much male dominant stuff," he says. "The male dominant market is much smaller, and 90 percent of my stuff is female dominant because it's a much bigger market.... I also have two versions of a film called *Footprints*. If you're not into feet you'll be brain dead by the time you finish watching it. It's 60 unremitting minutes. The last 20 minutes are nothing more than a man putting toenail polish on a girl's toes and blowing them dry. A foot fetishist doesn't want to see better tits. He wants to see better feet. To him that's erotic. That's the market I'm selling to."

A PORN ACTOR'S STORY

Another perspective on the business comes from porn actor Rick Savage. Savage has appeared in over 300 films and videos, including about 50 S/M videos. "My approach," Savage says, "is that, as an actor, you have to maintain a generic appearance so that you can be cast as everything from a criminal to the

Adult video distribution center, Los Angeles

president of the United States....I've played politicians, club owners, lawyers, nice guys, bad guys, and everything. I even played a Jewish archangel once—Archangel Ivan—and a buffoon KGB guy, and a mad scientist. I played a very funny hunchback in *Night of the Living Debbies*. And—how can I forget—I played the Jokester in *The Erotic Adventures of Bedman and Throbbin*. I've played guys kidnapped by aliens to perform sex in their spaceship. I've played the sleazy nightclub owner more times than anyone in porn."

Savage has been in the porn movie business for over ten years. "I didn't dream of growing up to be a porn star," he says. After two years in the Navy and some time touring with modern dance companies, he took a part-time job as a stripper to earn some ready cash. He soon tried live sex shows, and then porn films. In his first film, made in the early 1980s, Savage had sex with audience members in a sex club. After that, he says, "it was kind of easy....I did another and another and another."

As Savage explains, one of the primary job requirements for male porn actors is the ability to produce and maintain an erection on demand. "When I got started, directors were reluctant to hire new men. If they had to shoot five sex scenes, they had to know that if they said, 'Tommy, we want you to get hard now,' he'll get hard now. I think every guy has had that problem, but your batting average has to be pretty good—29 out of 30 times you better get it up. Out of 270 movies total in my career, there's probably five or six failures, maybe seven. Then there's those other days when you're not real strong sexually, so you come up with tricks that will make you hard enough....

"If you're aware of the process of making films, the process of editing, you're aware that okay, if you're having a hard time, they can put the camera between your legs for a close-up of when you're hard. Let's say you're not getting along with the lady you're working with: You can play with a part of her body and not look at her face. Or I use my hand and fantasize about my girlfriend. Then I say, 'Shoot it now, I'm hard,' so the camera gets a close-up of the penetration. And then when your fantasy doesn't sustain you because you actually have to look into the eyes of the person you're not excited by, and you begin to lose an erection—well, at that point, they've already filmed the close-up. So with editing, they can get the close-up and simulate the sex on a wide shot. There's, like, three or four crucial shots: a close-up of the girl, the guy, a wide shot. Then you can edit them together to make the sex scene...."

"Most porn actresses got into it for the money, or they wanted to feel like they were loved or desirable, or whatever reason....It is also very common for dancers [to work as porn actresses]. A topless dancer knows that if she's a porn star, she can command a salary before tips of $3,000, $4,000, $5,000 a week—a lot....So they'll do films so they can get some credits, so they can become a porn star, and then they can increase their revenue as a dancer....Overall, about one out of seven women really enjoy it. Two out of seven hate it. The rest can take it or leave it; once in a while maybe they enjoy the man they're working with."

Savage describes the "worst experience" he has had working with a porn actress. "She really hated it. She made it obvious. She was very disconnected. You'd try to get very intimate and get turned on, and she'd start a conversation with the crew. One day, she was giving me head, and I was almost hard, and she knew I was almost hard and almost able to fuck, so what did she do to undermine me? She held my dick by the base, pretended it was a microphone, and started singing to the crew, 'Nothing could be finer than to be in Carolina.' There I am, laying on the bed, and the crew is trying to be very quiet so that I can do the sex, and she does that and they break out into uproarious laughter....There were other guys that had no trouble with her. One guy said she was his favorite fuck, and I'd sit there and think, 'How the hell can he fuck her?'

"There are porn actors who have been working at this for 20 years, and they can still walk in a room and see a pair of tits and their dick gets hard....Me, I'd rather work with someone who is 40 years old and has average looks and wants to fuck me, than to work with some 22-year-old face and body that's just a pretty thing to look at, but there's nothing there."

Savage discusses how the porn movie business conforms to the perceived psychology of its viewership. "I've always thought of it as, look, if you've got an average guy out there—and he's not getting as much sex as he wants to, and he's dreaming of having sex with all these women—if the porn actor looks like the average Joe, then he becomes your alter ego. It's like, 'Whoa, there's Joey or Tommy, he's not a bodybuilder or a Mr. America, if he can fuck the girl, then so could I. God, maybe I'd have a chance, you know?'"

According to Savage, the industry has moved toward extremes, producing many dirt-cheap videos and a few high-budget videos. "The middle-of-the-road video seems to be disappearing. They're either very cheap or very expensive. Very cheap can be anywhere from $4,000 to $7,000. That's for a finished 90-

minute product, with editing and titles and everything. Then you get companies that do spend more money. Some of these companies make these big lavish productions that are shot on film."

The industry's overall shift toward low-budget productions has also changed the way porn actors are paid. "Back in the days when they took more than one day to make a movie—although there's a couple of people who still do—you could get about $1,500 for a film. In that range. We got paid $500 a day, and you'd work three days. "Now you just get paid for how many times you have sex....Most of the guys get paid anywhere from $75 to $300 per pop shot. That's what it's come down to. It used to be a day rate. Sometimes they didn't even think, 'Did Rick have sex today?' Now, because budgets have gotten so cheap, they pay by the sex scene.

"Women get paid more. The big stars, I don't know. Beginning girls make anywhere from $150 to $300 for a sex scene. That's girls starting out or average girls, not stars. It depends. If they get popular, then the per-sex rate goes up to $400 or $500. If they become a hot box cover item, I don't know. They can get up to $800, $1,000, $1,200."

After a decade in the business, Savage has mixed feelings about the work. "Have I enjoyed it? My standard line is that in order to continue and successfully perform, to successfully get an erection, you tell yourself every day, 'I enjoy this work, I enjoy this work,' because the minute you tell yourself you don't, you're not going to get erect....If I showed up on the set and found out that the script was changed and I had to work with someone I didn't like, for the first half-second after hearing that I might go, 'Oh, no.' But from the second half-second on, I'd start telling myself how sexy she is and how much I desire her. Getting geared up has to happen immediately....But I sometimes wonder what the effects will be on a man's mind of 20 years of telling himself he's turned on and enjoying something when half the time he doesn't."

Savage discusses how his work has affected his personal life. "There have been very few girlfriend relationships in last six years....My current girlfriend is not in the business. Sometimes for a couple of days before I'm going to work, I'll abstain. She understands that. It's very difficult for me to go from having sex with somebody I care about and have an intimate feeling with one evening to doing it professionally the next day....I have to isolate myself for a couple of days. I just can't flick a switch as easily as some people can. I've said to her,

Lené and Mark Davis, Malibu

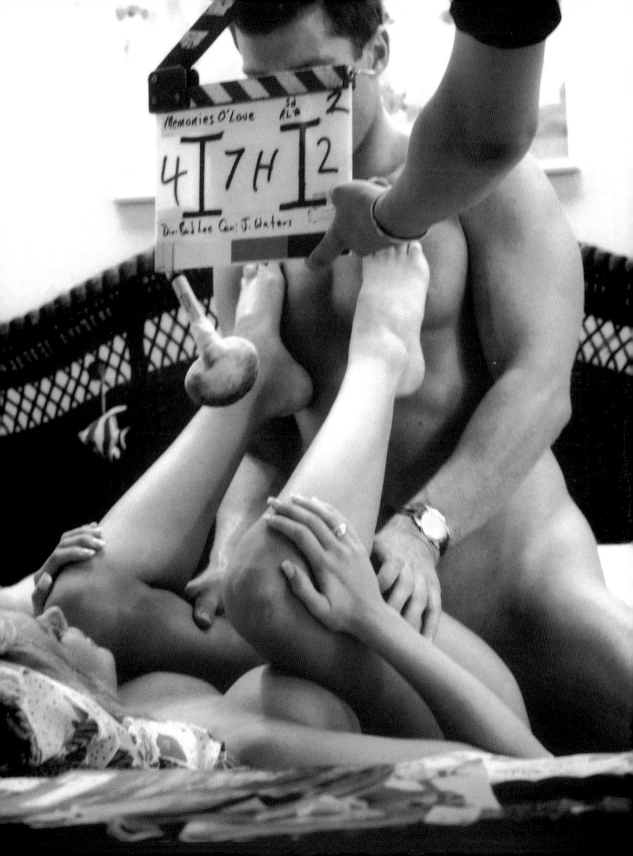

'Look, I can't fuck you on Thursday night and have this wonderful sex, and go in on Friday and have sex that's not even as intimate as masturbation.'"

Savage has been a single father for many years. "I've always taught my son to be his own person. And I've shared with him from my experiences. I've said, 'Son, sex with somebody you love is so much more wonderful and more important than sex with a bunch of different girls.' And when I said that, it was almost like he understood it already."

TALKING DIRTY

Another highly visible end of the business is phone sex, an intricately constructed enterprise in which telephone companies and sex entrepreneurs have grossed as much as $1 billion annually over the past decade. The basic vehicle for the business has been the 900 number services, which must subcontract for the use of telephone lines from the local and long-distance companies. So while keeping their own images squeaky clean, these telephone companies have earned considerable income from the phone sex business.

The 900 (and, more recently, 970) services offer many types of information and "entertainment" (such as job counseling and therapy of one sort or another), for which callers are charged on their telephone bills. By the late 1980s, the 900 lines were also filling up with phone sex services—mostly one-on-one "chat" lines run by companies operating out of offices referred to as 900 rooms, staffed with men and women talking sex to a growing pool of customers. The development brought an outcry from the religious right, as well as new regulations and threats from politicians at all levels. Fearing that phone sex would be knocked off the 900 system altogether, phone companies and phone sex services began policing themselves.

"There was no sex on my 900 numbers," said a former phone sex service manager. "They were just chat lines. You could have general conversation. It could get racy, but you couldn't be indecent or obscene. They would talk about wives, girlfriends, light fantasies, lingerie, but so far as sucking and fucking, it didn't happen on those kinds of lines. These girls were acting as counselors. They were like therapists. A lot of guys are lonely. A lot of guys want to talk to girls, or gay guys want to talk to other men. You can't just go on the street and say, 'Hi, will you talk to me?'"

Francesca, telephone dominatrix, the Poconos, Pennsylvania

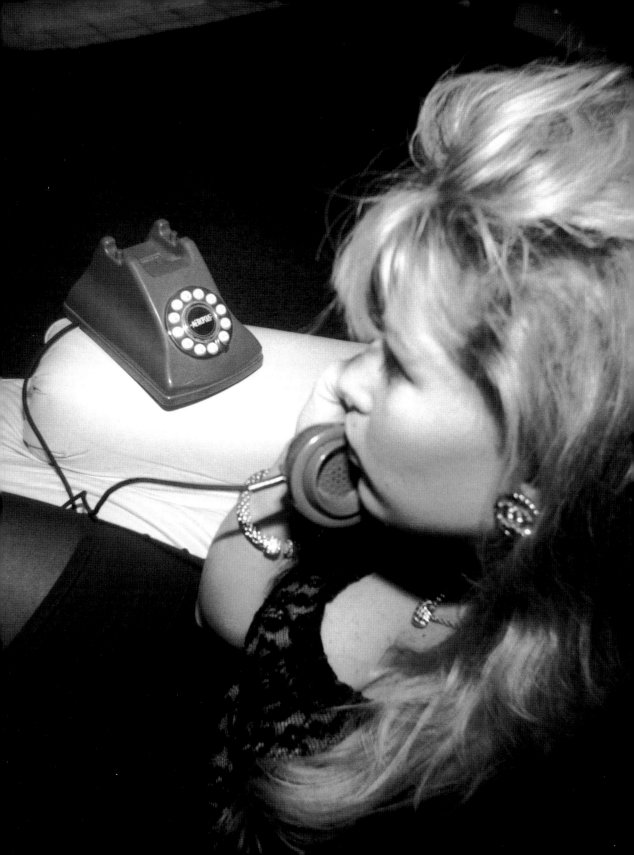

Many other customers, however, call for explicit sex talk. And the phone sex services, rather than risk losing a potentially lucrative clientele, became resourceful in adapting themselves to the changed regulatory climate.

By the mid-1990s, many had come up with a variety of different ways for customers to get down and dirty on the phone. With some services, a caller can still start out on a 900 line; but when he gets to the point of an explicit sexual exchange, he is "switched over"—encouraged to call back to a regular "private" number outside of the 900 system, and charge his explicit talk session to a credit card. (The local and long distance carriers, of course, still bill their standard rates for the call.) Other services have moved exclusively to regular numbers, and accept only credit card callers. In other cases, all calls still take place on 900 lines. But the use of those lines depends very much on the final approval of the different phone companies involved, which monitor their phone sex customers and slap them down if they take offense at their advertising.

The cost of phone sex varies from place to place. On the East Coast, a ten-minute call, charged to a credit card, averaged $15 to $30 in 1995. The caller pays more to talk to two girls, and the cost is generally higher for S/M. Some men call infrequently, but for others, according to Joy, a phone sex operator, it is "like a drug habit." Men will get hooked on a certain girl and call several times a day, running their bills up to hundreds of dollars a month. The phone sex operator—or "agent," as he or she is sometimes known—is generally paid $7 to $10 an hour, although in certain setups agents work on a commission basis.

Credit cards complicate the business because numerous callers turn out to be "deadbeats" and never pay. To eliminate the deadbeats, the phone sex services contract other companies to run high-speed computer screens on potential customers before the call goes through, and use other firms to process the card payments—all of which runs up overhead.

In general, the phone sex business has become less lucrative. The decline in profits in the 1990s has been due in part to the more complex tangle of regulations, and in part to the emergence of online computer services, which put customers in touch with one another more directly and much more inexpensively.

Donna, a poised and articulate Caribbean-American woman with two grown children and a master's degree in child development, managed a phone network from a tiny office in New York City's Empire State Building. She

describes how her company navigated the laws regulating phone sex. "The only way to have explicit sex was to go to a credit card or a 212 number [the local area code in Manhattan]....Several years ago we were able to do a sexual call on a 900 number, then we could not....

"Let me say this: You can successfully have a man ejaculate on a 900 number without ever talking sex. It's a longer call. But men will start talking explicitly. We had to police them. We would say, you know, 'You can't say that on this line.' So the object is to put him on the 212....What we would do is initiate the sex by saying, 'I'd like to give you a whole body massage,' without referring to any body parts."

Like a hustle in a strip joint, every move in phone sex is carefully orchestrated to extract money from the customer. Donna describes how her company trained women to do phone sex. "We would start training the psychology of the call, that is, what the agent—who is the telephone operator—what she should be thinking about, and what the caller is probably thinking about. Now, she should probably be thinking that he is not a deviant, he is not a pervert, he is not a jerk. He's calling up because we can provide a service of loving and warmth and contact of some kind. If an agent were to think that he's a jerk, she would not have longevity in the business, because no one wants to sit and talk to 70 jerks in one day, or in one night.

"What the agent should be thinking about the psychology of the caller is that we are all what we are through our own childhood psyche....No two of us make love the same way. That lovemaking ought to be consensual, so we do not do certain kinds of calls in our service—incest, bestiality, necrophilia, rape violence, that sort of thing. But if you prefer to swing from a chandelier and have someone throw daggers at you, and that is what turns you on and your partner on, that's fine....You can't start talking about norms. That word has no place in the sex business....

"You must become a very good listener. You must become the woman he's looking for. And to do that you must have the acting ability. You must have the empathy. You must have the command of the language. You must be able to move from one character to another and do it very comfortably....

"You must be comfortable with who you are about to become because you have to step into that role every day. It's not a script I'm going to write for you, but one that you have the opportunity to write for yourself. So if you have 36DD

breasts, do not say you have it on the line. I want you to remove yourself from it. It's all very much a role-making part....

"It's all really in the mindset, in making their psyche ready for what they are about to do. Because if they don't do that very well, then it will show in their voice. There are certain things they know to do to step into the role. Even if they are tired they cannot sound tired.... They're taught the subtle tricks of the trade. They're taught how to stroke a man's ego. They're taught what the men are calling for. They are taught how to empathize. They are taught how to do a strong closing. They're taught how to send subliminal messages while they are having vicarious phone sex.

"For example, if I wanted a man to call me back—simply because a straight sex man probably would hang up as soon as he comes, as he probably would do with a prostitute; he's not going to sit there and have tea, necessarily—because I knew he would hang up as soon as he ejaculates and that's the conclusion of the call, I would say to him, 'You're by far the best person I ever made love to.' If I were sucking his cock, I would say, 'I love feeling the way your cock swells up in my mouth. I love the taste of you. You must take very good care of yourself. I love the scent of you.'

"So I'm saying to him, 'I must talk to you again and again. I can make love to you all night long.' I'm saying to him—and sometimes you hear the girls saying—'I want you to say my name. It turns me on to hear you say it. I love the way you say Nicole.' You drive home to him that you are the best thing since sliced bread. And he must call you back....

"A strong closing would be to have him call you back. It would be, 'Please don't forget who I am.' Or the closing after he's come—let's say he stays on the line, you'll say, 'Aaaaaah, was it as good for you as it was for me?' Something that women don't generally ask. Or, 'You make me so wet. Give me a chance to clean myself up so you can call me right back. Oh, you can't believe how wet my satin sheets are. When you call back you must remember who I am. Say my name again. It's Nicole. Oh, you really turn me on. You can't imagine how much you did. Oooooh. My nipples are getting so hard, just thinking of you calling me back.' He is stroked yet again. She may say to him, 'Oh, it's not enough for you to come. I want to clean that cock up with my tongue.' She makes a second connection with him. He ejaculated and she stays on the line with him and she strokes him again. And strokes him."

SEX SELLS

Americans remain enormous consumers of sexually explicit print materials. The top-selling sex magazines—*Playboy*, *Penthouse*, and *Hustler*—have a combined monthly circulation of over 6 million. Still, sales are not what they once were at their height in the 1970s. In 1971, *Penthouse* catapulted circulation by introducing explicit shots of female genitalia, complete with pubic hair, to replace the "tasteful" airbrushed shots of earlier times. *Playboy* and other magazines tried to keep up with the times by moving toward steamier and "kinkier" content. But they faced more and more competition—much of it coming from new mediums: "Once we were the only game in town," says Cindy Rakowitz, director of *Playboy*'s publicity department. "Then other things started eating into our market share—other magazines, but really more so cable TV and home video. They took a significant part of our market share."

Vincent Stevens, editor-in-chief of the New York–based sex magazine *High Society*, discusses doing business in the competitive sex-magazine market. "Basically, what people want to see today, they first and foremost want to be entertained, and secondly they want more bang for the buck....

"Each month we present totally nude celebrities that [our readers] want to see—Sharon Stone, Shannen Doherty, and Pamela Anderson and Nicole Eggert from 'Baywatch.'" Stevens also gets many models from the go-go dance circuit. "They dance at night, do modeling during the day. It's in the dancer's best interest to get into magazines, because the dancer can use the magazine to make money for herself by autographing. It drives up her fee."

Stevens and his editors often shape the content of the magazine to attune to what they believe are the favorite fantasies of their male readers. "Most men want to make love to two women at the same time. I think that's still the number one fantasy for men. I also think that under the right circumstances with the right person, they're willing to experiment in areas they might have shied away from in the past—fetish garments, different types of role playing. It's certainly more out there now more than before."

The content, according to Stevens, is also determined in part by legal restrictions on pornography. "We adhere to Canadian restrictions [on content].

We have to be able to get into that market. The restrictions [exclude] any picture that is construed to be dehumanizing or humiliating to women—bondage, S/M, any type of rape, or any type of pictorial that would include a minor. Minors also applies in the U.S."

According to the pragmatic Stevens, fear of the HIV virus has actually been a boon to the pornography business, expanding the market for masturbatory fodder. It has also allowed porn producers to promote their wares as catalysts to safer sex. "The bottom line is that everything changed with AIDS," Stevens says. "We've changed our positioning of the magazine. We're much more up-front about what we do. Not clandestine, like in 1980s....The magazines now are really serving a safe sex purpose. A lot more people are comfortable going home and masturbating to a magazine than going to a swingers convention or going to a prostitute on the corner....

"With most magazines," Stevens says, "nine out of ten start-up titles fail the first year. The adult magazines do a bit better. The difference is that sex sells."

One porn publisher who has achieved success in his own corner of the market is Al Goldstein, owner of *Screw* magazine. By the early 1990s, his magazine had established a reputation as a hard-core, no-holds-barred guide to the New York sex scene. For readers who want to know what's up in the different sex clubs—especially what they've missed at a late-night slave sale or S/M fashion show—*Screw* will always try to have a reporter on the scene. *Screw* reporters scour New York looking for the streets with the best hookers, and publish guides to sex 'zines and underground films that can only be purchased by mail order. It's the ads in *Screw* that tell the story, as much as the copy; here, consumers can find everything from prostitutes to dominatrixes, from phone-sex services to massage parlors, from swingers to models.

"We didn't come from the sex world," Goldstein says. "We came from the political world. *Screw* started as an underground paper....My partner, Jim Buckley, was the editor of the *New York Free Press*. In 1968 I met Jim and I said to Jim, 'Let's start a sex paper.' We each put $150 in, and I bought Jim out for $700,000 seven years later....Now we gross $4 or $5 million a year. We make a profit on hooker ads and 900 number ads. I'm small potatoes, though, because *Screw* is primarily a New York publication....The really big money is in *Playboy* and *Penthouse*, in regular advertising. I'm so dirty I don't share in that."

Al Goldstein, publisher of *Screw*, in his office. Manhattan

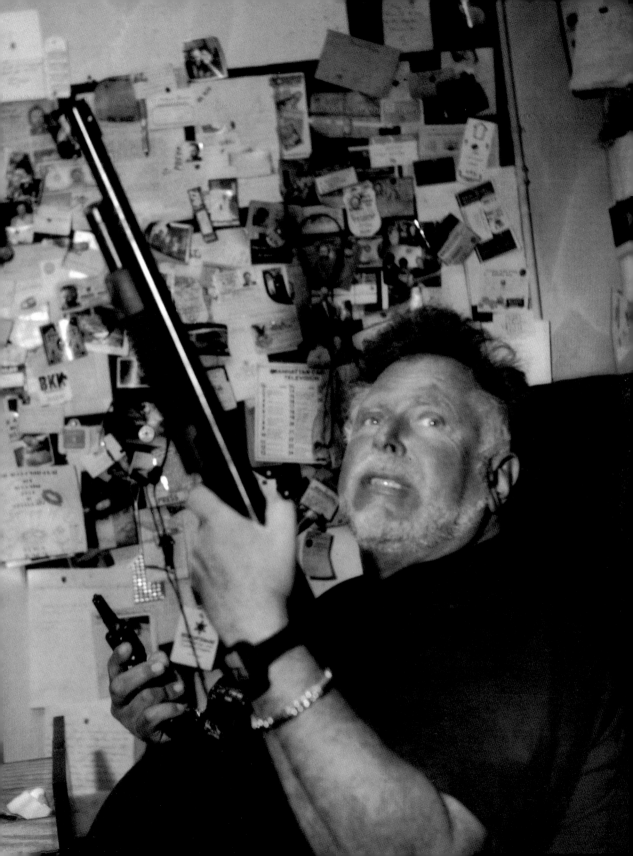

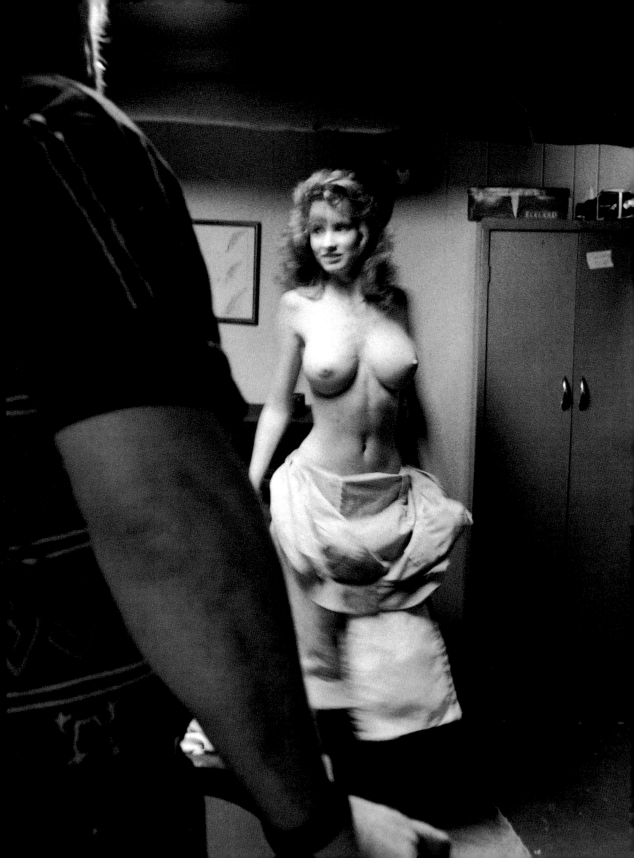

The people who go about the day-to-day business of putting out sex publications confirm that it isn't easy to get rich writing smut. According to Eric Danville, a reporter for *Screw*, salaries for most sex-magazine writers run not much higher than $25,000. Danville covers the sex beat in New York, and spends his weeks at events ranging from late-night sex shows to adult video trade shows. In the downtown New York sex scene, Danville says, the writers for a half-dozen sex magazines make up a kind of fraternity, meeting at events and socializing together.

As the fashion and sex worlds blur together, these sex reporters sometimes find themselves serving as guides not only to *Screw*'s readers, but also to other news media trying to get in on the action. Danville says he takes pleasure in things like getting to sit next to the reporter from *Women's Wear Daily* at an especially trendy S/M ball. In turn, many of the sex magazine writers look forward to a future of better money and more varied work in the fashion magazines. For them, sex writing is a way to cut their teeth in the magazine business.

According to Richard Kasak, publisher of Masquerade Books, the idea that writers can make a killing doing porn novels is also a myth. The author of the average porn or "erotic" novel, Kasak says, draws only about $1,000 in advance against royalties of 5 percent—$2\frac{1}{2}$ percent less than for an average mainstream paperback. Strong sales for a sex novel are 10,000 to 15,000 copies. "You can't make a living," Kasak says. "You can make an annuity after a while."

The only difference between a porn book and an erotic book for the regular trade market, Kasak says, is packaging—how the book is positioned, promoted, and sold. "If a book is packaged as pornography, it will end up in an adult bookstore. If a book is packaged as erotica, it will end up mainstream." Kasak positions his books as erotica and sells them in mainstream bookstores. Yet as in other parts of the sex business, what sells best is what's aimed at the devoted S/M market. "The classic man with a maid, and now and then a lesbian variation," Kasak says. "Female dominance and specific fetishes are what sells. Those people who have a foot fetish are very close to the readers who want to be dominated or abused by women." One of Masquerade's most successful writers has ten titles in print. "Laura Antoniou wrote *The Slave*, *The Marketplace*, and *The Trainer*," Kasak recalls. "They are very accessible S/M books. Heavy plot lines. Major story lines. No truck-driver sex."

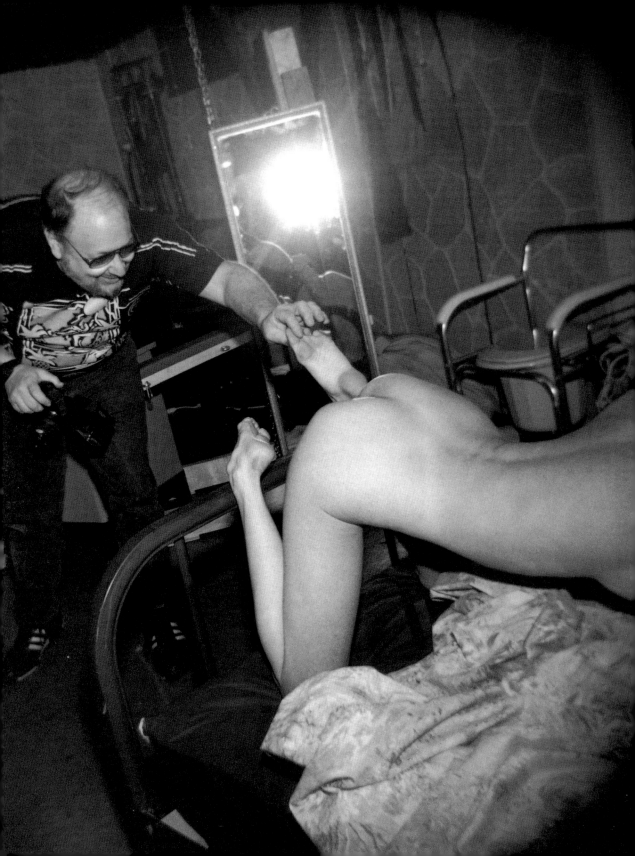

DO-IT-YOURSELF PORN

The newest player in the dirty magazine business is the 'zines—inexpensive publications usually put out by one or two people. Some 'zines look like newsletters, others are just a couple of sheets of paper, reproduced on photocopy machines and stapled together. Some contain elaborate graphics. The 'zines seldom publish on regular schedules, and sometimes last for only one or two issues. Networking is an important part of the 'zine scene, with editors trading their 'zines back and forth, and most 'zines reviewing other 'zines.

'Zines are an entire subculture in themselves, covering every aspect of life outside the mainstream, according to James Romenesko, publisher of *Obscure Publications*, a monthly that chronicles the 'zine scene. But by far the most popular group is sex 'zines, with names like *Plumpers* (for devotees of fat women), *Orientailso* (featuring shots of Asian asses), *Necroerotic*, *Honcho*, *A-Cup Honeys*, *Frighten the Horses*, and *Shaved*. There are straight 'zines, queer 'zines, and transvestite 'zines; S/M 'zines and fetishist 'zines; and 'zines for every possible combination of sexual tastes.

Probably more than anything else, the 'zine marks the frontier of the sexual world and points towards the future, and toward a free-floating world where gender trades back and forth across a broad continuum. Playing along the edge of this new sexual frontier is a 'zine called *Taste of Latex*, which is geared toward an "alternative" readership interested in role playing and gender bending.

"I was just your typical middle-class punk rock kid with no agenda as a child or teenager to go into the sex industry at all," explains Lily Braindrop (aka Lily Burana), founding editor of *Taste of Latex*. "I came up with the idea in 1989. My thought about it was that this whole underground desktop publishing thing was exploding in the name of providing a more substantial alternative to the mainstream media. We've got news about alternative culture, alternative music, alternative lifestyles, but nothing about alternative sexuality. And in a lot of ways I think the left-wing punk rock politics around sexuality are bone dry, really wanting to reason it away, and sex is bad, and icky-oogy. And yet everybody has the urge towards sexually oriented materials or sexuality. So how could I do porn and do it a lot better?—the way that appealed to me as a punk rocker and as a feminist and a relatively articulate person. So that was the challenge I presented to myself.

"I didn't have a lot of money. I started the magazine with about $100. I approached it as a business. I wasn't going to do the typical 'zine thing of 'I don't care if it doesn't make money.' No trust fund here. So I approached it pragmatically, businesswise, and it's turned a modest profit since the second issue….The distributors are mostly people who distribute fanzines, all kinds of alternative culture stuff. I don't have an adult distributorship yet. I am working on it, but they are much more rigid about what they'll carry than the newsstands are.

"The readership is a curious blend of dedicated S/M players, alternative lolapalooza punk rock type people, and queers. And of course lots of curious straights out there as well….I would say the readers are a lot straighter than I thought. Just because somebody is heterosexually identified doesn't necessarily mean he's straight, of course. I think so many people identify with more than one thing. The demographic pie is a little weird….

"For me, when you're presenting sexually oriented materials, my belief is that you should provide information so that when push comes to shove and people actually go to do it, the information is how to negotiate consent, how to do it safely in the age we're living in. But when it comes to the fiction…when it comes to the fantasy material, many people want to read about fantasies that are their own sex lives to the exponential degree, something more extreme and fantastic in a literal sense than they would ever do.

"So I have stuff that is really gory or really violent or sadomasochistic or really gender-bent because I think that's the job or the role of fantasy in the human experience—to give you permission to do all these things. Why is it permissible to fantasize about killing your boss or the guy who's snaked your parking space—that's regarded as healthy—and it's not healthy to fantasize about rape, which is the most common sexual fantasy? And yet we punish ourselves for having these fantasies. In the name of doing a more correct pornography or a more humane pornography we censor those fantasies. For me that's reactionary. That's not telling the truth. [The magazine] is not giving people permission to do these things in real life. Certainly not. But it is giving these fantasies a safe place to roam….

"As a direct result of the feminist movement, the gay liberation movement, and the queer liberation movement, and even the do-it-yourself punk rock movement of the seventies and eighties, the real thrust now is sexual self-determination, and people are coming to a place now where they can really say what turns

Carter Stevens's props

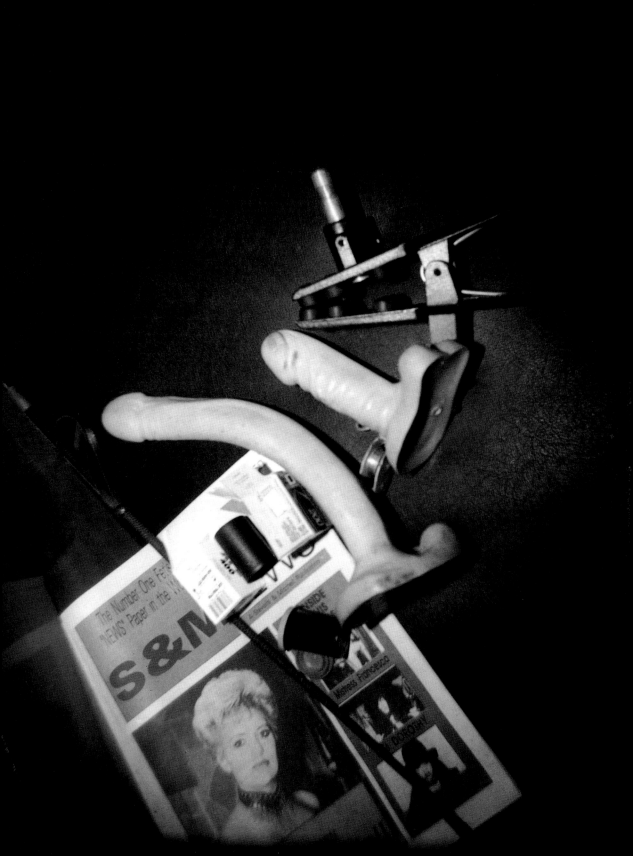

them on and then pursue that, whether it's your typical girlie mag or *Vogue* or *Taste of Latex* or *Honcho*.…Because sexual fantasy is not about reason or apology. You like what you like because you like it. And if we're dealing with consensual behavior it's really nobody's business. And it's not about being the most evolved, the most trendy.

"For me, if you have a perfect sex life that perfection lies in getting your needs met…whatever they may be—getting fucked 20 times a day or once a year or fucking cucumbers or men or, you know, college cheerleaders.…It's the difference in thinking that sex belittles you and it's a guilty pleasure and in thinking that sex is totally fucking rad and do it in whatever way you will."

CYBERSEX

The 'zine explosion, which reflects a taste for anything-goes, do-it-yourself sexual materials, has its corollary in the world of personal computers. Via their modems, groups of people are talking back and forth about different sexual interests, exchanging still photos and video clips, arranging dates, sharing all sorts of "how to" information, and engaging in role playing.

Devotees and dabblers in digital sex most often communicate through online services, which run the gamut from closed-community bulletin board systems (BBSs) and university computer labs to the giant commercial online services like Prodigy (co-owned by Sears and IBM), CompuServe (owned by H&R Block), and America Online, the largest of all, with some 4.5 million subscribers. Anyone can "sit in" on these communications—participating in real-time conversations in chat rooms (like telephone party lines, but with monitors and keyboards); or reading and commenting on the various digital conversations found in "newsgroups," or posting areas, on most BBSs and online services. These postings increasingly take the form of digitized and encoded images which can be downloaded and displayed.

These chat rooms and posting areas are monitored to varying degrees by the commercial online services to limit the displays of explicit or threatening language. People violating the TOS (terms of service) have their subscriptions revoked, or may have personal information passed on to authorities for investigation. But customers who stay within bounds can talk "live" with anyone else

attracted to the topic of the room, and many are devoted to sex talk, with specialties ranging from "Girls Who Want to Have Fun" to "Sons Doing Dad" and "Vampire Inn." By the mid-1990s, the large online services had introduced parental control options, allowing parents to block out areas on the service with passwords.

Most notorious for their explicit and "transgressive" content are the sex-related UseNet newsgroups found on the Internet, which are scattered among several thousand university and institutional UNIX systems and lack a central monitoring authority. Passwords are not needed on the Internet; all that's needed is an Internet provider (a service that allows users access to the Net through a local number and host computer) and a list of UseNet newsgroup names. Anyone can "subscribe" to a UseNet newsgroup, and anyone can start one. Since new ones start up and die out every day, there are no reliable figures on how many of the newsgroups are devoted to sex—but the offerings are numerous and varied. Users who subscribes to *alt.sex.bondage* (an "alternative" posting site for those interested in bondage and domination) or *alt.binaries.pictures.erotica.female* (a smorgasbord of amateur and professional pornographic images) can read postings from like-minded people on topics of common interest, and leave messages of their own—messages that range from the predictable fucking and sucking to the following, a posting from the *alt.sex.fetish.feet* newsgroup:

> I really liked the artwork of the giantess stepping on the little man. I'm really into giant women and would really like to find out more about the person or company that put it out, particularly if they have any videos about giant women (particularly barefoot giant women). Please send response to me at....

Postings also include ads for modeling, phone-sex lines, illustrated catalogues, and explicit CD-ROM portfolios. Any text posting or compressed image uploaded with a newsgroup's name in its header will be deposited into the digital mailboxes of all subscribers—to be looked at or downloaded at will—through any local Internet provider which provides newsgroup access. These providers range from the large nationwide online services to the smaller regional services specializing in discussion topics of particular local interest to the remote two-modem/one-man digital porn shop running ftp (file transfer protocol) sites from midnight to 2 A.M. (during which time users can dial into his computer, look for image files they want, and download them).

Posting, *alt.binaries.pictures.erotica.female* UseNet newsgroup

These providers are the ones who really stand to make money off of cyber-sex, via usage fees. Connection fees to the large online services start at $10 a month, with a few hours of time included, and additional time pegged at about $3 an hour. These fees include Internet access as well as proprietary chat rooms, games, financial services, and large reference areas. Monthly fees from straight Internet providers start at about $20 a month for basic Internet access, with extra charges for prime-time usage. For users, the costs are modest compared to phone sex lines or personal ads. But as their customers surf the Net, looking for a date or just a sex chat, the providers rack up usage fees.

The downloading of pornographic images is even more lucrative for providers. Dense, high-resolution images can often take five minutes or more to download. The use of newer, faster modems would normally cut these times down by half; but increased image detail keeps downloading time—and provider profits—high. Hence the drive by online services to provide ever-more-dazzling graphics; by the software companies toward the upgrades needed to see and manipulate these graphics; and by the pornographers themselves to offer more sophisticated reproductions of still photos, as well as videos—all of which keep the meter ticking.

The porn-centered BBSs often run the greatest risk in cashing in on cyber-sex. These privately run, dial-in services, which sometimes require proof of age (often supplied simply by typing in a number), charge subscribers an average of $10 to $30 a month, with additional fees for downloading from their private collections of pornographic materials. One market leader, the Amateur Action BBS, opened with twelve photos in 1991; four years later it offered its subscribers 25,000 images to choose from. Amateur Action earned $800,000 in 1994 for its owner, Robert Thomas; in 1995 Thomas was arrested after transmitting porn to a government agent in Tennessee and convicted and jailed on obscenity charges.

For the sex industry, as for most commercial ventures, the most promising long-term opportunities for making money online seem to be offered by the World Wide Web—an ever-expanding network of hundreds of thousands of computers storing files embedded with "hypertext" tags, which allows documents—or parts of documents—containing attractive graphics, sound bytes, and even moving images to be linked to any other Web site around the world. The Web is fast becoming a convenient and inexpensive means of advertising sexual services

and products, with hundreds of new sites appearing every day.

Any small business enterprise or individual with sex to sell can design ads complete with color graphics and sound for next to nothing. For as little as $20 a month, a Net access provider will maintain this multimedia Web site and give it an "address." Free listings are provided by robot programs that roam the Net ceaselessly, tallying and cataloging all new sites and indexing them for easy access by millions of surfers daily. Any user can simply type "sex" in his search, and the index will rapidly assemble thousands of site subjects and addresses. In fact, it may be on the World Wide Web, which offers anonymity (at least for the time being) to both sellers and buyers, that the many segments of the sex industry will come together to ply their services in cyberspace.

By 1996, the most popular features of porn videos, phone sex, and cybersex were also coming together on the Net. Computer-sex entrepreneurs in New York and Chicago began offering their credit card customers the opportunity to order a male or female model to do a private striptease. At a cost of $5 per minute, a closed-circuit TV camera filmed the model and relayed the image across the Internet onto the customer's computer screen. One service also offered subscribers a chance to talk to the models, telling them what clothing to take off and what body parts to have the camera zoom in on.

At the outset, these services remained small in scope, with discreet word-of-mouth promotion and select clientele. Yet they were harbingers of an increasingly interactive, multimedia future for porn. They also offered further evidence that new technologies will continue to be quickly adopted by prescient and resourceful pornographers.

Subjects

Send
Mes

great asses of the Po
More Tan Boobs - tits
More Tan Boobs - tits
More Tan Boobs - tits
More Tan Boobs - tits
More Tan Boobs - tits
List of fax numbers f

Mark All
Read

Stars... – porn01.jpg [01/
.gif (4/4)
.gif (3/4)
.gif (2/4)
.gif (1/4)
.gif (0/4)
our favorite senators

Mark Read

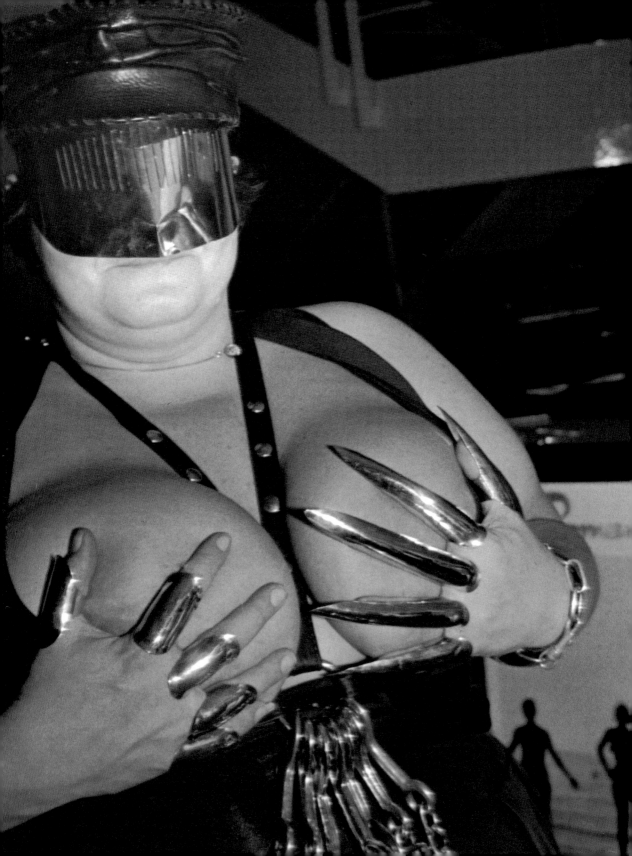

CHAPTER 2 RITUALS

One of the functions of the commercial sex industry has been to provide settings where nontraditional, "transgressive" sexual appetites can be satisfied. The industry, always responsive to the varied demands of the market, offers venues where every fetish or fantasy can be played out in nonjudgmental anonymity. The family man who nurses a hidden desire for bondage and punishment, the businessman who secretly yearns to dress in women's clothes, the young slacker with a taste for human blood—each, for a price, can find his place in the various netherworlds of the sex industry.

What unites these highly specialized venues—from the S/M dungeon to the cross-dresser's beauty salon—is the preeminence of role playing. Here, the sex industry becomes theater: The workers serve as producers or supporting actors and the establishments stages,while the clients star in dramas of their own devising, taking on roles and pursuing plotlines that are often far distant from their everyday lives. With only cooperative sex workers and like-minded fellow customers as an audience, even the most transgressive dramas can be enacted in relative safety and secrecy.

S/M

The theater of choice for many devotees of sadomasochism, or S/M, is the dungeon, a kind of specialized club catering to those with a taste for domination, bondage, or submission. Hidden in the nooks and crannies of many cities large and small, most dungeons have a peculiarly locationless quality; they are detatched from the outside world, often tailored to the contours of the gothic imagination. "It's very important that you have the atmosphere," one mistress noted. "The more it looks like a dungeon, the more people like it. You know, the theatrics, the crosses, the shackles, the stocks—all that. Real theatrical-looking. Props. A lot of it is just that, props."

Marion, vampire dominatrix, with slave, Manhattan

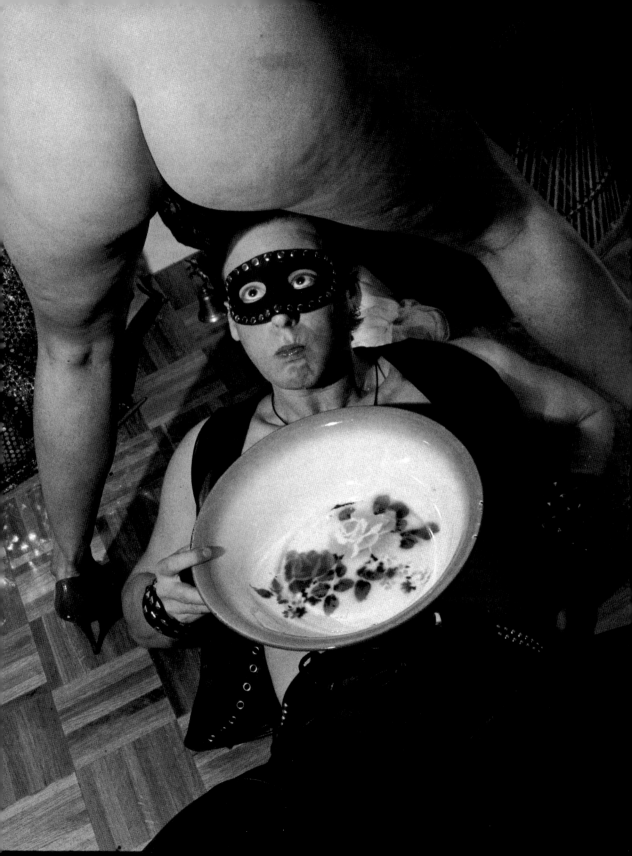

Many women recoil at S/M because it seems to reflect what history teaches them men want: to inflict sadistic pain on them. But the surprise of the commercial S/M scene is that it most often finds men on their knees, abject slaves of their steely dominatrixes. Often cross-dressed in women's clothing, they clank around in medieval chains, their cocks and balls ingeniously tied up, their bare asses lashed by whips, as they perform housewifely chores. "The male 'slave' relishes the forbidden, feminine aspects of his own identity," notes writer Anne McClintock in her essay in the book *Dirty Looks: Women, Pornography, Power*, "furtively recalling the childhood image of female power and the memory of maternity, banished by social shame to the museum of masturbation." But while the masochistic men may appear to be playing out their submissive "feminine" sides, the truth is that it is they who, ultimately, remain in power. They are being whipped, abused, or humiliated because they want to be. They pay for it, and they call the shots.

Men come to the dungeon on their lunch hours to act out the elaborate scripts they themselves have written: two Hasidic Jews seek a dominatrix who will subject them to Nazi tortures; a man pays his mistress to play a greedy wife, slowly extracting money from an open wallet on the table before which he kneels, naked, to receive the lash. The dungeon is the hothouse of the sex business, the place where taboo fantasies can be played out in a hermetically sealed environment. It is a friendly, consensual, lifeless experience in objectification.

The Vault in New York City is organized like an elaborate play dungeon, a theme park recreation of the real thing. At the door, men pay $30 for admission, couples pay $35, and women and transvestites pay $5. Once inside the club, the guests can become the audience, the entertainment, or both. One room leads into another, and people wander through, watching and sometimes joining in.

The activity in the Vault unfolds in scenes: a leather-garbed mistress appears and recruits a slave; he disappears, and then comes back naked. She looks at him disapprovingly, and then methodically pinches his nipples. He does not flinch. She orders him to his knees, and applies her riding crop to his ass. As she continues to apply the whip, the mistress sits down on a chair, and turns her slave-of-the-moment into a footstool. Meanwhile, in another room, a mock torture has begun. A beefy man hangs from chains while two mistresses listlessly whip him, pausing to tighten the fastenings around his balls.

The centerpiece of the club is a bar, where the unoccupied mistresses and guests sit drinking sodas and juices. Above the bar, television sets beam out closed loops of lesbian mistresses slowly torturing a tall blond woman suspended in chains before them. Against a wall, a man leans on an empty cage, talking to friends, who are seated on a couch, waiting for something to happen.

Chrissie, a topless bartender, explains that she has only recently gotten into the S/M scene and has just taken up mistressing. Previously she had worked as a go-go dancer. "I was a runaway," she says. "I was in state care when I was 12. [After running away,] I danced all over the East Coast, starting in Florida when I was 16."

Chrissie called the Vault thinking it was another go-go club. "They asked me if I wanted to do topless bartending, and I said sure. And because of my charming personality, I had so many men coming up asking me to beat their asses, my boss asked me if I wanted to do it, and I said sure. I'm a natural."

Chrissie is enthusiastic about her newfound profession, and also talks brightly of her new live-in slave, Noel—an Apache Indian who has a job with a dance troupe. Noel was adopted by a white family in New York, and says that his father was a pedophile. But he speaks reverently of the warrior tradition of the Apaches. "All my people—the Apaches—have been warriors. It's a way of living. To be strong and true and brave and all that." As for his choice to don women's clothes and offer himself as a submissive, he explains that part of his personality is feminine. "It has to do with the woman part. It gives me power."

Noel disappears into a dressing room, and reappears in high heels and a slip. Chrissie leads him to a chair, bends him over, and begins to apply a paddle, then a whip. Everyone in the Vault gathers around to watch—the naked slaves, the men dressed as women—many of them silently jerking off in the gloomy surroundings. Chrissie applies the paddle forcefully and methodically, making her slave count out each time the paddle descends and intone "thank you" again and again. Then she turns him over and begins to apply the whip to his balls.

The scene passes, and the players in the Vault return to their chitchat. Every so often the door opens, and the gloom of the mock dungeon is cut by the entrance of another voyeur. Chrissie discusses her future in the S/M business. "I'll stay here for awhile," she says, "until it bores me. Then I'll move on to something else. I don't know what I could do after this, but I am sure there's something. I can go up the perverted ladder."

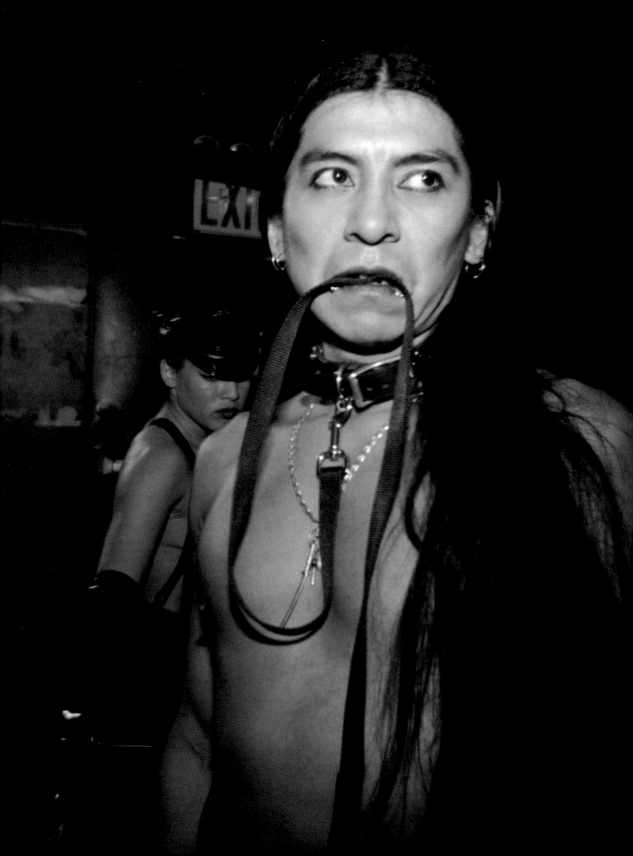

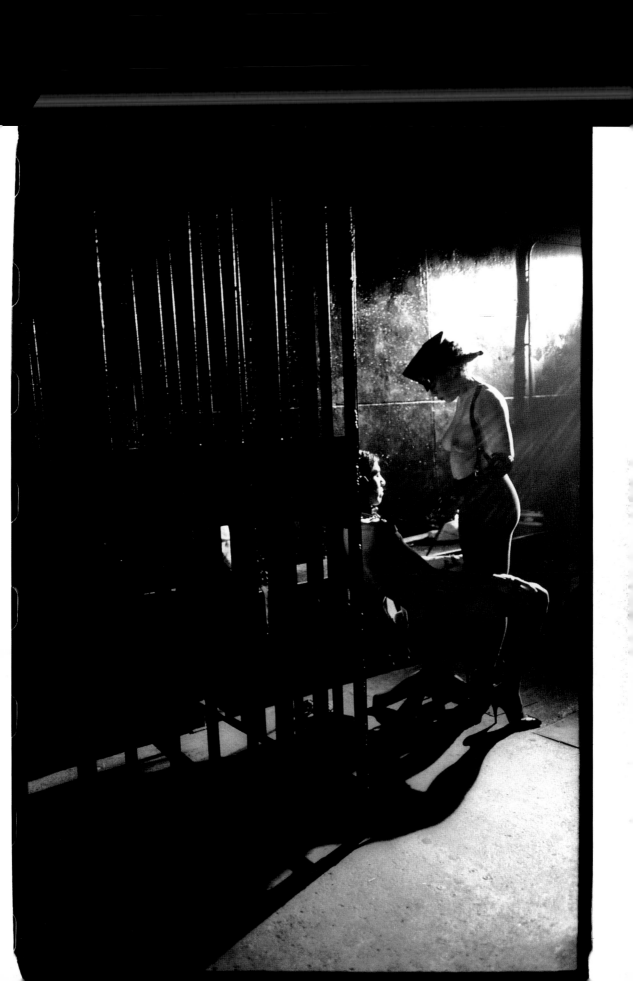

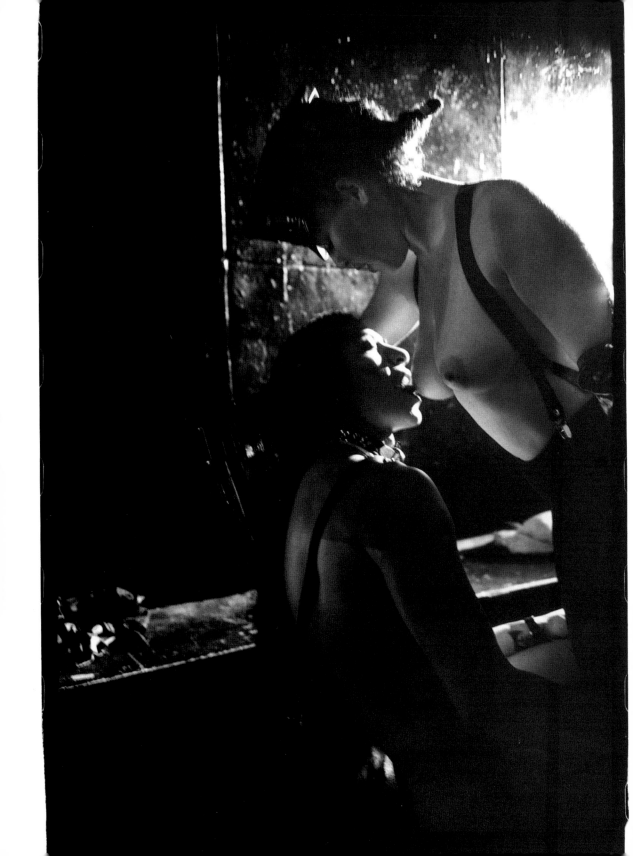

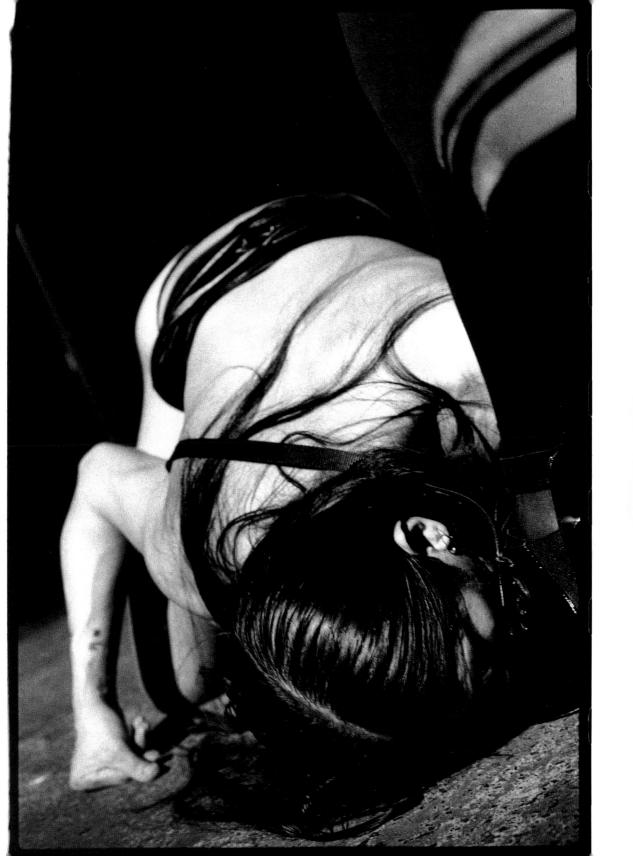

MISTRESS ANASTASIA

Mistress Anastasia, as she is known to her clients, is a dominatrix who lives on New York's Lower East Side. She describes a typical session: "I come in. I usually wear leather hip boots or thigh boots. I have on a leather miniskirt or a corset. They are on their knees. I usually start out to see how submissive they are by seeing what they'll do. A safe thing to start out with is to have them kiss your boot. No matter how they do it, I always complain it's wrong. You know, in S/M they want a woman they think is a goddess or something. They never please her. They try and try to please her. No matter what, she's never pleased. I don't know why they want it, but that's what they want....

"Usually the very first thing I'll really do to test his pain threshold is tie him up, usually with his legs apart and his arms apart, and walk up and pinch his nipples real hard. However he reacts, I can tell how much pain he can take. Some of them won't even flinch. Others will be like, 'Oh god, have mercy, Mistress!' So right away you can tell. If he's serious, heavy-duty into it, he won't flinch."

Before she became a dominatrix, Anastasia worked as a go-go dancer. "I was young and innocent, and it was rough. I guess it gave me a real negative attitude towards men, or those types of men. So I assume I ended up becoming a dominatrix partially because of that, and partially because of my home life as a kid. It allowed me to treat these men the way I felt like they should be treated. Because when you're a dancer you have to yes them and smile, and be nice. When you're a dominatrix you don't have to do that, and you make a lot more money being a dominatrix....

"I've always hurt men when I have sex with them. I pinch them or scratch them or bite them or whatever. I did this before I realized I was dominant, I just didn't have a name for it....So I got into being a dominatrix through my personal life. Three years ago my boyfriend said, 'Why don't you start making money at it? I mean, you do it in your personal life anyway.' So I went to an S/M house and checked it out, and it was good for me. It was perfect. It turned out to be how I really am....

"A lot of girls just do it for the money. For me, I think it just came naturally. I get off on taunting men. I always have. I enjoy messing with their heads—and that's a lot of what it is....Still, when I'm working as a mistress, I'm not having sex. He may be having sex. I am not having sex. I am not getting aroused. He's

a client. If I do it in my bedroom with my boyfriend it's different....

"I only take submissives. Some women switch back and forth...but myself, I only do dominant sessions. I wait for someone to call, make an appointment. Usually I'll just be sitting there with no makeup on, a T-shirt and crummy clothes, just waiting for them to call. Then I rush, get my leather on, and turn into Mistress Anastasia.

"Each session is different. The session could have anything in it, from cock-and-ball torture to whipping to just bondage....Some people are into humiliation, where you tell them they are a worthless piece of shit and they are not worth anything. Then again, some people aren't into humiliation. They're just into the pain....A lot of them know what they want. It depends. A lot of them that are new to it say they don't know. They say, 'It's up to you, Mistress,' which it is. It's up to me anyway, what I do to them. But in reality, I guess, it's up to them, because they tell me what they want.

"I never take off any clothes whatsoever. They don't touch me. They don't even look at me unless I allow them to. At the end of the session I allow them to masturbate. I don't touch them. Some mistresses do, but I don't. Sometimes just to be mean I won't allow them to masturbate. I'll make them hold it in. Some of them want that. They want to be deprived of ejaculation....

"You have to learn how to use the equipment. In the first place I worked, the head mistress would have girls work for about a month and bring you in on sessions and train you. They teach you tortures, like cock-and-ball tortures. It's with ropes, and you tie the testicles and penis all up in different ways. It's painful. And if you don't know how to do it, you can seriously hurt somebody. You have to know to remove it in a certain amount of time, not to do it too hard a certain way. Or whipping. Just the simple act of whipping, you have to learn how to do it. If you do it wrong you can leave marks on somebody. Some people don't want marks. They don't want to have to explain to their wives why they have purple streaks all down them. Or they may want marks. Believe it or not, it is difficult to give someone marks if you don't know how to do it right....

"I have a code word....If we're going too far, so as not to break the mood, I have a code word: 'Have mercy, Mistress.' Because, once again, a lot of people will want to say, 'Oh, no! Anything but that!' and that's exactly what they'll want. So I don't listen to people who say, 'Don't do that,' or 'Stop.' That may be part of their trip to say that. So I tell them to use the code word. Then I take the

money from them and then I go and give them a few moments to get ready. What they have to do is strip down completely, and I tell them I expect them to be waiting on their knees for me when I return.

"I will have anywhere from one to five clients in a day. They are all different kinds. Like [they want me to be] the Russian interrogator torturing the American soldier, or the schoolmistress who's punishing the bad student, or the head of a company who is punishing an employee who had embezzled from me.

"I had one client who I used to wrap up in plastic wrap and leave him for an hour. Severe bondage—every finger separate, every toe separate, legs…everything wrapped in plastic wrap with electrical tape over it. His whole head, too, just leaving a little breathing space. Then I'd tape him to a sawhorse and leave him there. Another one thinks my anus is his god. He discusses it and speaks about it as his god. He never sees it or touches it, but he likes to fantasize that he may someday be allowed to do this.

"Jimmy, the cleaning slave, wants to come and clean. He is completely nude and I make him wear these stupid knee pads and clean the floors. He cleans. That's all he wants—for me to come in every few minutes and smack him around and tell him what an insignificant little worm he is and leave.…I don't allow him to do anything anymore. He is so annoying. He never stops. He wants to call me every day and have me tell him what a pig he is. For free. He gets on my nerves, but I've stopped him.…He's trying to tell me what a womanizing guy he is while he's on his knees scrubbing my floors. I laugh at him.

"I had another who would leave his underwear on; he didn't even want to strip down. All he wanted was for me to slap him as hard as I could for an hour straight. Bam-bam-bam. The next day I couldn't move. I felt like I had been working out. My shoulders and arms would hurt so much from hitting this guy. So I started doing it where I would kick him, slapping him in the face with the flat of my foot. I couldn't do it. I was hurting so much from torturing this man."

Anastasia's clientele is generally straight and often wealthy—lawyers, corporate executives—men who, she says "need a few minutes or an hour where they're not telling people what to do. They need to have a break, I guess.…A session lasts as long as they want. They pay $200 an hour. At the last place I worked I kept 60 percent. I kept $125 and the owner kept $75, which is very fair. Usually it's 40/60." Since she has gone independent, Anastasia is paid directly by her clients, and can make as much as $1,000 a week working part-time.

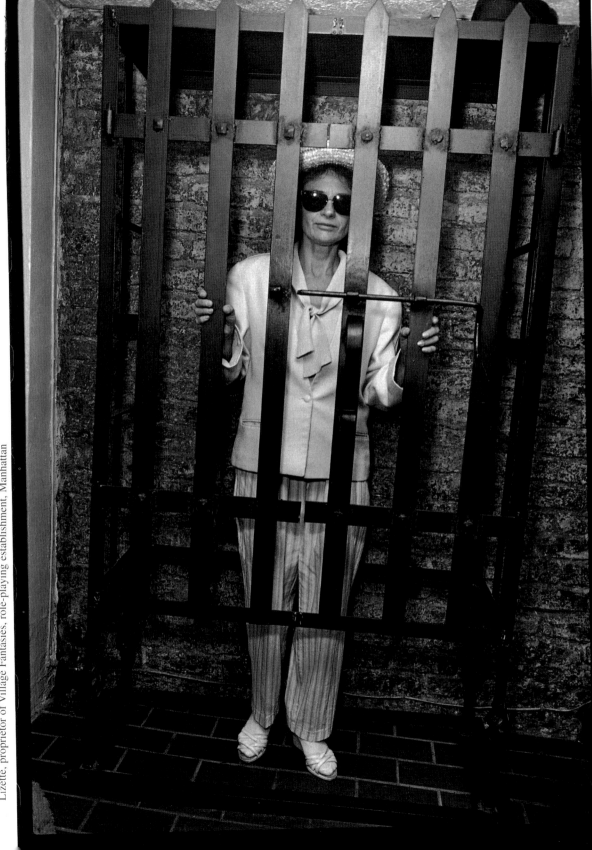

Anastasia says she will do golden showers, but not brown showers. Because of AIDS she doesn't feel comfortable with drawing blood, but were it not for the disease, that wouldn't bother her. She believes S/M has become more popular because of AIDS. "You can't get any safer than if the woman has all her clothes on and you don't touch her....The slave knows he's never going to have his mistress. He knows that. And he likes that." She has never had a woman client. "I suppose I'd give a woman a session, but you know what? Women don't have to pay to be abused. They get smacked around and insulted and hurt enough."

Many sex workers find their way into the S/M business as they grow older, or otherwise cease to fit the image of the young, sexy go-go girl or call girl. "In this country, prostitution is totally youth-oriented," Annie Sprinkle says. "Men want young girls in regular prostitution—the younger the better. In Europe they respect their prostitutes more, and you can work until you are 60 or 70. But here, when you get to a certain age, it's kinky time. Mostly the women will become dominatrixes at a certain point, because you don't have to look a certain way. The kinky people, they want the mother figure, they want the older woman. And you can be enormously fat...the bigger the woman the more power, or whatever." As a growth area of the industry, S/M also offers prospective mistresses the promise of steady employment. And mistresses—more than other types of sex workers— tend to say that they enjoy their work.

ALTERED STATES

It is through the S/M world that the most unusual sexual tastes find their expression. Ms. Rena Mason, as she calls herself, is an artist and dominatrix who also lives in New York City's East Village. She makes masks and other costumes for actors in horror movies, and to supplement her income also does highly specialized S/M work. For a fee, Rena will perform services that range from suffocation to various kinds of mummification and other unusual forms of bondage.

Clients find their way to Rena when they know they want something unusual. But sometimes they are not sure exactly what it is they want. "Sometimes they say, 'Do whatever you want,'" she explains, "and then I say, 'You tell me.' But if they don't know what they want, I try to help them figure it out....Because if you're not sure, maybe you might have a fetish or something."

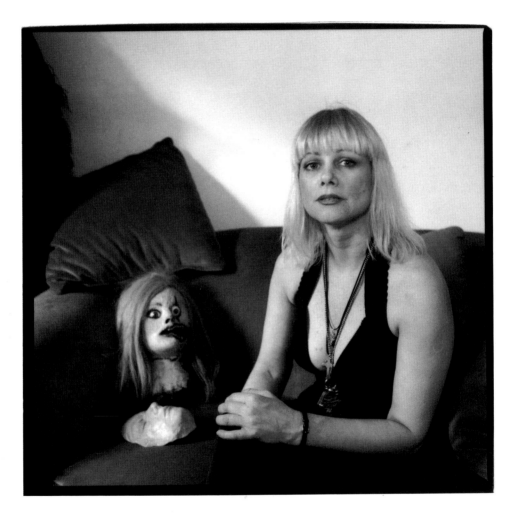

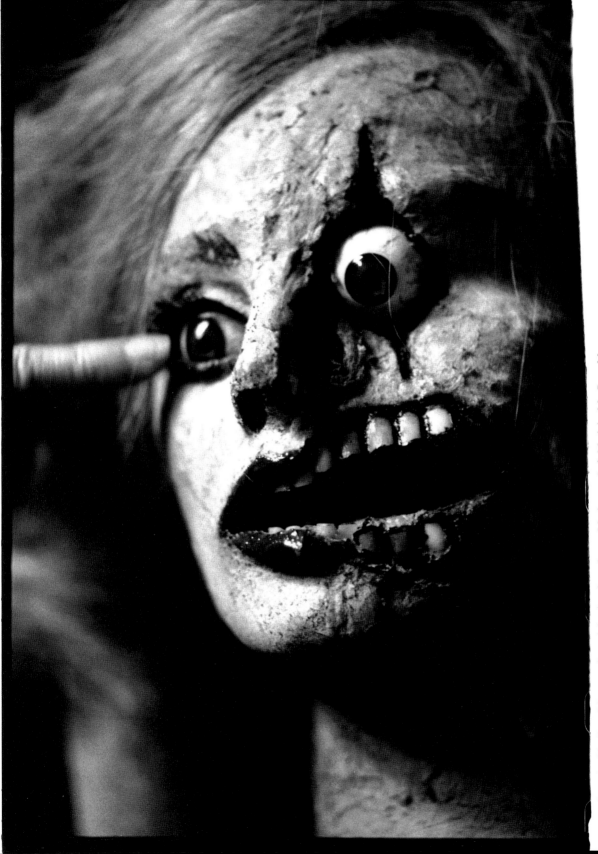

Opposite, Ms. Rena Mason, artist and dominatrix, at home, Manhattan. Left, Mask by Ms. Rena Mason

Rena's sessions often involve elaborate preparation and considerable skill. One of Rena's clients repeatedly sought a near-death sensation, and she arranged to bury him alive in wet concrete. To get ready for the session, Rena had a friend help her carry 300 pounds of cement up to her second-floor apartment. Pushing the furniture in her living room off to the sides, she used wood to construct the framework for a coffin. She also got advice from a friend who was knowledgeable about concrete on breaking the client out.

"It's going to take time, and I have to do it little bit by little bit," Rena explains. "I give him weak points [in the cement] so when I hit it it can crumple. Otherwise I'd never get him out. Plastic wrap will be separating the two layers so it will come right off….I'm not using cement on his face because it's too heavy on his eyelids. I'm using latex." This particular client "took a lot of investigation," she says. "I went to school for plaster and casting. He would be a fool to trust an amateur, because if he wants to be near death he would probably be very close to it.…

"It's pretty scary once you're inside there looking up. It does feel like a coffin. It's high enough. When you're inside there, looking up, you kind of feel like somebody's going to put the lid on you any minute. It's got that weird feeling, like, 'Say good night,' you know?"

The client, a middle-aged man, shows up with his own video camera, which he mounts at the end of the coffin, aimed down at the spot where he will lie. Then he disrobes and lies down nude on the floor inside the coffin frame. "I have as much time as you need because my mother is going to pick up my daughter," he tells Rena, respectfully addressing her as "Mistress."

In return, Rena speaks to him as she might a small child, with a rather detached interest. "You're not going to be thirsty or hungry or nothing like that?" she asks. "If you do have to go to the restroom at any given time, you're just going to have to do it. I'm not going to get you out. I know you'll survive."

The man says he feels "strangely calm…like an altered state." He explains that he has done this kind of thing from time to time. "I've also laid around in bogs and stuff where I get trapped and couldn't move…a situation where I couldn't move, and see if I couldn't remain calm through it and basically overcome it." He acknowledges that for him, part of the experience has to do with mastering his own fears. He had a "strange upbringing," he says—a frightening one—and this kind of experience seems to help him.

Rena sets to work like a small girl making mud pies. First she wraps the man's body in plastic wrap. Then she stirs up batches of cement in plastic mixing bowls, and places the layers of cool, wet cement over the man, working from his legs up through his groin. Once, the man cries out: As cement hardens, it grows incredibly hot, and the plastic wrap is not completely covering his balls, so the cement is burning him. Rena stops what she is doing, cracks the hardening layers, and quickly pulls them off. The cement is almost too hot to handle. She covers his groin with a fresh layer of plastic wrap and continues on.

About an hour later, she finally finishes encasing the man's body in a sheath of rock-hard cement, layering his head in the lighter latex. Her client has been transformed into a neat white mummy, with only a little air hole left where his lips used to be. Rena leaves him there for close to two hours. Every once in a while she offers him the bottom of her bare foot to kiss—at the same time, temporarily cutting off his only air supply. When the man indicates that he is ready to come out, Rena, in her mistressly mode, does nothing. Then, in due course, she gradually breaks up the cement and releases the man. "You're a good candidate," she tells him before he leaves. "We're slowly advancing. The next project, I don't know, we're going out some place, burying you alive."

This client is a regular; he comes for a session every one to two months, and, according to Rena, he would come every week if he could afford it. Rena always works out a price for each session in advance. "Since I know him," she says, "I'm not giving him a real high professional level. That would be from $100 to $150 an hour. Since he stays four or five hours, I work something out with him." For the cement job, which required expensive preparations, Rena charged $800. For another session, in which she mummified the client in industrial plastic wrap, she charged $300. In the future, she says, she would like to do live burial, but she has not yet worked out the logistics for making such a scheme safe and affordable.

Rena explains what she feels motivates her clients to seek out these types of altered states. "It's overcoming some type of fear....You want to be helpless, powerless; you want someone else having full control. Say like you're a boss, an executive at a job, you're telling everybody what to do all the time. You just want to step aside that and let someone else take control. And you're totally immobile, like in a cocoon. And you can be left that way and be in an altered state, and for some it's very spiritual. It can be very enlightening. Because when you come out of it, you're just like a butterfly...."

Ms. Rena Mason and client, Manhattan

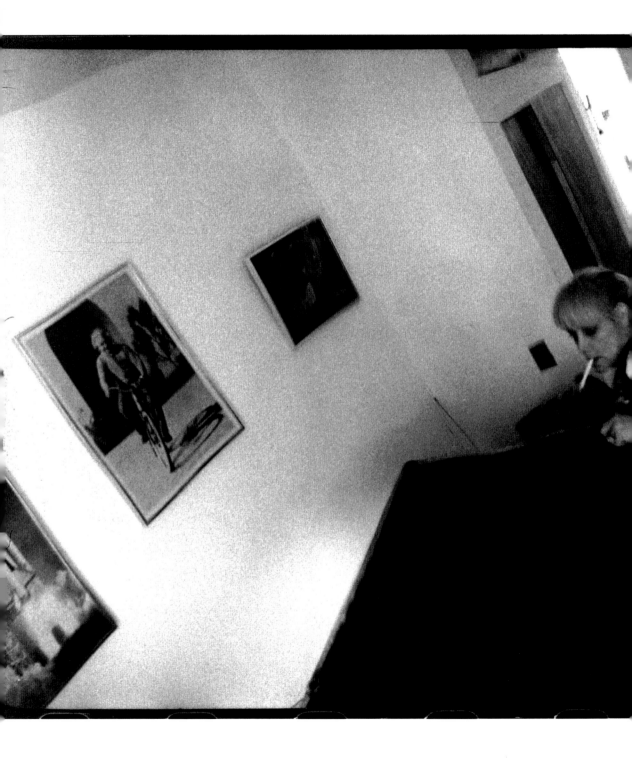

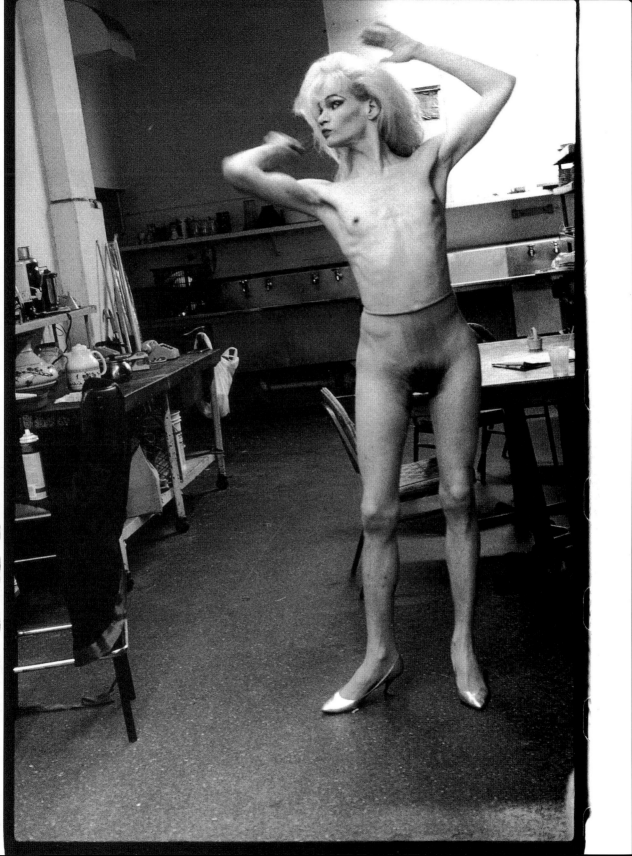

Rena says that she is not surprised by the high demand for services involving things like bondage, domination, cross-dressing, and altered states. "I think every man has a quirk they have to work out, and a dominant woman can understand it. I'm a type of therapist, actually. Sometimes it's deep-rooted, you know. It goes back to childhood....It's nothing really abnormal. You'd be surprised how many professionals I get—doctors, lawyers, politicians. You'd be amazed. Some of the most competent men have this thing that they do—they have this double."

BLOOD SPORTS

Although classic S/M rituals, in the Sadian tradition, sometimes involve bloodletting, AIDS has led most workers in the sex industry to worry about any sort of exchange of blood. Exchanging blood, however, is the main event for a small group of people who think of themselves as vampires.

This group comes out of the Goth (Gothic) scene, a kind of mid-1990s descendant of punk. Goths—who probably number no more than a few thousand—hang out at a handful of clubs, most of them in New York and San Francisco. Predominantly white, middle-class, and in their early 20s, they exhibit a taste for black, Victorian-style clothing, deathly pale makeup, and antiquated English—addressing women, for example, as "M'lady."

Self-proclaimed vampires dot this scene. They will appear in two and threes in the early morning hours at certain clubs, congregating in the back rooms. Their rituals are hidden and secret. Using razors, open syringes, or—they say—sometimes their eye teeth, they drink each other's blood, usually piercing a vein in the arm or neck.

Vampire dominatrixes have become popular in New York and San Francisco in recent years because male submissives who flock to the commercial dungeon scenes were seeking a greater variety of experiences, and bloodletting—despite the dangers—appealed to some. Commercial dungeons say there is an increasing demand for blood rituals, but emphatically insist they refuse to engage in the practice for fear of being shut down. However, as one dominatrix confirms, private arrangements for paid sessions are sometimes made.

Marion is a vampire dominatrix who lives and works in New York City. At the beginning of a typical ritual with one client, Marion rings a bell, begins calling spirits, and starts to slither around the man, making circles with her hands.

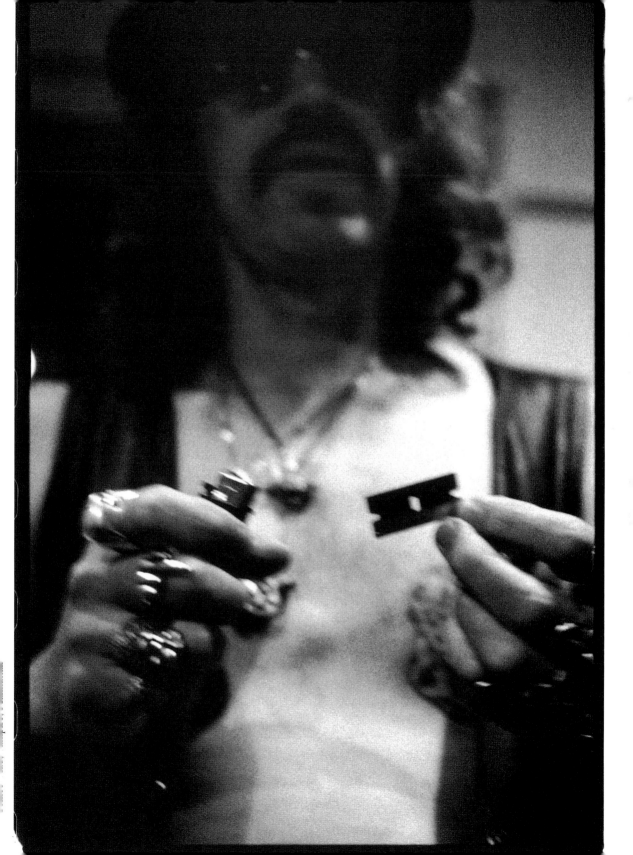

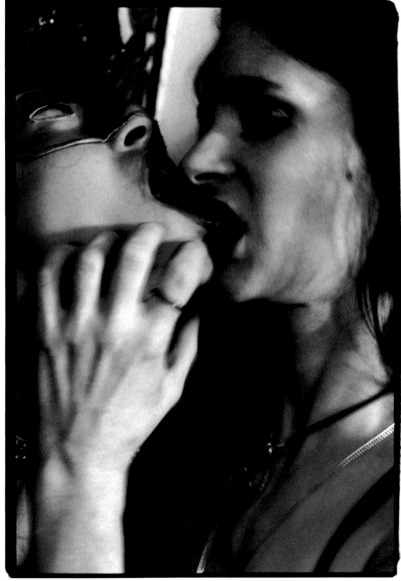

Right, Vampire goddess with victim, Manhattan. *Opposite,* Prince Vlad and Princess Black

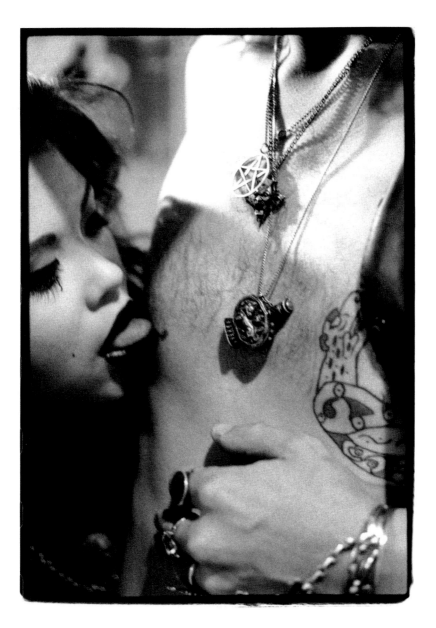

He falls to his knees as an S/M slave would; but in this instance, the submissive is Marion's "victim" or "giver," from whom she will draw psychic energy. Like any dominatrix, Marion issues commands to her slave, ordering him to remove her clothes, fetch a bowl from the other room, and lie down on the floor. Marion places her foot on him, and begins to burn incense.

As the ritual begins, Marion straddles the prostrate victim, and drips her menstrual blood mixed with urine into his open mouth, catching what he can't drink in the bowl. Next, the slave obediently sucks from a frozen sanitary pad that is clotted with Marion's menstrual blood; she pours champagne over the frozen pad and then spits on it. The slave squeezes the frozen mixture into his mouth, and Marion begins to masturbate.

The slave then masturbates and is ordered to come by his dominatrix, who chants, "Give me your energy." Unlike most of the participants in the commercial S/M dungeon scenes, Marion actually looks turned on by her ritual. Later, she will say that she was in a trance and does not remember what happened.

Marion says that before she got into the vampire scene, she owned a profitable small business on Wall Street. Now she is exploring magazine ventures, and has been featured in several vampire videos.

A lesbian, Marion says that people who drink her menstrual blood know that she is not HIV positive because she has had negative test results and because she does not abuse drugs or have heterosexual sex. In one of her videos Marion bites into a former girlfriend's chest and draws blood. Blood spurts on lips, faces, breasts. Blood is everywhere.

Many vampires claim that they need blood for "nourishment," referring to it as "liquid protein." For them, the blood is the reason for it all. But many others claim that their rituals have less to do with an exchange of blood than an exchange of psychic energy, of which blood is only one symbol. Some vampires only want to hit on a "victim," and seek to draw the energy from his or her body. Others will participate in a more equal exchange of energy back and forth. Sometimes these rituals are full of passion and carried out for sexual gratification; other times they are not overtly sexual.

The members of one community of vampires insist that all participants are over 21 and have tested negative for the HIV virus, and that participants in blood-drinking—"feeding," as they call it—are carefully screened and matched.

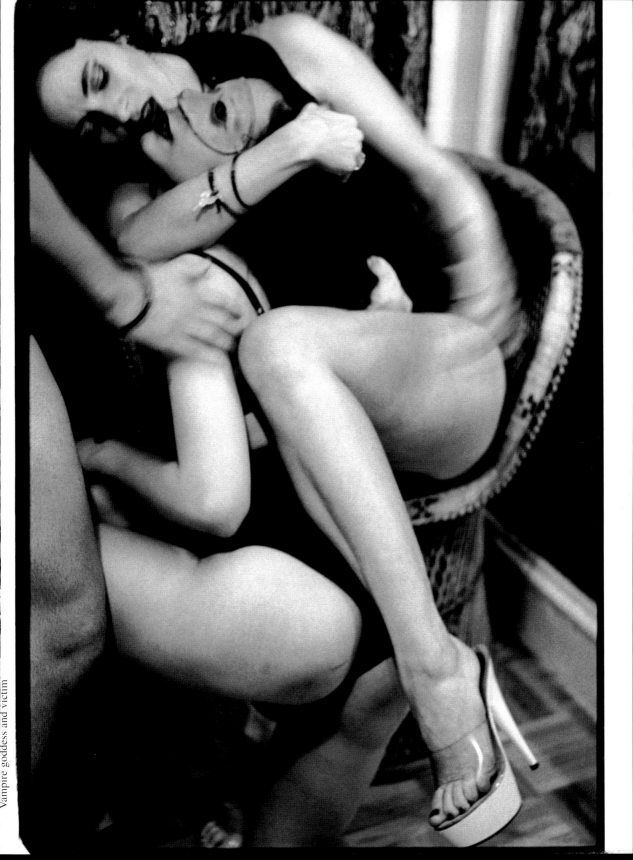

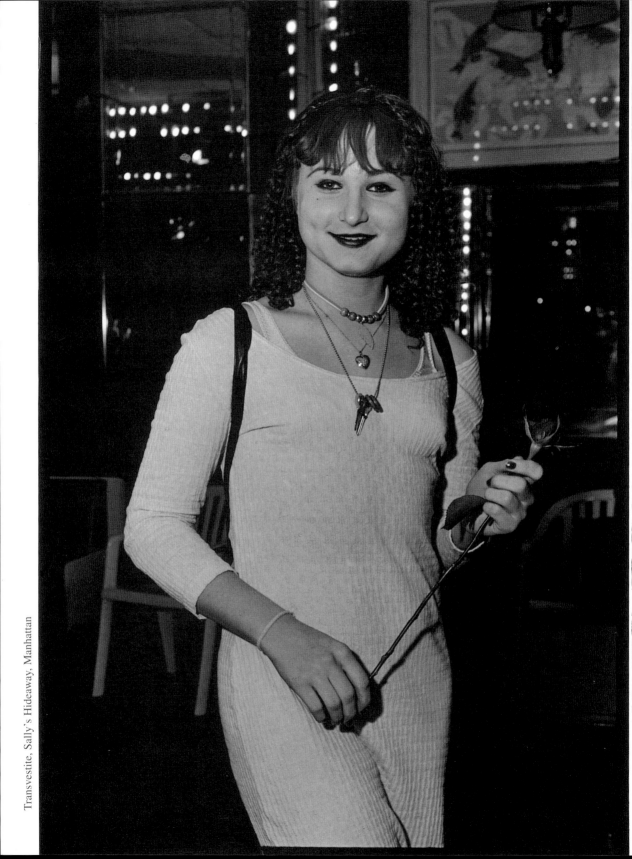

Some also claim that if a good match cannot be found, blood is sometimes obtained from blood banks and hospitals.

While the community of vampires remains small, its members seem devoted. "I have always been drawn to vampires," says Ethan, who is 19, "and I was checking out books on them in my elementary school, old books in the back that nobody knew about….I don't know if there was a connection, but I definitely was drawn to it. The dark of the night and all that stuff. I always just chalked that up to a little kid's fascination, but as time went on it didn't go away. Like, a lot of little kids love dinosaurs, but as they get older they forget about them. I never got over the vampire thing. After a while it just stuck, it became a part of me….

"I love the taste of blood—my own, someone else's….As long as they are clean, who cares? If you like it, go for it. If you are happy and they are happy, then who cares? One of the things I tell people is that God gave me fangs for a reason, and I am going to use them."

GENDER BENDING

Individuals are born one sex or the other, but gender is largely a social construct—and as such, it is rife with ambiguity and subject to change. The role playing that takes place amidst gothic props of the dungeon—where most men beg for punishment while most women brandish the whip—belies the traditional contours of gender. Here, men take on the socially constructed attributes of "femaleness" (often in stereotypical or exaggerated form), or women try being macho—or they experiment with any of the combinations in between.

Sometimes the backdrop for gender bending expands beyond the simulacrum of a gothic past into the iconography of more modern times—the hair salon, the finishing school, the debutante ball. At a small midtown Manhattan studio called Alter Image, Janine and Aja, two makeup artists, make a living by dressing business and professional men as women for $150 a session—often during the lunch hour.

"What we basically do here is transformations for men who want to be females," Aja explains. "These are men who want to experience being female. Either they want to learn about how to put the makeup on and they've never done it before, or they've done it before and they need expertise. They need someone to help them fine-tune and make them look more passable.

"A lot of our clientele are professionals—businessmen, lawyers, doctors, a truck driver....Most of them are married men who at some point in their early life got turned on to cross-dressing in one way or another. And when they get dressed these men want to have some sort of fantasy. Usually they would like to experience being with another woman or a man. They fantasize about being a maid, a prostitute, a little girl going out on a first date, a stripteaser.

"Getting them in here is the hard part—dealing with them on the phone. They call up and say, 'Hi, my name is Cindy and I want to be a woman.' Or 'I'm wearing panties'—those are the ones we have to weed out. But the average guy will come in, business suit, very nervous....We'll have to sit and talk to him and show him photos and tell him what we're all about. When we get through all of that, when he finally gets into a slip or whatever and we do his makeup, he's relaxing a little by that time.

"After a while, they usually get excited, and that's when the stories come out. And it's the same three stories. One of them is that their mother, their babysitter, sister—it always goes back before puberty to childhood—made them into a little girl. And this turns them on somehow and they went through life hiding it from their wives and from their girlfriends."

"Like their mother when they were younger might have had them dress like a little girl," Janine adds. "Like Christine, who said her mother used to have her dress up when he was punished. When she was a little boy, her mother would force her to dress as a girl. These mothers didn't have the girls that they wanted, so they'd make their sons dress up, especially if there was no father around. And somehow, along the way, the boys got turned on by this. So when they get older they want to get dressed, and they come in."

"They get made up and act out their little thing," says Aja. "They walk around, look at a video. They want to be left totally alone. Some of them are a pain in the butt because they want to know everything about being a woman and they want to know it quick. I'll go through the movements and show them how to change their voice a little, and show them all the little things....

"We have parties on Friday nights so guys come in and get dressed, then leave. Like that guy last week; he got all dressed up and when he was leaving he left with a trench coat and a full face of lipstick, big red cheeks. We've had people come in half and half, androgynous....They can walk around as a woman, watch a movie, act out a little fantasy if they want to."

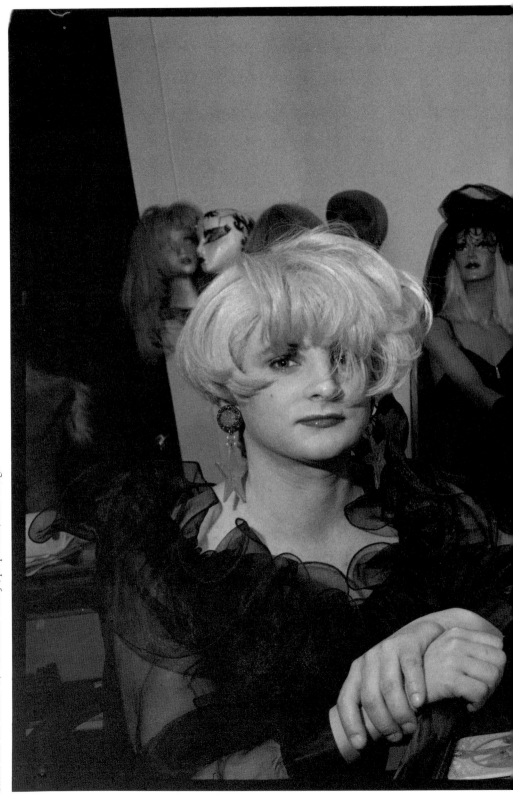

Client after his makeover, with Janine and Aja, proprietors, Alter Image

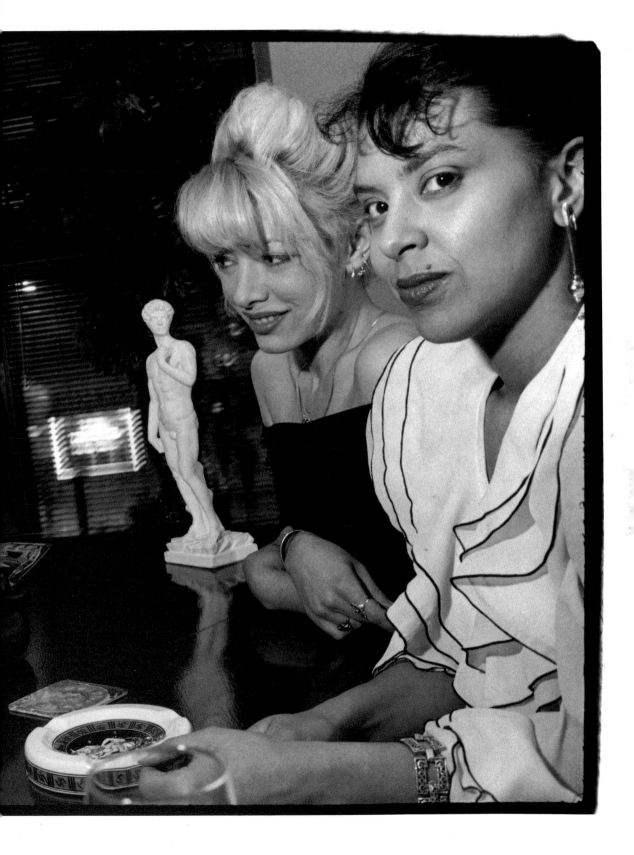

One Alter Image client wanted to recreate, in reverse, the prototypical woman-passing-construction-site scene. He brought hard hats for the two women. "We whistled at him," Janine recalls. "He brought in a big dildo and we flaunted it around, saying, 'We're gonna rape you and gang-bang you, you little slut,' and things like that. He brought a bunch of cigarettes, and wanted us to blow smoke in his face."

"A lot of them want us to talk about them being with a man," Aja says.

"Like, 'We're going to get a man for you and he's got a big you-know-what,'" Janine adds. "Or, 'We're going to pimp you off and you're gonna be a whore. We're going to send you down to Show World and make you dance. We're going to take you down to the corner and leave you there. Then you'll be a prostitute.' That really gets them off.…We sit them down in the chair and say, 'What kind of looks do you like, the sophisticated looks, the businesswoman?' And they say, 'No, I want to be a slut.'"

Veronica Vera is proprietor of an establishment serving men's desires for cross-gender experiences. At Miss Vera's Finishing School for Boys Who Want to Be Girls, it costs $375 for a two-and-a-half hour class, and $2,500 for a two-day "femme intensive."

Vera explains: "One of the homework assignments at the Academy is to create a 'herstory,' and in that way they address a lot of questions about their female persona, so they can really think about who is this person." She cites a sample herstory: "'Jamie Sissyribbons is a 21-year-old airhead. She doesn't have any responsibilities. Her parents take care of everything. She reads *Sassy* magazine, and she thinks Kevin Costner and Mel Gibson are hunks.'" So when Jamie came for the weekend, Vera "decorated her room with photos of Kevin Costner and Mel Gibson. *Sassy* was on the bed. There was bubble bath and only female clothing in the room, along with cheerleading pom-poms."

According to Vera, the Academy attracts a surprisingly diverse clientele. "We have a nuclear engineer and a lumberjack. We have quite a few lawyers, a lot of people in the computer field. Just about everyone will say, 'When I'm dressed anything goes.' Sometimes they mean that only in fantasy, and sometimes they mean it in reality. Sometimes they will be up for trying to flirt with men in bars. It's really fun taking them out." But, she adds, her students are always chaperoned.

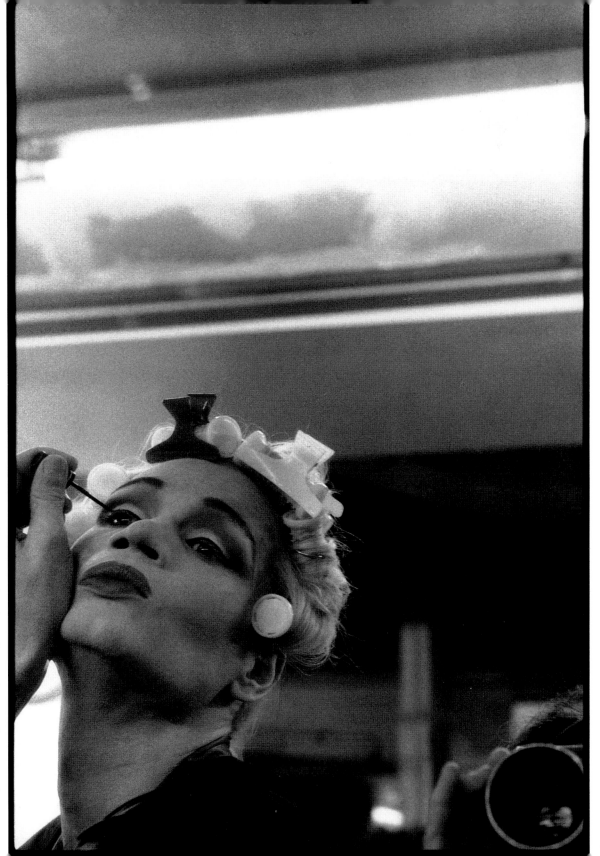

Gina, transvestite performer, dressing room, Sally's Hideaway, Manhattan

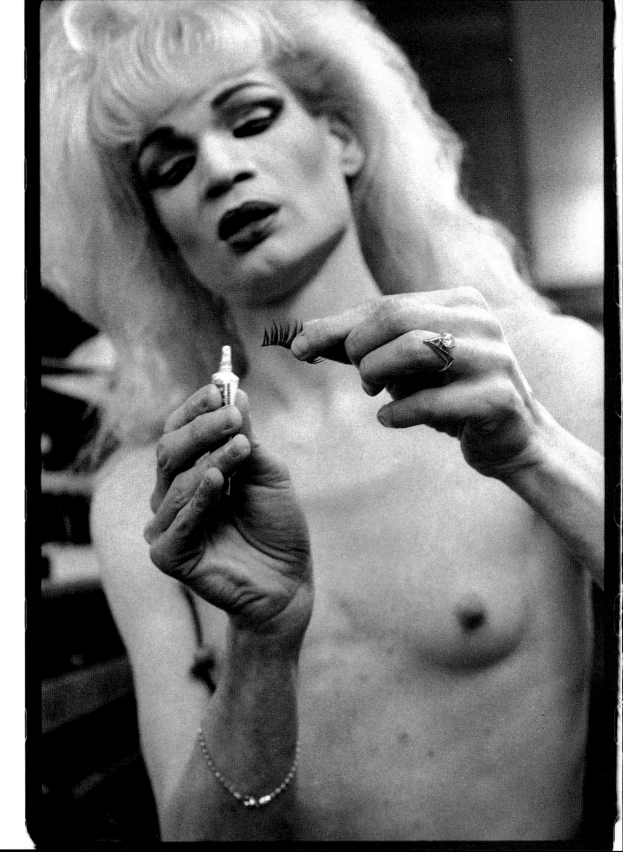

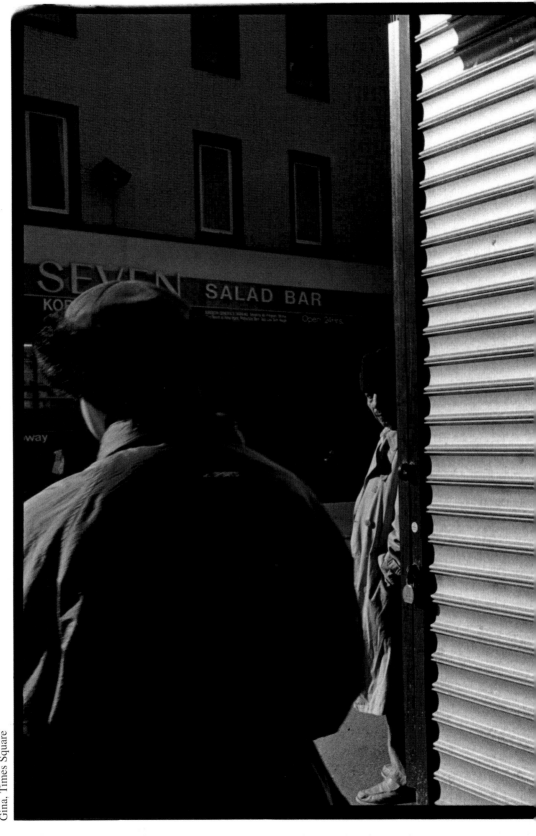

Gina, Times Square

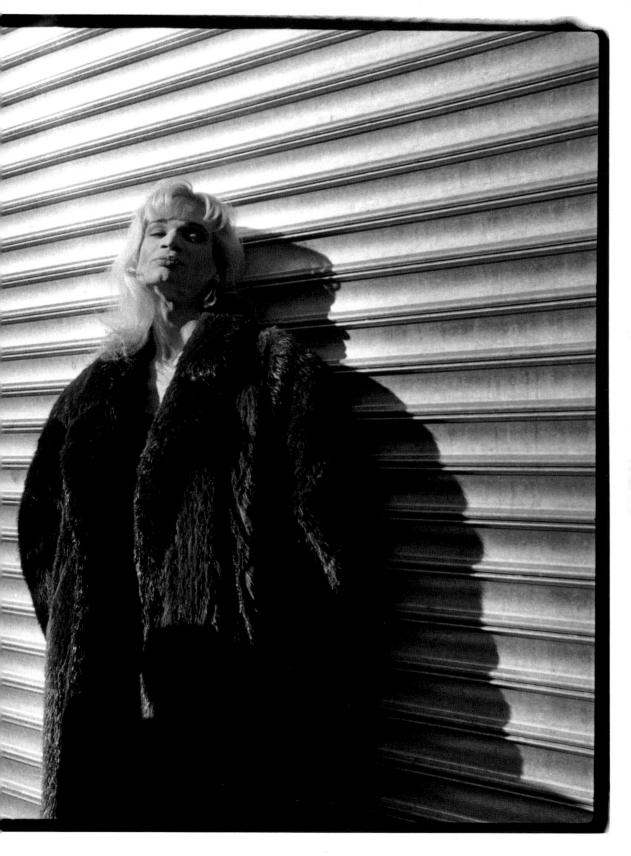

Janine and Aja also say that they are careful not to leave the clients outside by themselves in untried situations. Experience has shown them that when the cross-dressed men actually manage to pass for women, and are consequently treated as women—like when men start hitting on them in bars—they really cannot deal with it.

TRY THIS AT HOME

Torture harnesses and man-sized corsets, along with an array of other implements aiding in physical restraint and sexual release, are provided to consumers by businesses specializing in "sex toys." Catering to individuals who want to experiment in the privacy of their own homes, as well as to workers in the sex industry, these stores and mail-order outlets sell a wide variety of pleasure- and pain-enhancing items. Some of these items are made by business groups in Asia and imported into the U.S., where they are sold at a considerable markup. Others are the work of myriad small designers and manufacturers, from the man who braids whips to the maker of enemas to the sculptor who designs nipples for the fake breasts worn by cross-dressers.

Helen Wolff is proprietor of Come Again, a sex boutique in midtown Manhattan. Wolff once ran a swinger's club, and then got into the sex toy business when she helped out a friend by managing her store. She has been in the business for 12 years now. "My clientele" Wolff says, "is anybody and everybody—but you can't come here just to hang out or to pick up my customers, because you get thrown out....My clientele is the everyday person who is either playing with it or seriously interested in it....Everyday walk-in people. Middle America. Although the guy who came in and spent $800 on bondage equipment I would not call Middle America."

Many go-go dancers come to Come Again to buy G-strings and costumes, and many women not in the sex industry come to buy dancers' garb to dress up for the evening with their boyfriends or husbands. "We sell a lot of the little mini dresses, the real tight skimpy ones, which we didn't used to. We sell babydolls, nightgowns, a lot of vinyl lingerie. They want to buy kinky. If not kinky, why buy it?...My lingerie used to be a very small section; now it's half the store. Bondage was practically nonexistent when I opened; now it's 15 percent of the business."

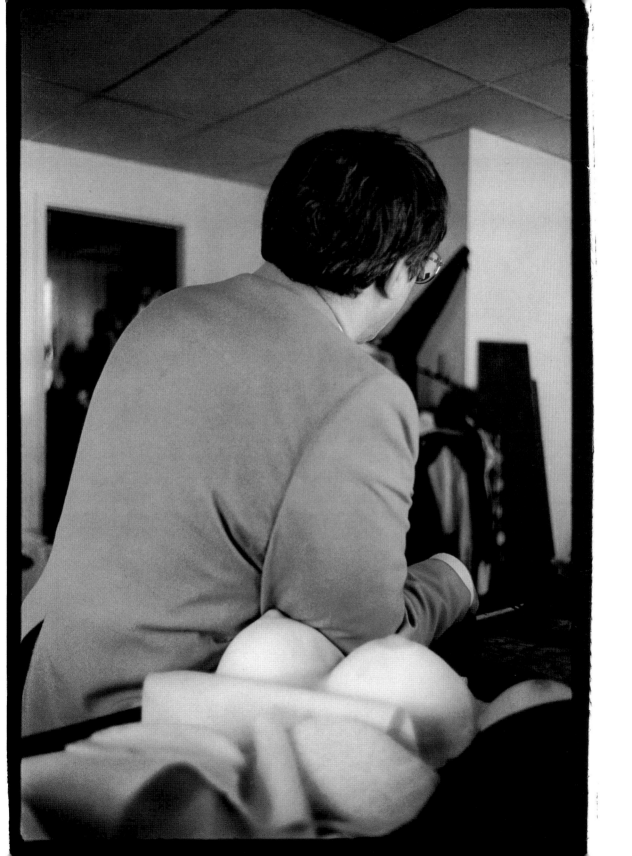

Wolff displays what looks like a high-tech harness. "It's got a pair of restraints to the ankles. It's made out of parachute nylon long enough to tie on a king size bed....It's made with velcro, adjustable. Great for beginners. So you're not going into this heavy, heavy S/M leather pricing, because leather can run you, with chains and hooks, into big money....I always suggest trying this because it's fun to play with once in a while, and if you're really into it and want to go deep into it, then it's worth the investment, and if you're not, then why spend a couple of hundred dollars on leather stuff that you might never use again?...And this is small enough and neat enough that if you're going on vacation and you don't want to carry all the leather stuff, you take this along."

Wolff's stock is diverse. "You can come in here and buy everything from bondage stuff to vibrators and lingerie to adult video to oils and lotions to body paint. There isn't much you can't buy here....I must have 300 to 400 suppliers I deal with. In all, business has tripled over the last decade, and the store is twice its original size."

Michael Salem caters to a niche market in the sex-supplies business—male cross-dressers. "Most of my sales are to men, Salem says. "Ninety-nine percent. This is the cross-dressing crowd. The average customer? Age 55 to 60, five foot eleven, 190 pounds, 34-inch waist. We have many people in the military—generals, colonels, captains." Most of the customers are straight and, according to Salem, most love dominant women.

"This is a Victorian-type corset," Salem says, displaying his wares. "It sells for $260, and costs $100 to make. This is a padded girdle....The airline pilots, when they want to be transvestites—and many of them are—they wear padded panties and nice stockings. They are not allowed to drink or do a lot of things. But to wear female underwear and get themselves excited, that's okay. They wear a size A bra, and these little things here are just like nipples.

"A lot of these people love garter belts. They run from $29.99 to $89.99. The shoes are a pain in the neck, because the size is never exactly what you want. Shoes sell for $260....You have to spend at least $500 to be outfitted properly."

Salem owns the lasts for many of the items he sells, and for his largest-selling item, fake breasts, he has worked with a woman who is a sculptor on the West Coast. He is excited about his newest product, a "natural feeling" fake breast that costs $400 and sells for $700. "That's for the rich cross-dressers,"

Merchandise on display, Come Again, Manhattan

Salem says. "The other thing they like is maids' outfits. The richest people in the world want to be maids."

Salem also runs a 900-number service where cross-dressers can meet one another, but doesn't provide any sexual services. "Talk is fine. They talk. But if they have to come, they don't come with me." He claims he has a mailing list of over half-a-million individuals, and has recently put his catalogue online, receiving an especially large response from the Japanese market. He also claims that he sells to the White House and Supreme Court, in addition to his special market in the Pentagon.

Ed Sharp is the owner of the Pink Pussy Cat Boutique stores, which also sell through mail order. Sharp once had as many as 12 stores, but has cut back to three—one in New York City and two in Florida. He has been in the sex-toy business for about 20 years. "Nothing's changed," he says of the business. "People buy everything. They buy dildos, vibrators.… You stock what sells. There's nothing new on the market.…

"Vibrators sell the most. They induce orgasms in women. Most women have problems with orgasms.… We sell a really good-quality vibrator. Several different models. We have our own trade name—Orgasmatron, an electronic orgasm. It's a hand-held vibrator with a special tip. Costs $24.95 and up. We guarantee you an orgasm or your money back. Now, the truth is any vibrator will give you an orgasm. But nobody's had the balls to guarantee you an orgasm or your money back. I thought it would be a fun thing. I try to keep the fun in the game.

"Dildos are dildos. You stick a dildo up your ass and fuck your brains out; if there's pressure on your prostate you'll have an outrageous orgasm. You put a dildo up a woman's ass and anything can happen, right? Gay guys want 'em. Gay girls want 'em. Two girls can't have a gay relationship without a dildo.… When you switch lovers you change dildos. 'You're not going to use her dildo on me.' So you pick it out together. You can write a whole book on the psychology, the sexuality of the toys.…

"What about condoms? You lose your erection one-tenth of a percent with a condom on. Here's the situation with the condom: You get an erection. You put the condom on. By the time you put the condom on, your erection goes down a little. You need a little stimulation to the penis but you can't because you have a rubber glove on. So you can't do anything. A lot of men say they really hate it.

Now there are tricks to it. You can use cock rings. You can use China Brush. You can use Stud Spray. There are ways you can handle it that we know about in the store, but if you don't ask we can't tell you….

"Stud spray numbs you. China Brush doesn't. China Brush is herbal. It's a very old product. You put it on your penis, and it keeps you hard forever and it keeps you from coming. So maybe you have a problem with premature ejaculation. Your wife's out of her mind. Every time she gets ready—everybody's hot, and boom. Bam, it's done. That's it. It's over. You go crazy. She's nuts. Every time you have sex you blow your wad immediately. So what we'll do is give you something for a quick fix until you can get your ass to a therapist to find out what it is that's going on."

Sharp describes the economics of the sex-toy business. "[Dildos are] an American-made product. You've got to be pretty big to make dildos. You've got to do injection molding. It's a complicated process. It's big bucks….Dildos cost $2.50 and $3 wholesale….

"The vibrators are made in Hong Kong. I have an office there. We export to people all over the world. We export to distributors, to wholesalers….We buy from the factory. We're right in the main crunch of it. There are about seven or eight guys in the business. Hong Kong is the center, but some are made in Taiwan, some here. Everybody's in vibrators. It's a very big business….They cost from 39¢ to $10 in Hong Kong, depending on the brand. Then you've got customs, shipping, packaging, overhead, salaries, insurance, lawyers, protection, rent, sales help. And the government is harassing the shit out of us."

Despite these costs, the sex-toy industry is lucrative for both wholesalers and retailers. In Sharp's opinion, the business also performs a social service—providing "first aid" for marriages and other relationships that need some short-term help on the sexual front. "When you get into bed, you want to have fun. This business is everybody's fun. The serious side is that it's really important that the sexuality of a relationship stay together or the relationship is gone….

"Basically the problem is boredom….The wild, crazy love affair where you can't keep your hands off each other turns into boredom….Nobody can turn someone on seven days a week. And that's what marriage is….What do you do after you get married, after you have children? What do you do to keep the goddamn thing alive? What we do is we're first aid for marriages….Toys come in when a relationship gets fucked in the mud."

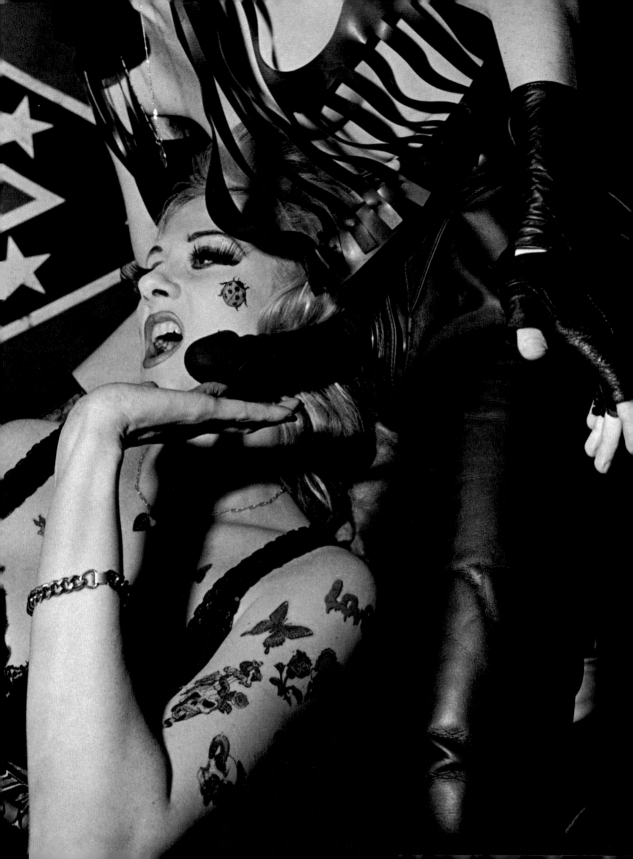

SEX WORK
AS PERFORMANCE ART

The images of the sex business reach well beyond the confines of the whore-house, the strip club or the dirty movie. They form the raw materials for a good deal of advertising, fashion, and mainstream entertainment. Increasingly, they are also the subject matter for art.

A number of performance artists employ the stuff of the sex business in their shows, but in the process become both commentators on the industry and its avant garde. Performer and director Penny Arcade put together an entire show that mimics the straight strip joint, with her actors descending into the audience to join in the parody of the sex held out, but never fulfilled, within the strip club. Former dancer Jill Morley turned her experiences into a successful comic theater piece called *True Confessions of a Go-Go Girl*. Many of these performers come out of the industry. Others dabble at its fringes, gathering material for their art.

Annie Sprinkle is a guru to this scene, turning her own body into an art show, where she invites the audience to examine her vagina through a speculum and caresses dildos of various sizes and colors. She ceaselessly creates perform-ance art out of her life—starring in videos and theatrical pieces, making books and picture spreads with her fuck buddies, supporting other sex workers and photographing them for porn magazines, and acting as a spokesperson and orga-nizer for sex workers through the group PONY (Prostitutes of New York), among many other ventures. She promotes the sex industry while at the same time attempting to elevate it to both a "helping profession" and an art form.

Among artists influenced by the sex industry is Ron Athey, a Los Angeles–based performance artist. Athey, in his 30s, has a body covered with tattoos and piercings, and has been directing and performing highly ritualized spectacles since the late 1980s. Athey and his troupe achieved some prominence for a performance at Minneapolis's Walker Art Center. He soon became a target of attacks on government funding (through the National Endowment for the Arts) of "transgressive" and "indecent" art.

Trash and fellow performer, Jackie 60, Manhattan

"The sex industry has always been a part of my life," Athey explains. "I was raised in a Holy-Roller family in Pomona, a suburb of Los Angeles. All the people I met were strippers. I never knew my dad. My mom was in an institution. My grandmother and my aunt raised me in these little shanties in the desert. I spoke in tongues and danced in the spirit, and I use that in my performances now. There were faith healings.

"I have always hung out with strippers, prostitutes and porn stars and stuff. Every girlfriend I ever had was a stripper....I was a heroin junkie, which had a lot to do with the people I hung out with. I needed daily money. I got out of heroin about seven years ago and started working at the *LA Weekly*. Then I started doing performance art. I started go-go dancing at Club Fuck in L.A. We started doing small piercings and candle melting. Just scenes. I wouldn't call them performances. Short rituals every night in the middle of the dance floor. They just evolved until I started doing 30-minute performances."

Athey describes his more recent hour-long performance piece, based on images first developed in the L.A. sex club. "The first scene is a hospital scene with three fetish nurses. My mouth is stitched shut so the other nurses cut it open and I do a reading with blood pouring out of my mouth. It's about how many different things the body can symbolize. Then we cut some bodies open and do weird sort of medical fetishist things to the bodies. Then I leave and come back like a Nazi in a temple setting where there are two boys. This scene has gotten much more erotic since I first did it in Chicago. The guys had extreme cock harnesses with semi-hard-ons and Indian veils. Like they are prostitutes from the temple. I beat them....I get this spinal needle crown of thorns put in my head. It is intensely painful. While all that is happening the two dancers—one of them is a Mary Magdalene figure—take off all my clothes. I am sitting in a big chair where my head is getting pierced and wrapped really tight with wire. Then four dykes come out and restrain me. It's like spirit dancing. Just like the stuff I used to do in church. Dance until you are in outer space! I fall down and get taken away and martyred like Saint Sebastian. It's a really slow and painful scene. Then the needles get pulled out of my head and I lose one to two cups of blood through the puncture wounds in my head. It's a bloodletting, a strong political statement to me." Athey is HIV positive, and "that adds an element of danger to the show. It's like a weapon. When I'm doing the dance, if they pull too hard I'll fall on one of them....

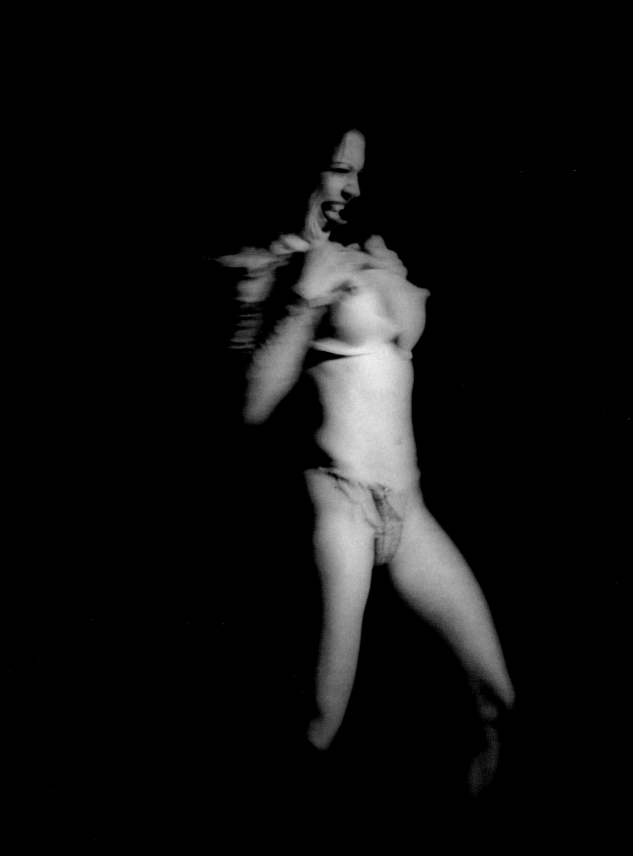

"Blood images aren't shocking to me. Asshole, dick, and pussy are not necessarily used to be shocking in my work. The most I do is, like, penetration. Or a hospital scene which is supposed to embarrass everyone. Somebody gets an enema. Somebody gets a speculum examination, and an asshole examination. Someone gets pierced, mummified, cut open, washed in a hospital setting....

"I'm not making statements against Jesse Helms and against people's morals because I don't care. I just take things that have deeply affected me as an American—like the charismatic movement, like living in the sex industry."

Trash is a performance artist who looks like and dresses like a young man. She grew up in Houston where she did tricks for food and danced for a while at Show World. She now lives in and out of the S/M scene, where she has developed performance art from what she calls "gender illusionism."

In her shows, Trash piles visual contradictions of gender on top of one another. Garbed as a man, she emerges from a crowd of curious straights, dancing lesbians, and dressed-up drag queens in a packed and smoky club. The music is top 40s pop. On the wall, in parody of the sports bar, video screens show young men riding Harley Davidsons across endless terrains of roads and dirt. One man shoves another over the cycle handles, and rams first his fist, then his cock up his ass. The crowd's gaze is fastened on the wall as Trash takes the stage, bares her breasts from a men's overcoat, and whips out a long dick and begins to tyrannize a female "lover" who is dolefully parodying the straight-world stripper.

"Society is so repressed sexually," Trash says, "that we can't even find our way out of it. I shouldn't say 'we.' I have found my way out of it. But I was never conscious of what I was doing, except that I was being sensual and sexual and, you know, androgynous. I think it's a good thing that people are getting interested. I'm just working on the articulation and getting information out to people that sex is a positive thing....I think my work now is focusing a little bit more on the ambiguity of gender and why we find it so important that we have to be one gender or the other. People have called me a gender illusionist....It's more of a performance on sensuality, you know, sensuality in spite of sexuality....But society is very closed minded in thinking it has to be one way or another, male or female or homosexual or heterosexual or bisexual. Sex goes way beyond these choices, and that's what I think role playing and S/M is about. It's about transcending the immediate, the body, to come to develop from the mind...."

Members of Ron Athey's troupe, P.S. 122, Manhattan

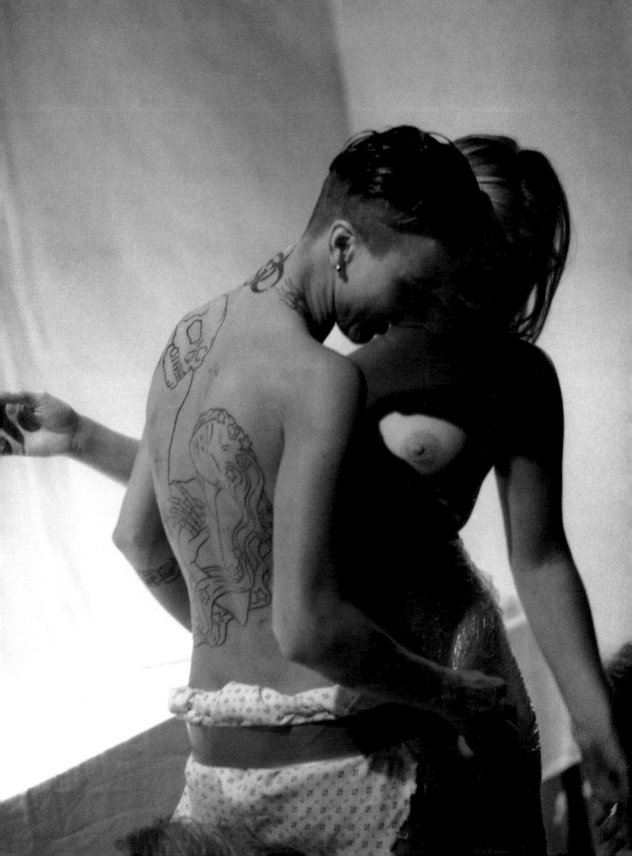

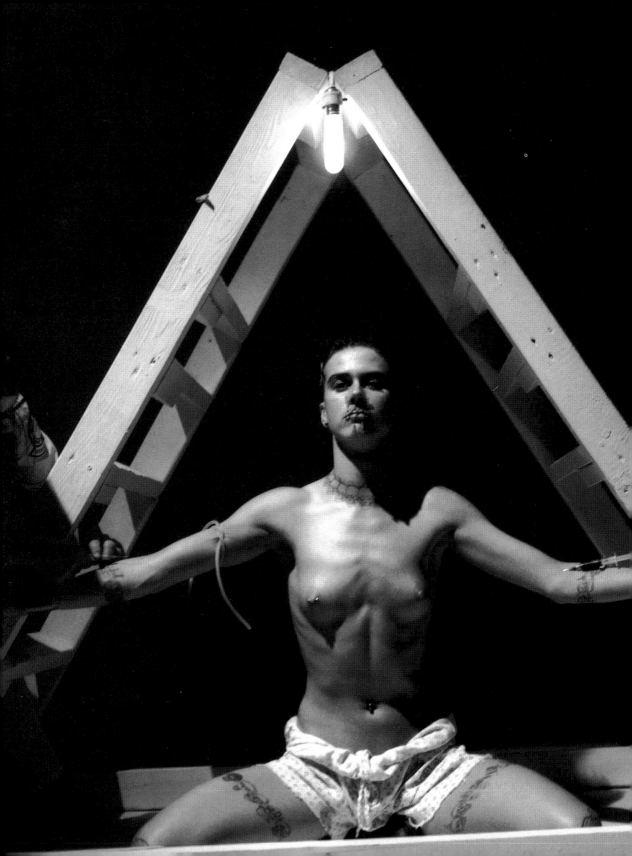

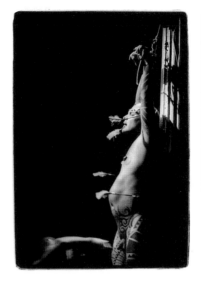
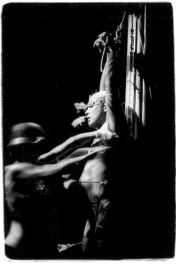

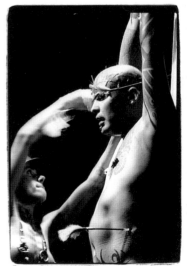

"There is such incredible noncommunication between the sexes, except in go-go bars or houses of prostitution or domination," Trash says. "I believe there really is a secret coded language, and you start reading minds and bodies instead of identifying somebody by what they have below their belt. That's what I found, just working at Show World. The place is set up like a street in Paris, where the women are hanging out in the hallways and you try to lure them into the fantasy booths. The third floor is live performance with chicks with dicks and dominatrix acts, transvestites, and other such novelties. And the floor I was working with had the fantasy booths, which was really interesting. Each woman was required to dance a 10-minute segment every hour on the proscenium, which was a semicircle. Nothing so glamorous as Madonna in her video.

"The men put their tokens in. You're in there and it's however you want to set it up. The shield comes up and there's Plexiglas separating them from you. But they can see you and you can see them. They drop their pants. On the Plexiglas the two bodies superimpose. So they look like they've got tits, and I look like I've got a cock. It's overwhelming visually. They masturbate. You're not required to do anything. You have to show nipples. That's it. You have to show tits. Then it's up to your judgement....

"I do think sex and sex work is somewhat psychological. Especially because S/M and the dominatrix are really touching upon things. They are rather cathartic and necessary, relieving a lot of psychoses through the pleasure of pain....The sex industry—when you can't find anything else you usually go to that. It's not an unfortunate thing. It's kind of comforting to know it's there, if it comes to that. It's like survival....

"I think a lot of people are very frustrated. Perhaps it's coming from the unconscious, this whole curiosity about the sex world, or perhaps it's another fad. It's too early to tell."

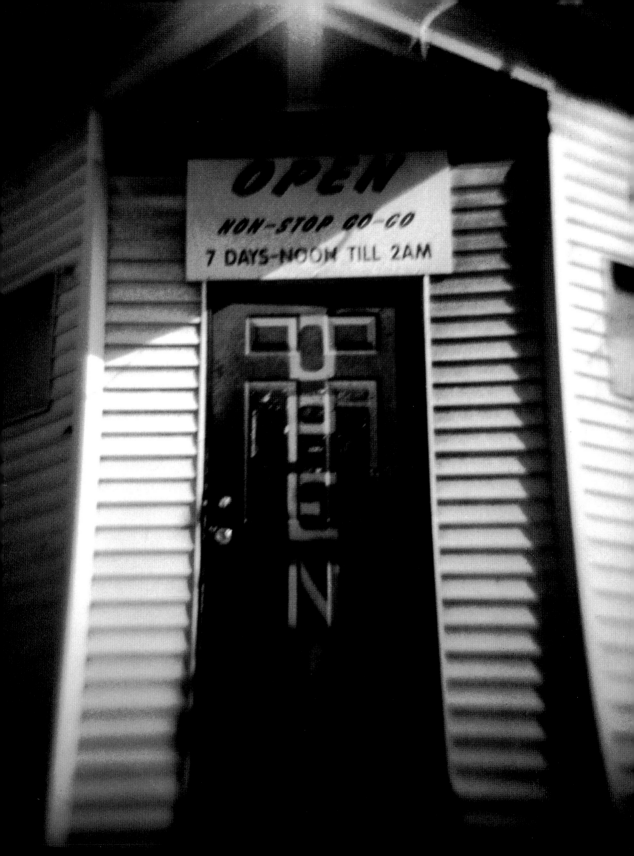

SHOWTIME

What happens in the thousands of go-go clubs spread across the country is one of the main events of the modern sex industry. Often, it seems like a parody of an earlier time—the sleazy old strip joint of the traditional red-light district transformed into a sanitized adult theme club. The sluts of yore are now often portrayed as upwardly mobile, career-minded college girls who are proud to display their bodies, but won't tolerate a touch. And the guys gather to stare at naked women just as they would to watch a football game, and "have a little good clean fun."

But for Susan Walsh, a writer and a dancer, the go-go club is the DMZ, a place where tensions between the sexes are raised to knife's edge. She writes:

> When I first started stripping, I thought it was really something special. I assumed different looks each 30-minute set—glamorous, sultry casino madam, leather-adorned East Village metal girl, white-laced vixen. I practiced slick moves in the mirror and worked nude because I was so thin and white and I thought that I had to compromise in order to be accepted as a dancer. The men's smiles were my payment; the dollar bills they stuffed between my breasts were just extras. I was a dancer, and they liked me.
>
> Now, sometimes the only thoughts that comfort me are penis mutilation fantasies. I lie on the dressing room stools staring up at the ceiling, running images through my mind like slides projected on a wall: me taking a blade to a swollen cock and slicing it up like a cucumber for salad; feeling it swell in my mouth and fiercely chomping down with my incisors.
>
> "Just let me get my finger wet and I'll give you this twenty," one customer will say, holding the bill between two fingers as if it's his precious dick, the middle finger erect and pointing between my legs. Then he'll try to shove it in before I can move back as his friends laugh. Their buddy's getting married and he deserves a little from the slut on stage. Wagging their tongues in proud displays of cunnilingus, grasping my hand after they tip me so I can't go back on stage, pulling me by the waist and planting me on a barstool as I try to run to the dressing room, they struggle to be warriors in the dirtiest battle known to humanity.

Go-go club, New Jersey

Susan Walsh, dancer, Dubonnet, Newark, New Jersey

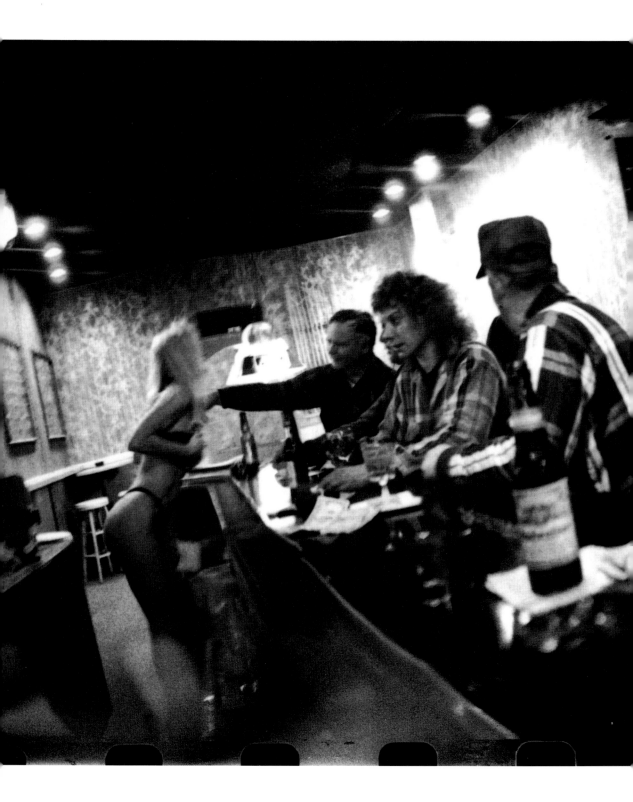

~~flipping~~ for
a dollar,
posing in
a frenzy.
How dare she ~~████~~
~~████~~ ~~bringing back~~
~~██~~ ~~turn the key~~ to
~~████~~ the playground
of his nightmares?

Ode to the ~~men~~
~~the boy,~~ ~~it~~
who ~~████~~ hold
their scabs
within the sheath
of their sex,
wagging tongues,
insisting that the
girl is the object,
not them.
Insane throwaways,
they refuse to see
that even viewing
hours are limited
as the funeral home
And

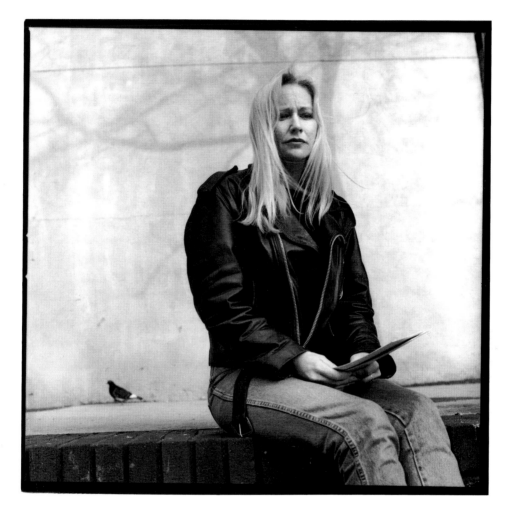

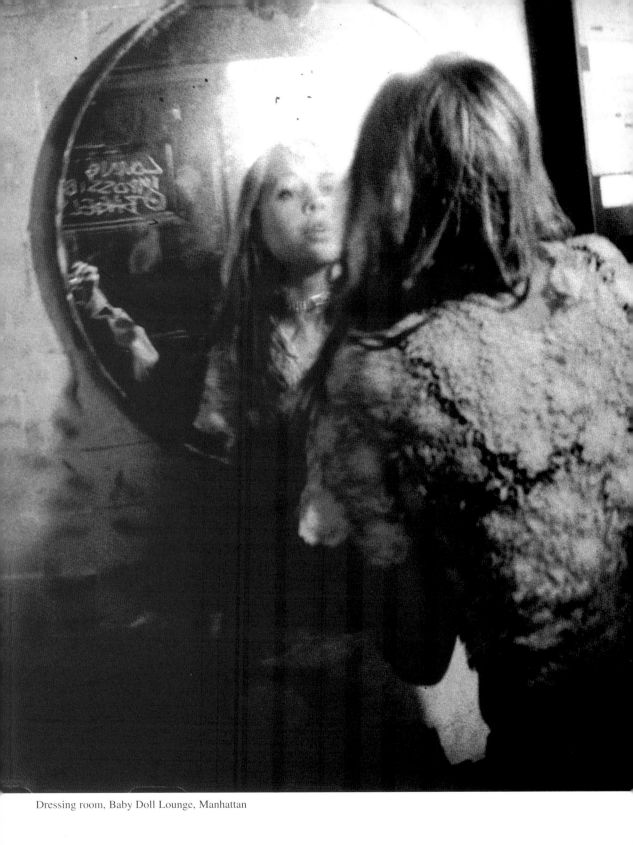

Dressing room, Baby Doll Lounge, Manhattan

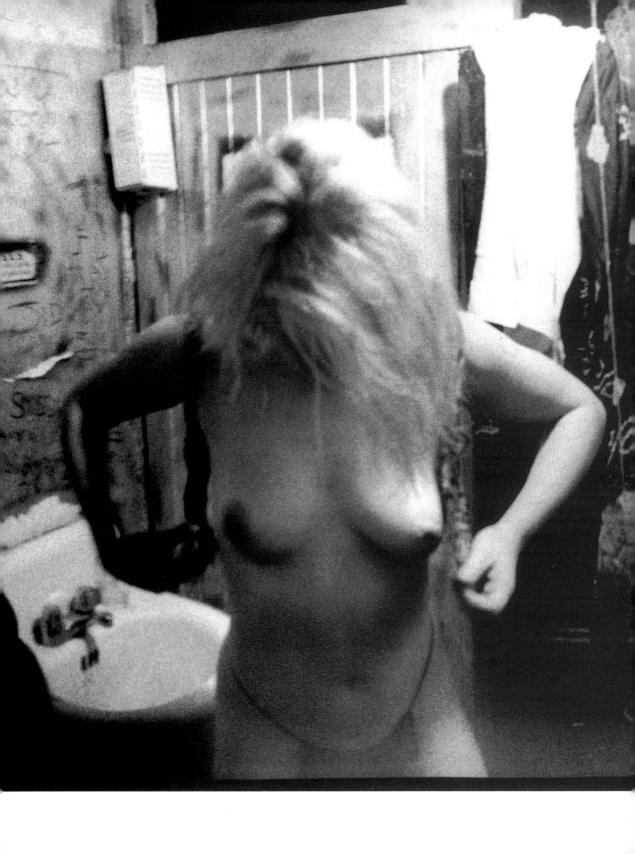

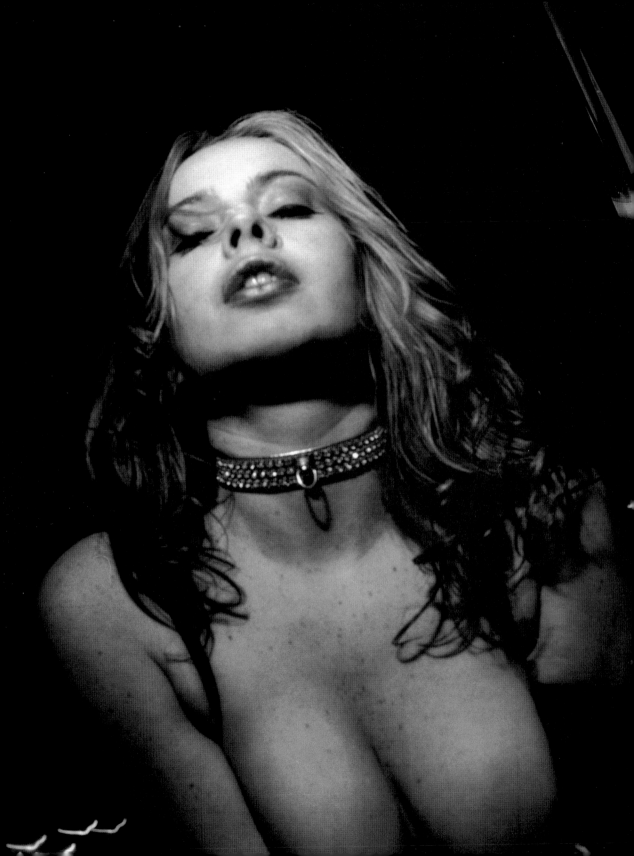

ROAD WARRIORS OF GO-GO

Although many people still call these bars strip clubs, stripping is seldom the primary activity. The dancing is generally broken down into three distinct types: nude dancing, sometimes with a G-string, and sometimes without; topless dancing, with bare breasts and bikini bottom; and top and bottom bikini dancing.

At most of the clubs in New Jersey the women dance in bikinis. New Jersey also permits topless dancing, but alcohol cannot be served at topless clubs. Some of the suburban clubs maintain a high degree of decorum. At others, the dancers sometimes "flash"—revealing a nipple or a glimpse of crotch. In fact, flashing can be much more sleazy than nude dancing—as, for instance, at one club in downtown Newark, where a woman wearing a bikini bottom and an open leather vest sticks her finger in and out of her vagina as she humps around on the floor, to the delight of the men who have stopped by for a beer after work. Nevertheless, many of the Jersey dancers have a code. Sticking your finger in your vagina, for example, is generally considered vulgar. The same is true of spreading your legs. But often, the customers will hassle the dancers to do more or show more. "It gets to the point," Kim, another dancer, says bitterly, "where it's, 'What do I have to do? Whip out my uterus?'"

The reality is not just that strippers hardly ever strip; it's also that go-go dancers don't really dance. In fact, the dancers explain, if they actually danced, they wouldn't make any money. The trick, they say, is to start by moving to the music; you've got to know enough to be able to sway to the beat. You check out the audience and then, gyrating very slowly, rubbing your hands up and down your body and looking directly into the eyes of the men, go from one to the other in search of that recognition that will yield a dollar bill. "Out of 200 girls I have, five can dance," says Karen English, a former dancer who now owns a club and operates an agency in Staten Island. "I danced at Virginia Beach and I had to dance down there. All the girls I get from the Beach, these girls dance. But in New York and New Jersey you just hustle. Girls just hustle around the bar and make their money."

Tara Ball, dancer, Baby Doll Lounge

Up until the late 1980s, dancer Donna D. explains, "the guys handed you the money. You danced. You were fully dressed, fully covered, glued, taped in. Nothing showed. And it was great." But as more and more dancers flooded the market, competition among dancers—and demands from customers—increased. "When the recession started, you had to do more for the money. The guys weren't happy with just dancing any more. It got sleazier. There was a lot more contact....There was flashing, and then bottom flashing. Then there were the tits and the G-string, and then it just kept getting worse....People don't wear their tops half the time any more in Jersey. The laws are there, but nobody bothers with them."

"There was a lot more money back then," says another dancer who began working in the early 1980s. "I don't know if it's because I'm a little older or because go-go is so middle class. But then it was still illicit. Naughty girls did it. Now you get nurses, librarians—anybody will do it these days."

Hennessey, who has been dancing for over 20 years, summarizes how the business has changed. "You take more off and you get paid less....When go-go dancing started like 30-odd years ago, you had to come out in leotards or shorts—what are now considered hot pants. You were dressed. You were clothed. You even wore a clinging type of top with maybe a vest. You had these short pants. You remember how it looked when Tina Turner used to dance, the shorts and tasseled vest? That was go-go dancing then. And they'd be on their little square boxes. That was go-go dancing. How it's evolved is, you take more off. Your ass is hanging out. Your tits are hanging out. It's silicon city."

New Jersey has more strip clubs—over 200 in all—than any other state in the nation (although both Texas and Florida are close competitors). The dancers who inhabit this arena come to it from different places. For some women, Jersey go-go is the least frightening setting for a temporary stint in the sex business. For others, it can be a step back from the brink, into a manageable holding pattern. For them the little clubs with their tiny bars and predictable clientele are a relatively safe haven from the street.

Many women who used to strip in New York try to get out of the city to dance in New Jersey, where the atmosphere is less intense. "In New Jersey," says Kim, "they are happy to see anything, and you can make more money. In New York you could do amazing things and they're still not impressed. It's a

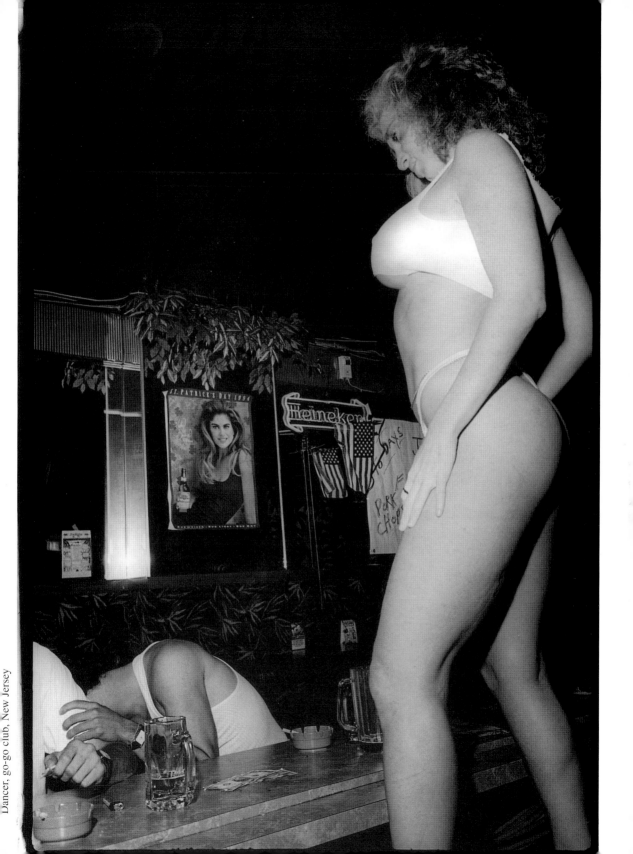

Dancer, go-go club, New Jersey

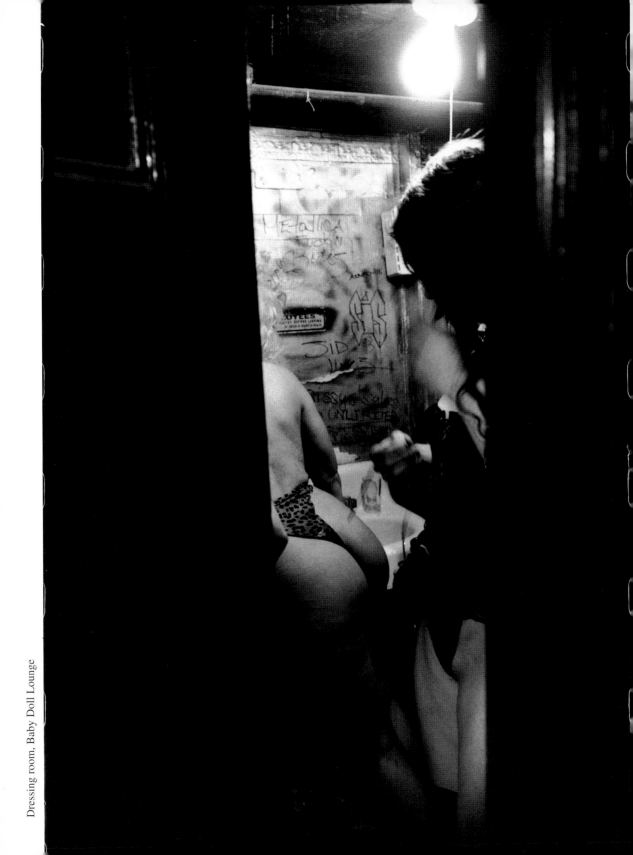

Dressing room, Baby Doll Lounge

much harder crowd." This exodus has created a new subculture of commuters, and it's stretched the working day out. Every afternoon women from all over Manhattan start heading out to the clubs in Jersey. Most will not return until early the following morning.

Lola has been one of these commuting dancers. "I work both afternoons and evenings and I work about four days a week," she says. "So my typical day? I wake up around 8 or 9. I shower, have some breakfast, and get on the 10:30 bus to Paterson. I'm on stage at 12. I'm dancing half hour on, half hour off. On my breaks off I either sit with a customer and have a Perrier or something. You don't have to sit with people unless you want to. Maybe they've given you a $10 or $20 tip or maybe they're interesting or maybe you might be attracted to them. If I don't sit with people I go into the ladies room and read, change my costume, freshen up my makeup....

"I'm a suburban go-go girl. Have G-string, will travel. I'm the road warrior of go-go. I will not shake my clam in front of a tragically hip East Village audience for $35 a night when I can be doing the same in Jersey for $300 a night. And if that means I'm not an artiste then gag me with a salami....Shut up and eat. That's what I say to them when they sniff sniff. 'Shut up and eat.'

"Over the years I've polished up my act. I'm sort of like a Mae West up there. Or Bette Midler. I come off more like a bride than a Barbie doll. I like being on the stage alone. Nobody should be in the stage with me. I'm like a lion up there.

"The other reason I like working out there in Jersey is because you get more of a blue-collar crowd. In Manhattan it's all yuppies and preppies. They're the cheapest and they're the biggest perverts. They are always the ones that are the most demanding, the most critical, the sickest motherfuckers you've ever laid eyes on. They're all like Norman Bates. They may want you to show your corn hole. A lot of them are very anal....

"Or they might want you to talk dirty to them. The yuppies and the preppies, they don't want their secretaries up there. They don't want a Barbie doll. They want a pig. They just want a pig. If you act like a big pig you might get a buck or two from them. Whereas the blue-collar workers, they know what it's like to struggle for a buck and they're very generous. And they drink their Buds and their Coors and their Kamikazes and their Alabama Slammers, and they throw you a lot of money."

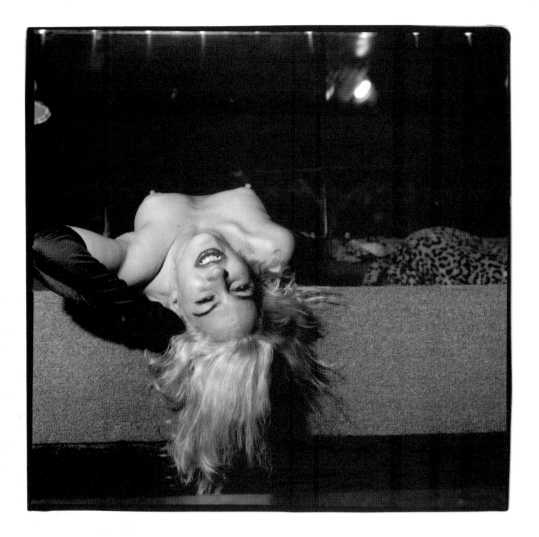

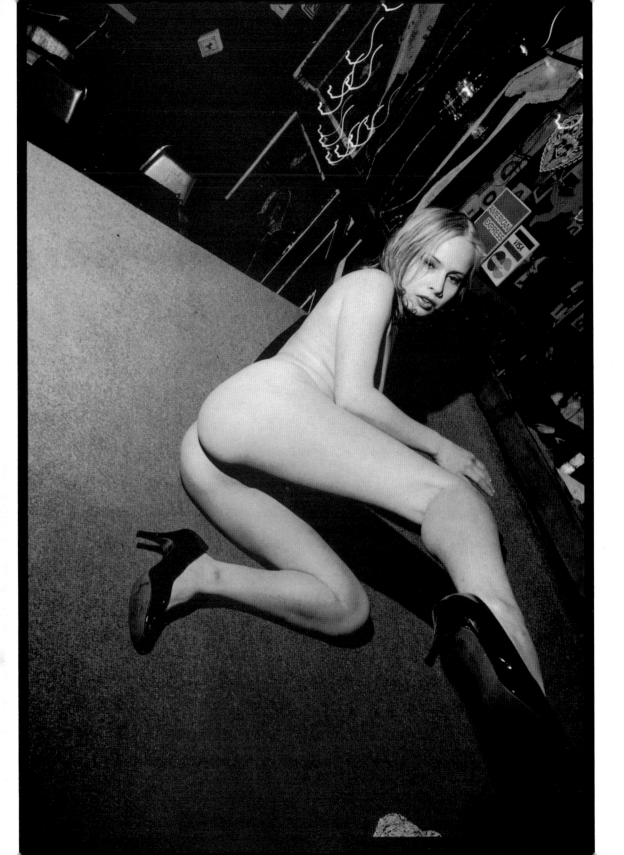

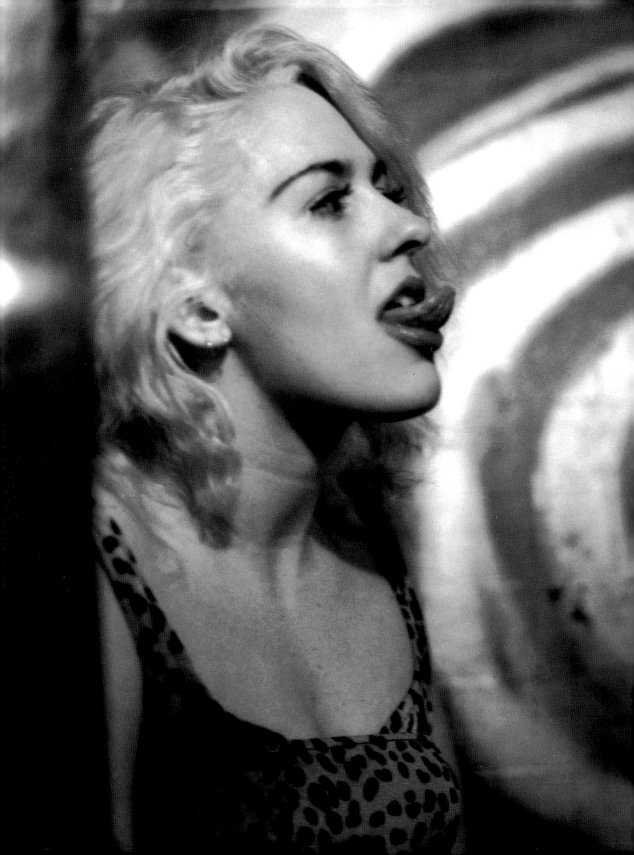

Miss Kelly Webb, Baby Doll Lounge

DIFFERENT STROKES

Although the Jersey-style mom-and-pop clubs—found in the working-class neighborhoods of cities, suburbs, and towns across the country—account for a large percentage of the go-go industry, there are other settings as well, each geared to its own special clientele. The elaborately designed upscale chains strike different voguish poses, set up in what the originators must think to be imitations of casinos or Broadway sets. Some areas are set up as cages where the clientele can gather as if at the monkey cages at the zoo, and watch the dancers do their tricks; others are lush sunken pits where the women can perform lap or table dances in more intimate circumstances. The dirty dancing of the sleazy mom-and-pop club is replaced with the frozen feel of high design, replete, in the case of Solid Gold, with vapor blowing out of vents in the ceiling.

Donna D., who began her career at suburban clubs in Jersey and Queens, now makes most of her money in high-end Manhattan clubs which cater to businessmen on expense accounts. She says that she has developed a loyal following, and a carefully choreographed act. "I know how I look good…I am very conscious of my movements.…I know not to sit there and clinch up my butt cheeks because then you have cellulite there. I know not to bend over with my legs wide apart because it makes your ass look like it's too big.…

"There's a lot of things with the pole [that make me look good].When you're holding on to the pole, if you lean back, you cross your legs and you turn, basically like a lot of swimsuit models do. So it's half front, half side. Your waist looks small, your chest looks big, your butt looks very small, and your legs look very small. Spins are really good. When I'm feeling heavy I try to move a lot. When I'm still they can really see it. If I keep moving they can't focus so much on the bad stuff. There's all kinds of things that come from practice. I practice in front of mirrors.…

"Every guy is so different. It's a personal preference. There is no one look. There's a lot of girls that are flat-chested who make a lot more money than I do.…But then there's the night where I'm table dancing left and right because everybody in the crowd that night happened to like a redhead with big boobs.…That's what I hope for—that at least 25 percent of the people will like my body type. And everybody else, fuck 'em."

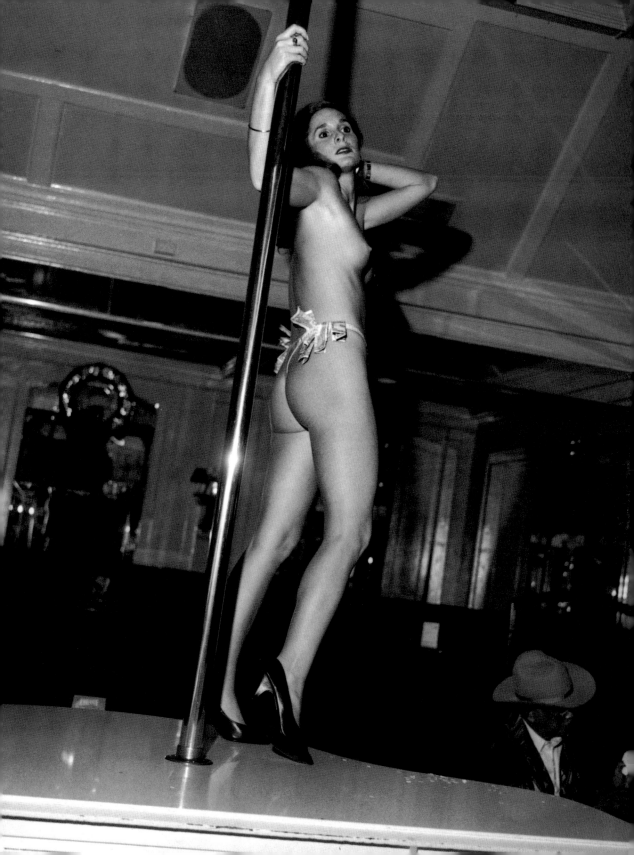

Michael is a dancer who performs both in clubs for straight women and in clubs for gay men. "I'd say most of the guys who dance in gay bars are straight," Michael says. "Well, they say they're straight, but they're probably bi. It's not necessarily their preference, but they might do it [with men] for the right price and for future work and to get a foot in the door for other things....

"In most gay clubs they don't like nudity. They don't even like towel dancing. They get offended by that. Some of these guys flash their dick for extra money, and a lot of guys don't want that....I usually put my hand on my crotch. It looks like I'm playing with myself. I'm really covering up....[In the gay clubs] you move more. There's a different type of teasing involved. Guys in general just love nipples. Guys like nipples on girls. Guys like nipples on guys. I just sit there and pinch my nipples. The guys go nuts.

"When they tell you the girls are worse than the guys, it's not true. No way. Not even close to it. Guys are a lot worse than girls....Girls scream a lot, that's it. Gay men are more aggressive. They see you for a minute and they want to give you a blow job. They don't even think twice....

"My experience is that, okay, the girls are going to hit on you. But it's how you carry yourself. The girls might grab my pants, but most of them really don't. Most of them just look at me, stare at me, and just give me a tip. They don't even know what to do. Half the time they're embarrassed and a little shy. But the guys will proposition me....[They say,] 'Oh my god, it's a shame you're straight!' I tell them I'm bi. When they get to know you they don't care. They always look at it this way: 'If you're straight, what are you doing dancing in a gay bar?' They don't realize this is a job. They think I'm enjoying it."

Steven has worked as a prostitute and a dancer in clubs for gay men. "It's a really dreadful experience. I mean...the go-go boys in strip joints here. Like [one that opened near Penn Station]. They were touting themselves as being an upscale strip joint. But it was more like 'Club Lonely Guy'—'Club Lonely Ugly Guy.' More polyester than I think I've seen in one place at one time, and dreadful, ugly decor and everything. The go-go boys were gross. Except one or two of them were kind of cute. It was a hungry, needy social dynamic. There was this overhanging motif of desperation. [These guys] were all trying to ignore it, like 'Oh I didn't need to come here. I just wanted to come here.' No you didn't. No one wanted to come here. It's gross. It's gross. They don't even serve beer here."

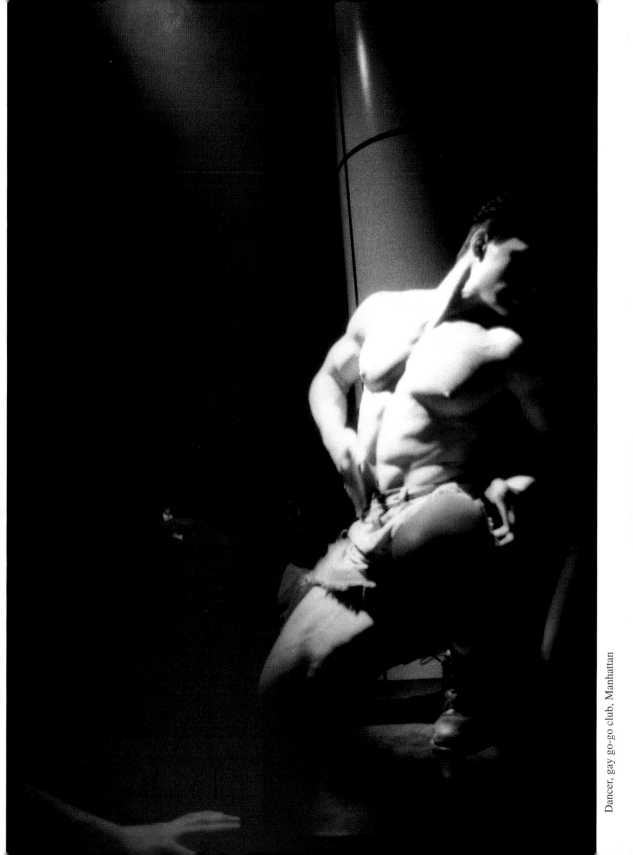

Dancer, gay go-go club, Manhattan

"I dance at lesbian clubs too," says Donna D. "It's easy money　not big money but easy money. It's the same; the lesbians are just like men. I dance for them just the way I dance for men. They are looking at me the same way. There is no difference. They all want to take me home. They want to marry me. They want to take me away. It's exactly the same, and when the guys dance for guys it's exactly the same as dancing for women. Actually, guys dancing for guys have a better deal, because men do tip more. They make a lot more money in the gay bars than they do in the straight bars. About 90 percent of all male dancers do work in gay bars, whether they admit it or not, because that's where they make their money....

"In the gay bars, the people automatically assume we are there for their pleasure and they can do whatever the hell they want. They are very abusive. They are very rough. They grab anything they feel like grabbing....Most of the women scream and make a lot of noise....

"Some will throw you on the ground and rip the clothes right off you. I've gotten bit. My friend Alicia got a hickey; a woman bit her boob. She got a big hickey right on her boob. In Queens."

Greasa Gal moonlights as a dancer for lesbian audiences. She describes her-self as coming "from an old-fashioned Spanish family." By day she works as a carpenter, and some evenings she performs in lesbian dance nights at clubs in Manhattan's East Village. She has a different view of the lesbian go-go scene. "The women don't tip as much as the men do," she says. "It seems like women still earn less than men, even in this scene.

"There's not as much money in the lesbian community....But it's a hell of a lot of fun. I get $25 for each night I dance, and most of the time I dance for an hour or two. The tips amount to about $15 each night. I don't do it for the money. You have to look at it as extra cash. You do it because you goof around, because you have fun.

"It's accepted to be a ham. You can tell when a woman is used to dancing for men. She bends over and stiffly sticks out her ass like she's ready for sex. That turns me off. I dance like a fag. No come-on gestures on the stage....They [lesbians audiences] like to see an experience that's free, with a desire to make other women dance. We try to get people to smile and dance—there's a lot of energy. That's worth a lot more than money."

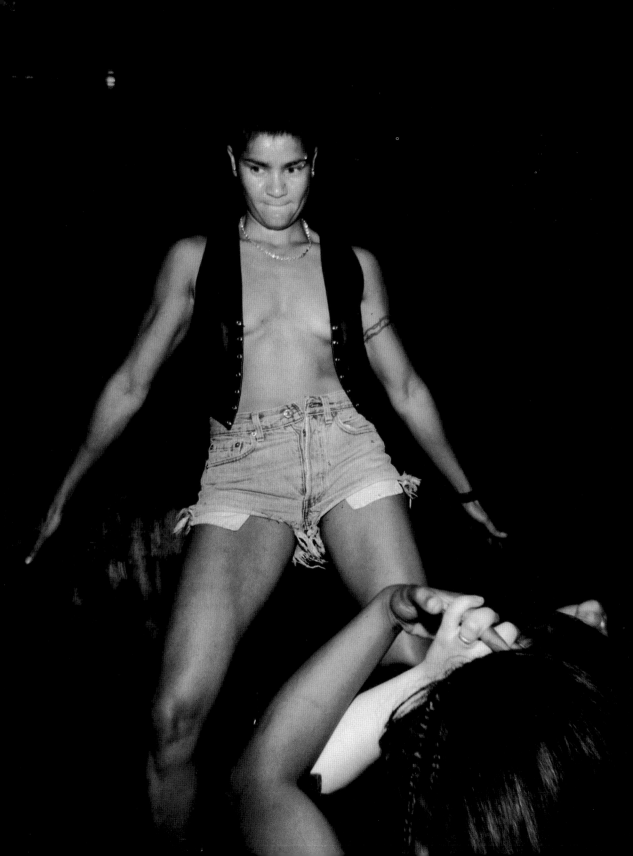

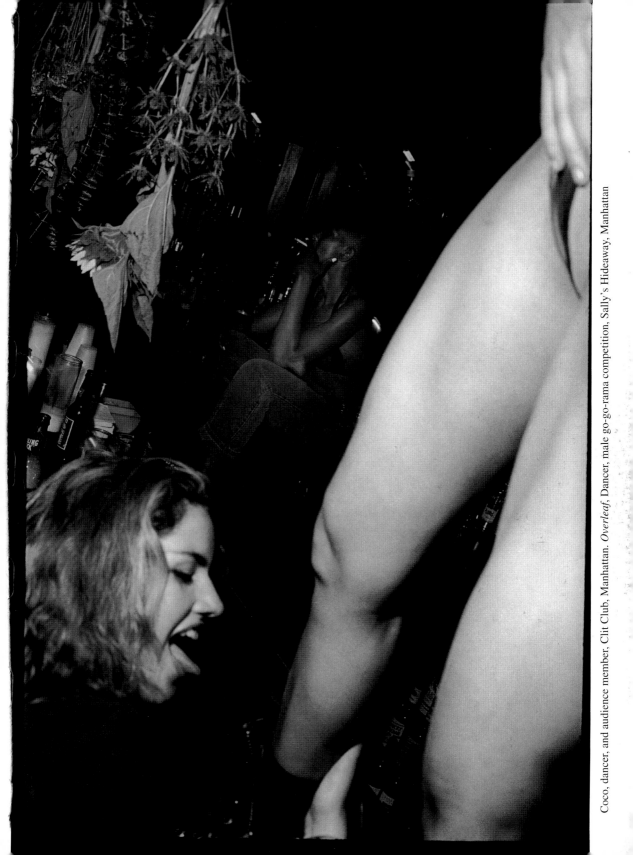

Coco, dancer, and audience member, Clit Club, Manhattan. *Overleaf*, Dancer, male go-go-rama competition, Sally's Hideaway, Manhattan

DANCING FOR DOLLARS

Most go-go dancers are what in another business would be called independent contractors. In New Jersey, the dancers set up their own gigs or get dates through an agent, whose fee is usually $10 or $15 a night. Some clubs insist on dealing directly with dancers in order to secure a handpicked lineup; in other clubs dancers have to go through a certain agent to get a booking. Sometimes agents have a percentage ownership in one or more clubs, and they push their clients into bookings there.

The dancers in Jersey are paid in cash, from as little as $5 to as much as $18 for a set of 30 minutes. An average shift of six hours includes five to seven sets. At times, the dancers receive no payment from the house, and work for tips alone. These tips seldom total more than $200 a night—and are usually acquired a dollar at a time. A hardworking dancer can sometimes make as much as $500 a night, but only if she can hold up for a 12-hour double shift. Certain dancers make much more, and some clubs are more lucrative. But by the mid-1990s, most New Jersey dancers were complaining of lower wages for harder work (and some club owners were even talking about ending wages per se, because, they insisted, the dancers were making more than they were).

Michael describes how he gets paid at the clubs where he dances for women and for men: "We get a fee and work on tips, depending. In a male revue it pays anywhere from $50 to $100, on average $60 to $65. It used to be higher....Before, they'd try to get $100 a guy—if it's a four-man show they'd get $400, and the agent would pay each dancer $65, and the agent will make $35 a guy. Nowadays what they are trying to do is just pay $75 a guy, and the agents will make $10 to $15 off a guy....

"You get paid your straight-out fee and then you do a routine, you do an act. All together your routine will be about 15 to 20 minutes. On an average in these male revues you're making about $50 to $70 in tips. You get about 30 women, and you probably grab a dollar from every girl, maybe twice. You might get a

$5 bill occasionally. So if it pays $65, and you're making $50 to $70 in tips, you're taking home around $120 all together. There are shows where there are 200 women, and you're making over $200 in tips, but there aren't that many shows out there like that....

"If I do a male revue—a straight show—and I get out of there around 11 o'clock, I can go over and do a gay bar and get paid $100 and maybe walk out with $50 to $80 in tips. So it depends. I've also done up to five parties a day. I came out with $650. A party lasts 15 minutes. Without parties, I usually average $500 a week. That's just doing the clubs, four nights a week, and I'm probably in the clubs for a couple of hours a night."

At some clubs—including most of those in New York City—dancers receive no salary at all. "We don't get paid in New York," Donna D. explains. "We pay the house. It's all tips. We pay $35 a night to the house, $5 to the makeup lady, a minimum of $3 to the valet, a minimum of $5 to the deejay. So about $50 is what I tip out every night, not counting my tolls, which is another $10 and gas is $5. So it costs me almost $70 before I make anything."

"The girl who's hired, she's really being pimped," Hennessey says, "because she's got to pay the house $40—$25 is paid to the establishment, then you've got to pay $5 to the B-girl [who serves drinks to customers], $10 to the deejay. You pay everyone's salary....At the end of the night they're giving you what they want to give you. And you think, 'Oh, wow, $700'....You don't know how much the house kept. It's a rip-off. But everyone's happy. The girls are happy. Who makes $700 a night? You're glad and grateful to take that. But you've been robbed. And you've been pimped, because you're paying the house...It's so organized."

DO THE HUSTLE

Whether they get a salary or not, dancers have to hustle to make good money at go-go. And it helps to have an act—a distinct stage persona. Donna D. tries to mold her professional persona so as to attract the men with the most money to spend. "I don't do the bimbo....even though I am a very good bimbo player; it's easy for me. But what I like to attract are guys with money, and nine times out of ten guys with money don't want a stupid little bimbo because when they get her off [the stage] and they can't have a conversation with her, that's it. The money

is cut off....I have a very good following because guys see me on stage and they are attracted to my act—it's fun, and it's happy-go-lucky, no care in the world. When they get me off stage and try to talk to me, it's 'Wow, you're normal. I can talk to you.' They like that."

Donna D. works hard to expand her following, sometimes keeping a notebook of facts about her biggest tippers, and watching for regulars in the audience. "As soon as I'm offstage, I'll run over and give him a big hug and say, 'How're you doing? How's your wife and how's work—how's that proposal?' She also hands out the number to her answering machine. "If they want to find me, they'll call up and I'll say, 'Hey guys. How're you doing? I'll be at such and such tonight. Come see me. I miss you.' They'll show up."

Diane, a dancer who got into the business after her second child was born and her husband lost his job, has developed her own technique of efficiently extracting money from customers. "When I go up to the bar, the first thing I do is I make sure I say hello—not personally, but I walk by and say, 'Hi, how are you doing?' That's the first thing I do. Then, when I get on stage, I focus on getting a dollar. I concentrate on being very sexy, and I concentrate on staring the guy down, because most of the time, the guy's going to give you a dollar if you stare him down. You know, it's not because he likes it; it's maybe because he feels uncomfortable, and he'll give you the dollar to just, you know, to break that stare.

"Or a lot of these men go in there thinking they're going to go home with one of the dancers—which is so foolish because, let me tell you, nine times out of ten, it doesn't happen. But the stare can sort of tell the guy you're interested in him—maybe."

Sometimes the hustle takes place off the stage as well as on it. In certain clubs, women can dance for a customer at his table. These private dances cost $10 and up (a dancer usually gets a little over half) and last the length of a song or two. "At a table dance," says Donna D., "I just grab the guy by the back of the head and very gently rub my lips against his ear. That's it. And [he'll say], 'I'll take another.' That's $20. You always want to try to get two."

"When I'm drunk and I don't really care what they're saying," Kim explains, "I get right in their face. They feel they have to give me a tip; you pretend you're with them. Some men will give you a tip just because you're up there dancing. Then there's the customer that really wants you to work for your dollar. If you still have your costume on, you take it off just for him. You get down on the floor.

Diane, dancer, Dubarnet, Newark, New Jersey

Diane at home with her daughter, New Jersey

It's so ludicrous. They get so much into the fantasy of the whole thing, they don't realize the girls don't give a shit. Know what I'm saying? Some men prefer different body parts. It's whatever gets the reaction. [If he likes breasts] then you start playing with your breasts. You play as much as you can without getting thrown out of the club."

Another technique is for the dancer to move through the crowd, from one man to another, brushing against their crotches for a dollar apiece. Lap dancing—where the dancer rubs herself against the customer for a longer time—brings in more money. This widely popular technique—which resembles the fully clothed gropings of yesterday's teenagers—has been banned in some areas. But what constitutes a lap dance is open to interpretation. And dancers report that in some clubs, arrangements for private, back-room lap dances—and almost any other activity—can often be made.

Then there's the drink hustle, where a dancer will sit at the bar or at a table and persuade the customer sitting next to her to buy her an overpriced mixed drink (which is sometimes nothing more than soda). In some more upscale clubs, the dancer persuades the customer to pay $75 for a bottle of champagne. He then gets a private dance or a private visit in the back room. The dancer gets a percentage of the price of the champagne. "Drinks are the big rip-off," says one dancer at a New York club. "If you sit there with one beer for two hours they'll ask you to leave."

In many of the high-priced clubs, the owners maintain control over the cash flow by issuing the customers a kind of scrip, or "play money," to be spent on the drinks and the women. "Play money is an option if you want to charge it on your credit card," says a dancer who works at an upscale Manhattan club, "and that's like the biggest scam. The club charges a percentage to the customer—a 10 percent service charge—and they have to buy a minimum of $50 in play money. Then, when the dancers cash in [the play money they have received from customers], they charge 15 percent to the dancer. We're paying more than the customer....In Manhattan it's more businessmen, more corporate expense accounts. So most of it will be charged. In Queens it's more of a local place. There is a dress code, but guys do come in a little more grungy and it's a cash thing."

By issuing play money, clubs cut down on private cash transactions between dancers and customers. Because they serve as the "bank," the clubs can be sure

that they will always get their cut. "You're not making the money," says Hennessey, "because most of these clubs have play money. For instance, they tell the customer it's $65 for champagne. You've got a B-girl, the girl who goes around with the tray serving the drinks to the customer, to the fucker. Here I am, the dancer....I've already winged the fucker, right? We're sitting down at the table and I'm rapping to him. Oh, he wants me. Bottom line is he wants to fuck me, right? I'm yanking on him under the table. But there's a room in the back where you can take him for a private lap dance—if you buy that champagne. The champagne is $65. But it's not really champagne. It's bubbly. It fizzles. The customer from out of town, the conventioneer, the sailor, he doesn't really give a shit. He knows it's not champagne. He's only concerned with the babe. He could care less. He knows he's got to splurge. But the B-girl, she transforms his $65 into something called play money. Because the house is never actually going to let you see your whole $65....You never see it, because they collect the money as play money, and then they pay you." The dancer, says Hennessey, ends up with perhaps half of the money she has earned for the club.

The dancers are constantly confronted with choices about what they will and will not do to hustle some extra money. "I don't flash my pussy," one dancer explains. "I'll show a little nipple but never flash pussy." Another says, "I'll flash, but I don't want them touching me. Sometimes I'll let them touch my pubic hair, but they can't go any further."

Sometimes what the dancers do as "side work" is borderline prostitution. "I wouldn't say I never crossed the line," one dancer says, "but I'm not quite sure what the line is....A lot of [dancers] are kept. They have one customer who will give them a lot while they're on stage and then later set them up in an apartment and take care of them. There's more of that than actually leaving the bar with a man. In some places there are back rooms."

"[The club owners] were always trying to fix you up with one of their friends," another dancer says, "Tony or Guido or Denny or something....I am sure they would have accommodated a blow job in the ladies room, if you were willing. And of course, in that business you get propositioned all the time, all the time. Whether it's $50 or $500 or whatever. They might want to buy your shoes and drink beer out of them or sniff them. Some guy bought my G-string and put it on his face, and masturbated. He paid $75. It's always a good thing for a go-go girl to have extra G-strings and extra pairs of shoes."

Sometimes dancers try to supplement their income by doing bachelor parties, which bring in about $150 for two sets. But this is usually nude dancing, so a bouncer is a must for protection—and he costs at least $50. At a bachelor party a dancer can always hope for tips, but most men want to touch the women in exchange, and things can get out of hand—as they did at a party for cops, when one dancer was grabbed, turned upside down and, with her legs spread, carried around the room so every cop could make his own investigation.

Some dancers will do blow jobs or hand jobs—in the back room, in the parking lot, or later at the man's apartment. Dakota, a dancer and prostitute, described her feelings on a slow night: "I didn't make shit. I only did four sets. Like, I would have really liked to pick up a date tonight....Even for a hundred bucks I would have done it."

Dynomite and Ivory, performers who live and often work together, ensure themselves a steady income by being involved in many different areas of the sex business. "I have a full-time job as the publisher of a magazine called *Black Tail*," says Dynomite. "Then I dance at local clubs and at bachelor parties, strip-o-grams, boys' parties, birthday parties, girls' parties, all types of parties....I am an agent for other girls....I do videos as well. Whether they are girl videos, lingerie, S/M, or massaging videos. And I do massages on the side. So I juggle a lot. If business is not good in one area, then I can go on to another. I always did more than one thing. I'm a Gemini, so I juggle more than one job."

GODFATHERS OF GO-GO

It is conventional wisdom that the mob dominates the go-go business in New Jersey, but it is impossible to know precisely which crime families are involved, who controls each club, or how much money the business yields for organized crime. This, of course, is no accident.

As Marty, a former go-go bar manager, explains, the mob-controlled bars are almost always owned by front men. "What happens is, you can't own a liquor license if you have a record, if you committed a felony—at least in Jersey and New York. So most of these families, on paper they don't own the bar. They get some schmuck to buy the bar, and he actually runs it. If the government looks into it, they don't find out who the real owner is because everything has this schmuck's name on it. The families that are involved are big, but they have

so many interests that this is just one of their little, you know, nest eggs."

For Marty, managing a go-go club was an entry-level position in the mob. Gradually, he began to participate in the real business of the place: guns, drugs, prostitution, and especially gambling and loan sharking. "They would get me to lure the customers into things like gambling and betting and talking about sporting events, and I would ask them if they were ever interested in gambling, and if they said that they were, I would actually take their bets for them. Most of the time I would let them win a couple of times to lure them in, and then the gambling fever would take hold and most of them ended up losing a lot of money."

Part of Marty's job was to help the mob collect from delinquent customers. "Like, as soon as the customer walked in the bar, I would have to beep this guy with a code, and then this guy, he would tell me to keep the customer there. So I would keep him there by giving him his first drink for nothing, and then I'd try to get into a conversation with him to keep him there until the guy got there." The mob collector would take the customer outside, where the collector would "get physical with him."

Marty observes that the clientele at most go-go bars represents a ready-made market for other mob activities. "I have a theory that they prey on go-go bars, first of all because of the variety of people that come in. From your 50-to-60-year-old businessman to your 20-year-old punk rocker, you have diverse amounts of people that come in. And it seems like they're all involved in at least one of three things: women, drugs, or sports." In addition, the entertainment at the clubs provides cover for these other transactions. "A lot of people who go into go-go bars don't even look around to see what is going on," Marty says. "They're too busy trying to pick up the girl. I mean, there were sometimes four and five people going into my bar to do coke in the bathroom, and no customers ever came out and complained to me about it....

"You'd be surprised how quick money changes hands. They are very shrewd about how it happens. This guy told me, 'If nobody sees money change hands, they can't prove anything was done.' Like if it's a drug sale, all right, you can get arrested on coke possession, but that is a lot better than getting charged with intent to distribute. That's why I think the girl gets involved, because she can play interference. The girl's up there shaking her ass, shaking her tits with no clothes on, people aren't looking at what Joe's doing in the back with Tom. They're looking at what is going on onstage.

"And that's why I think [the mob] uses go-go bars. Because most guys that go into these bars, they don't give a shit about what's going on there, as long as they get to see the girl naked onstage and try to get ahold of the girl. They don't care if there is a riot going on in the back."

Sometimes the women are used more directly to aid in making deals. "What they'll do," Marty explains, "is call the girl over and make friends with the girl, and maybe the guys they're doing business with will go out with the girl a little bit....Keep the guy in a good mood. They use the girl as a pawn. I think they know the easiest way to get to a guy to agree is through his dick. They would have their arm around the girl, and they would tell her, 'Say hello to my friend Tony. Say hello to Vito. Come on, honey, go up and say hello to them.'"

One of Marty's jobs was to provide women for friends of the owners. "I had to pretty much guarantee that the girls would give them whatever they wanted," he says. A dancer at another club states: "Guys would come in and tell me I am with them. These are guys you don't say no to." Once a friend of the owner arrived and, after inspecting all the dancers, picked her. "I had to stay with him. I had no say in the matter. I had to stay with him until he got ready to go. I was not allowed to move. I wasn't allowed to go to the ladies room. He gave me $100 for my time. Three hours. I lost a lot of money. Everybody is disposable in this business."

Becoming the girlfriend of a mob figure can be a dangerous proposition for a dancer. "I don't think these guys will ever confide in them about anything serious, so I don't think it would be worth their lives if it didn't work out," Marty says. But he admits that sometimes dancers can just disappear. "The girls you don't see any more, it's because these girls found something out or were let in on it, or maybe overheard a conversation about something that was going down. Then if the girl wants to turn around and get out...they'll get rid of her or whatever, because they can't take the risk of this girl opening up her mouth to the government. There are a lot of government people sitting around just waiting...

"And if they're hooked up with somebody that is in the mob, there's no way they'll ever fuck on the side, unless that guy okays it. Sometimes the guy pretty much plays pimp. But if she's being taken care of by someone in a family, there is no way she is going to turn a trick in the bar. Because she is dead, and the guy she did it with is dead. Because [fidelity] is one thing the families value very highly."

HIDDEN COSTS

In addition to the payouts to club owners, bartenders, and deejays, go-go dancing entails a lot of occupational expenses. "I used to get my hair done every two weeks—$100 every two weeks," says Dakota. "I get a pair of shoes every other week when I work a lot. They wear out, and they don't have enough support. Some people like old shoes that are broken in. I like new shoes. When I'm dancing and I'm drinking, I'm stepping on my own feet. Once a month I need all new makeup. When I used to buy good makeup, I spent $300. Now, I'd say $100. Then, it's at least $100 a month for tanning. I go every other day. When I'm working at the big bars, at least once a week I buy three outfits. The sheer stuff, it snags and pulls and gets ripped real easy. That's about $50 for an outfit, right? I've had one night where I spent everything I made, which was $300." In all, Dakota spends well over $1,000 a month to keep herself looking good for dancing. In addition, she says, "I could spend $40 a day for a driver. And then spend $40 a day for a baby-sitter."

There are other hidden costs to being a dancer, body parts being the most expensive. Many dancers have had their breasts augmented with saline or silicon implants. These operations run from $3,000 on up. Some of the glitzy chain clubs will pay for their dancers' implants, but usually the dancers pay the cost themselves, as a career investment. Increasing numbers of dancers seem to feel that they need to have their breasts enlarged to survive in the business.

"I've got new boobs," says Lola. "I've been told that when a woman is over 35 in the sex industry you either have to have blonde hair or big boobs. I didn't want to go blonde so I got the boobs. And I love them. I always wanted them. My mother had big boobs. My little sister had big boobs, and I was short-changed in that area. I am so fucking grateful. Every time I look in the mirror I get on my knees in gratitude."

Another dancer experienced serious problems after she got her breasts enlarged. "I almost lost my whole career one year because of them. I got them done with saline, and I got them done large, because I figured if I am going to do it, I might as well really do it....It balances off my body because I am a big broad. It cost $5,000....Everything was fine for the first few months, and then I developed a sore spot in my left breast and it started growing. It got huge....Between

the implant and my breast, there was just a sac of fluid. They drained it and test-ed it, and it was infected. I was out of work for two weeks the first time, and later I lost another month of work....I had one more treatment with a killer antibiotic, and I've been good for a while now.

"If they have to take these out my career is done and I'll go back to bartend-ing and a normal life....Now [my breasts] are stretched to a double-D. If you take out the double-D filling, it's like having a water balloon that's been stretched out and now it's empty and kind of flapping in the wind." She says that if she had been in another line of work, she would not have had the surgery. "It wouldn't have been an issue. I have a fine body. It's just that when you're competing against 18-year-olds—it's tough. I'm thinking about having my lips done."

Male dancers also rely on artificial means of enhancing their bodies—both surgery and steroids. "Guys who are 25 years old have cosmetic surgery," says Michael. "Everything: cheek implants, chin implants, pecs, calves, color con-tacts, hair....They know as they get older—they realize, 'I'm not going to be doing it that much longer.' Color contacts are cheap, like $99. Pec implants for a guy have to be at least $2,500, $3,000....

"With the steroids, they don't know what the hell they're buying. Half the time instead of buying some kind of methotestosterone, they're buying estrogen. All of a sudden they start talking like a girl....And for just a six- to ten-week cycle of steroids, you're talking about $300 easy. That's just for one drug, but these guys are stacking. They're taking three drugs at a time....Of all the guys I work with, I'd say at least 98 percent have done them at some point, and 90 per-cent are on them right now.

"There's no reason for it. Dancers are very lazy people. They want easy things out of life. That's why they rely on steroids. They spend all their money on their drugs, whether it's coke up their nose to make them feel better about themselves, or steroids. They know they're losers. The steroids give them a lit-tle hype to make them look good."

"An interesting phenomena I'm beginning to find," says Mary Nolan, a psy-chologist who treats sex workers, "is the amount of plastic surgery that's required on the girls to make them palatable to themselves. The ideal sex work-er is an anorexic with breast implants, hair extensions, and false finger-nails....You get your ears done, your eyes done, your nose done, your chin done your cheeks done, your face peeled, liposuction, hip implant, butt implant, calf

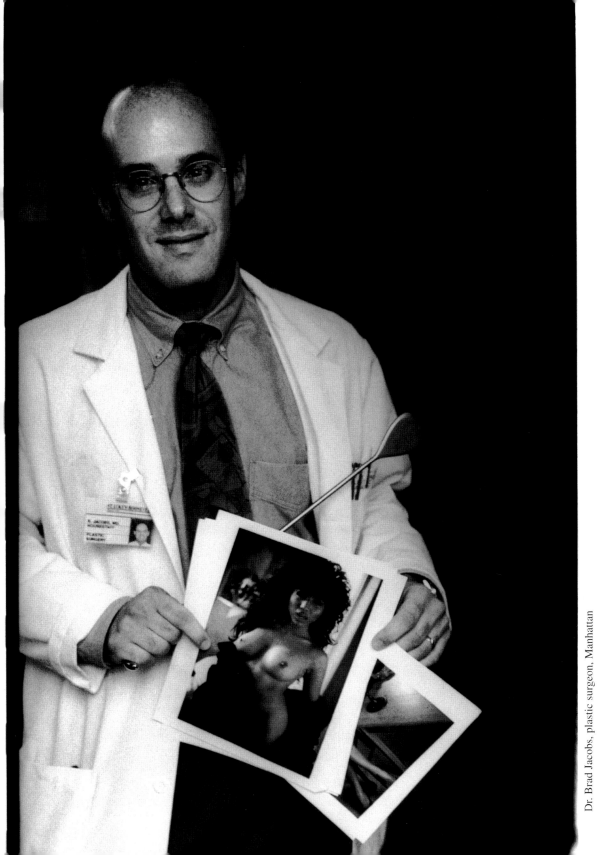

Dr. Brad Jacobs, plastic surgeon, Manhattan

implant. It's really phenomenal. It depends on the girl, and I see that as they continue on, and the more work they get done on themselves, another dynamic starts to set in. The more work they get done the angrier they get at what they're doing, and the more successful they become; there's an angry component to the actual work which is very seductive for both parties."

Some plastic surgeons have developed a special following among dancers and other sex workers. During the early 1990s one plastic surgeon, Dr. Brad Jacobs, reported performing a variety of cosmetic surgeries on New York sex workers at the clinic of a large city hospital. According to Jacobs, the breast augmentation business has boomed in the last few years. "There had been one to two a month, and now we're at four to six a week....The price two years ago was $800. Then it went to $1,500. Now it's $2,600. When we raised the price we got rid of the 11th Avenue prostitutes....

"We do them through the belly-button, through the armpit, or through the breast," Jacobs says. "My favorite is through the armpit. It looks and feels the best the longest. I want them to look great forever—at least 10 to 20 years....It's a same-day operation, ambulatory surgery, 43 minutes. I don't want them dancing for a month, and I don't let them smoke two weeks before and two weeks afterwards. If you smoke you don't heal....It takes six weeks to settle and I don't want them showing my work before that."

For some of the sex workers who come to see Jacobs, he is their only contact with the medical establishment. "I try to get a really good relationship with my patients. My beeper is always on. I always have my phone with me....I have all their numbers in my little brown books....None of these folks have insurance. They call me for all their medical problems...for sore throats, accidents, sexually transmitted diseases. Whatever it is I take care of them."

Jacobs's cosmetic work extends beyond breast jobs. "We do anything that is in the imagination. Take a recent 27-year-old. We start from the top down. We raised her brows. We raised her eyes. We added fat to her face. We made lips. She looks much nicer....

"We can do liposuctions anywhere on the body. If they've got extra fat up here we can take that down....I also do lifts. We sculpt their abdomen....Rear ends we do with liposuction. We try to make them look like Brazilian or European rear ends. Nipples? We make them smaller or bigger. Vaginas? We've been asked but haven't done it yet. But if things are a little loose we can tighten

them up....I can't look at anybody without saying, 'What can I do to fix them?'

"A lot of people come back. As long as it's on a positive course, where they didn't feel that good about themselves to begin with. They need something simple like a breast augmentation. But they say, 'I'm still not pretty.' Something bothers them like their nose. I don't force any procedures on anybody. But if something's staring me in the face, I'd say, 'How would you feel if your nose were a little thinner?...

"I still hope I'm doing it for the women....I don't know whether I'm giving the girls what they want, or the guys what they want....Nobody meets the standard of what beauty is or what is desirable. Very few people fit that mold any more, and the rest of them have to come for plastic surgery."

PERSONALITY PLUS

Go-go dancers are as diverse and individual as people in any other profession. But to succeed in the business, they often have to attune their personal styles to the tastes of their audiences.

In many of the upscale New York City clubs, the dancers have a faux-elegant casino showgirl look, often appearing in evening gowns. These clubs shun the tattoos, body piercings, and black leather costumes that often appear on dancers at the grittier downtown clubs. In New Jersey, the clubs will take just about anyone—although many patrons like big breasts, tall hair, and lots of nail tips. In the urban areas of New Jersey, where there are more Italians than in any other state, along with a substantial population of Latinos, clubs favor brunettes; in the more rural areas, blonds still reign supreme.

Go-go dancers increasingly represent a broad racial mix. But most white women still have an easier time getting bookings, and in the clubs, as in most lines of work, they often make more money. "Across the board, it holds," says Hennessey, who is black. "Let's be real here. It holds. For the ones who meet the criterion in terms of skin tone, it's a fortune every night in some of these clubs. You can make $700, $800, $900 a night. For the dark-skinned girls you're lucky if you get off with $200 to $300. But you have to hustle your ass off. You got to pull on some yang yang in the corner. You're really busting your ass."

"You might be beautiful," says Dynomite, another black performer. "You may have the best body, and you might have the best act, and the best costumes,

and the best presentation, but because the white girl come along and she is white, she gets the job. Or she'll get a higher salary or she'll get to work less."

Even among black women, Hennessey says, skin tone can have a significant impact on work opportunities. "Black—we're talking about different classes of people among the black. Your dark-skinned dancers, they are the ones that suffer the brunt of the discrimination. Not the ones who can possibly cross over; they can play both sides of the field. I can put on change-of-color contacts and alter the color of my hair, but my skin tone will remain the same—understand what I'm saying? Whereas if you're fair complexioned or Latino in appearance and put on hazel eyes or blue eyes and a blond wig, one would never know. There will always be a big question mark that will remain. Not for me."

"A lot of clubs don't like to use black girls," says Karen English. "Because they're black. But we have no problem with them at all. Some of them are beautiful. I book a lot of clubs that will take no black girls. If you talk to any black girls about this business, they'll tell you they have a hard time finding work."

Dancers from Brazil have become quite common in New Jersey. "They're easy," says English. "They work cheap. They work for nothing. But they're starting to clamp down now because of the immigration law. We card everybody. We don't want immigration coming in here. They close you down for 30 days....I hire mostly Americans, whether they be Oriental, black, or whatever. I hire American girls. I just feel like this is America for American jobs."

Most suburban club owners, however, welcomed the Brazilians, as well as the most recent influx of new talent, from the former Soviet Union. The Russian, Ukrainian, and Lithuanian women appeal to the customer's fantasies, still shaped by the Cold War, of sexy KGB agents and ice queens. Handled by a tight group of Russian agents—some of whom travel regularly from New York to Moscow to recruit new women for the American club circuit—these dancers are performing in large numbers at Jersey clubs, which initially announced them with signs saying: "The Russians Are Coming!" The other dancers are less delighted by the foreign invasion that's undercutting their income in what is becoming, more and more, a buyer's market.

At times, there is considerable competition for go-go jobs. "Personality on stage is a big plus" for a go-go dancer, English says. "Like today, I sent this girl to Uncle Charlie's in Linden [New Jersey]. She had an earring in her nose and

Dahlia, dancer from Lithuania, go-go club, Newark, New Jersey

one in her nipple. And the manager calls me up and he goes, 'What are you fucking blind? This girl is ugly.' I said, 'Wait. Wait until she puts her makeup on and wait until she gets up on the stage.'

"So he calls me back and says, 'You know what? This girl is gorgeous.' That's the way it is. With me, I like girls with personalities. I can't stand girls with big attitudes. I won't tolerate that. I fire them. I fire five girls a week."

English says that the women who dance have "improved" over the years. "When I first started dancing these big ugly fat women were dancing. They were hideous. That's why it was so easy. Nobody danced. Now you're competing with 18-year-olds who've had nose jobs, boob jobs. That's what you're competing with now. I think most dancers have their breasts done, their nose done, their lips done, their eyes done." But English laughs at the often-touted suggestion that many of the dancers now are college girls. "College girls!" she snorts. "College of what?"

Most go-go dancers say they aspire to being something other than go-go dancers. And all have lives outside of the go-go clubs. Many dancers are single mothers, who keep their work secret from their kids. Some are grandmothers supporting extended families. And a few really are college girls.

For some, the strip scene is a way up the ladder from the streets—a step up from street prostitution or massage-parlor work. For others it is a tightrope between the mainstream world and mental breakdown. Most of all it's daily money—for drugs, a kid's new shoes, or a new transmission in the car that gets you to the next club date. But women often talk of using go-go dancing as a way to another world. They dance by night to get the money to go to school, start a band, or look for a professional job.

For Dynomite and Ivory, dancing and other types of sex work are strictly a means to an end—an early retirement and a financially secure future. "You can't do this forever," says Dynomite. "That's why we're working so hard now, so ten years, or eight years from now, or whatever, we will be very comfortable financially. Then you'll able to pick where you want to live at, and have your security, and you don't have to worry about, oh, when the next bill is going to be paid, which becomes a real big hassle when you're older and you have more health problems and so on. So if you're financially comfortable, then everything kind of smooths right out...."

"Being able to enjoy the money—that would mean I could get to travel, get to meet nice people such as yourself, and pay for my college education, and take care of my family, and get homes, and cars, and boats, and everything that I desire. And invest in stocks and mutual funds, and all that good stuff. So that really turns me on, because I know when I get old and gray, I have something to look forward to."

GO-GO BURNOUT

Most of the dancers seem to feel deeply ambivalent about the work they do. Dancers from all levels of the go-go business have stories to tell about the dancing life—and how they got into it, whether they want to get out of it, why they do it, and what it does to them.

"I can relate to a lot of [the dancers'] problems," says Karen English, who came to the United States from England and has been in the business for over ten years as a dancer, agent, and club owner. "I understand go-go burnout," she continues. "I understand hating the men. Every club owner to me is a woman-hater. They all disrespect women. Dancing does that to you. It fucks your head up—a lot. You get used to making this money. You're a sex object on stage. You get off stage and in your real life you don't know which way to go. It can really mess your head up a lot.

"I've been a successful go-go dancer, and I have problems. Definitely. I just now started dating a guy eight years younger than me for the first time in near-ly a year. I would not go out with anyone after I quit dancing. I would not be bothered. I was very burnt out. I would get up on stage and cry. I couldn't do it no more. I didn't want to be bending over no more. Didn't want to be shaking my boobs no more. Didn't want to be smiling at these guys. And I developed a very bad attitude. My [business] partners sent me away at Christmas to Europe, and they said, 'You better come back with a better attitude.' Because I was bad. I hated all men.

"The dancing spoils you. It spoils you fierce. I used to go to work and make $600, $700, $800, $900 dollars a night. You get this big head. You're on stage and it's, 'KAREN ENGLISH!' And you think you're something. Cindy Crawford. But you're only a go-go dancer bimbo. It does a lot of good things and bad things. But I don't regret it. It's been a great ten years."

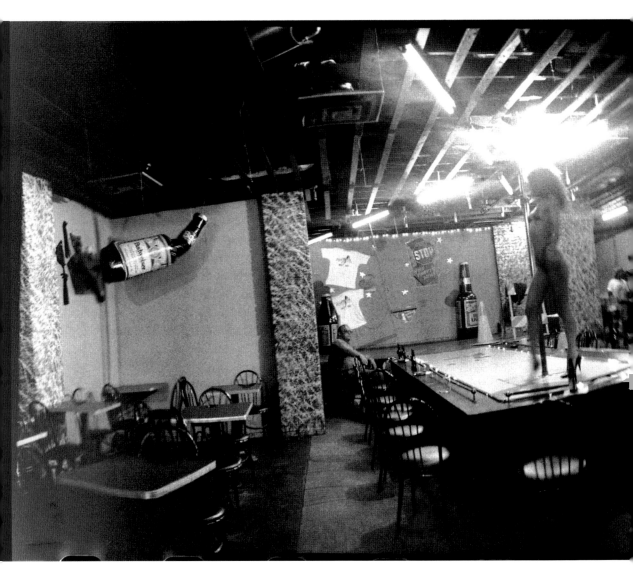

After Dark, Newark, New Jersey

Susan Walsh, who has been in and out of the business for over a decade, describes some of the contradictions she believes dancers face. "Women are there projecting images of sexuality which usually are very much in contrast to what they feel inside themselves. They are the recipients of anger when they don't follow through on what they are projecting—and in the way that many of them were abused as children, often sexually, it makes them angrier, but it's also familiar. Like they are back home again. It's like the child when someone comes in and says, 'Did your father beat you or touch you?' and the child says no, thinking to herself, 'If I'm just better everything will be OK.' It's this kind of familiarity....

"What the women think they want is a healthy thing. They want to get paid, they think they want to tease, they think they want to have power over men. But what they really want is that mixture of winning and losing, that mixture of power and lack of power.

"The men want to be teased, and they think they want the women to come through. They think they want the women's phone numbers. But what they really want is that futility. It keeps them coming back for more. It keeps them in that safe fantasy world, which is very submissive—which is the same thing as a masochist going to a sex club and saying to a woman who's just walking in, 'Let me suck your toes,' and she says, 'Get away.'"

Dakota describes how she feels about her stripping work: "You know, sometimes when I'm overworked...I get sick of these fucking guys with their hands all over me all the time. Some days I just don't want to fucking be touched. And some days I don't want to put any fucking makeup on. I don't want to put on makeup every goddamn day. Or put on hair, or put on nails.

"One time I was dressed up more like New York. I had this leather vest on, combat boots, and a mini skirt that was not even really short, zipped up the front. I stopped and asked directions to a girl's house and the guy said, 'What are you, a go-go girl?' And that just kind of pissed me off. 'Cause that's not all I am. That really pissed me the fuck off. I'm like, 'What are you, an asshole?' I said, 'Either give me the directions, or get the fuck out of my face!' Actually, I said, 'It's none of your goddamn business.' Then I was only dancing one or two nights a week, so I didn't really consider myself a go-go girl. I considered myself a mother."

Donna D. got into the go-go business in the late 1980s, when she was in debt and was fired from a job. "When I first started, I got sick on the way to work every day, every single day. I had to pull over. I was so nervous. I just didn't want to do it." Now she dances three to five times a week. "It's hard. My bust weighs so much. Being topless for that amount of time really hurts. There's the physical thing. But then you also get the mental shit: How many more stories can I hear, how many more times can I smile when the guy's breath smells like a goddamn sewer? It's really hard....You have a fight with somebody. You're sick. You get your period. Your manager just pissed you off. You're dancing with some girl you totally hate. The guys really smell....Four or five days a week for five years. I'm numb."

Donna D. says that it is difficult to have intimate relationships with men who are not themselves involved in the sex industry. "Actually, it's better being involved with somebody in the business than outside the business. [With guys who are] outside the business I feel I am always working. They get the attitude, 'Well, you're like that for everybody else,' and I have to be more than that at home....Most guys love a girl who's in the business until they fall in love with her, and then they want to take her out of the business."

Lola, now in her late 30s, began working in the sex industry after escaping to New York from an abusive family situation at the age of 18. "I saw a job in the *Village Voice* help-wanted ads for a barmaid," she says. "You can always tell it's a sleazy joint when they say barmaid. Otherwise they'll say 'bartender/male or female.' But barmaids, you know you're going to be running around with your bird hanging out. And they said something about wearing leotards, and that's another dead giveaway. I started tending bar, and it didn't take long to see who was making all the money and who was getting all the attention. I wanted all the money and I wanted all the attention....

"My first dancing job was a place in the South Bronx. An agency, run by these two dysfunctional wannabe mobsters, Eddie and Angelo. One of them thought he looked like Clark Gable, and if you wanted good bookings you had to agree with him that he looked like Clark Gable. Anyway, I was a small-town-girl and I didn't know where the South Bronx was. They gave me directions. I took the subway and I got out, and I said, 'Oh, fuck, where am I?'...So I worked in this place, and guys were stuffing money down my G-string; I knew I'd arrived.

"I'm a very different person than I was when I started. I am a recovering alcoholic and drug abuser. So I just need to take care of myself. The dancing's great. I love the exercise I get. I love music. I love to dance. I love the attention. I am a performer. I love all of it. I love the male adoration...."

But Lola has also struggled with the downside of dancing. "There is this one place I'm working in, it's a real toilet. Mom and pop runs it. The wife wears a turban because she had chemotherapy and all the hair is falling out of her head. She still smokes cigarettes. And when I wear see-through outfits she makes me wear Band-Aids on my nipples. She says, 'Don't bend over like that!' There is a stage against the wall. It's a real shithole. And on top of the stage there's a sign—you know, like your mother might have in the kitchen, like 'Bless this Mess.' There's a sign there that says 'Butcher Block.' That says it all."

Angel is a 52-year-old dancer who got into the business late in life and has remained in it long after the usual retirement age. Born in El Salvador, she married at 15 to escape sexual abuse by her grandfather and moved to the United States. After her a second marriage ended, she turned to dancing as a way to earn money. Angel now lives in a motel on the Jersey shore, sharing her single room with her 20-year-old son, a born-again Christian and heavy metal guitarist. She makes a meager living dancing in New Jersey go-go clubs three to four times a week. She doesn't say so directly, but she has a harder and harder time persuading managers to let her dance.

"It wouldn't be bad, dancing," Angel says. "I love music. I love the feeling of dancing, I love the stage. It used to be better. But now it's gotten to the point that they just look at you as a piece of meat. You're not there with a heart.... I want to live a normal life, but the way people treat dancers, it's just low."

When people ask her age, Angel says, "I tell the truth sometimes. One guy says, 'How old are you?' I say, 'Well, old enough to know better.' And he goes, 'How old are you?' And I say, 'Well, I'm 75, I just look good for my age!' But then when I tell them the truth, that I'm 52, they go, 'Gee, you look fantastic for your age.' I'm not embarrassed....The way I look at it is, everybody is beautiful, you know....It's hard, because there are a lot of young kids. But you know what? I know how to dance. I don't let my age stop me. I dance pretty good.... I dance hard. I do splits, I do everything....I've been lucky that way. But I'm getting to a point now—I have to stop soon."

The go-go business is not an easy business to grow old in, and most dancers are forced to find other means of support as they approach middle age. "I am a veteran," says Hennessey. "I am a seasoned performer. [But] the club owners...they don't know and they don't care. Because it's about the young babes with the silicon-city tits and ass. The veterans usually go into costume making. Or they become choreographers or they become agents. That's where the veterans go....Or if you were a real party girl, getting high off the booze and high off the drugs, you're probably on skid row. No teeth. With AIDS. You're—dead."

But despite their sometimes negative feelings about their work, many dancers find that it's not an easy business to quit by choice. "I know girls who have been in it so long that every time they stop, they go through attention withdrawal," says Ron Athey. "Like no one gets that much attention walking down the street as they do crawling across the table. It just changes your whole life to be in it or out of it."

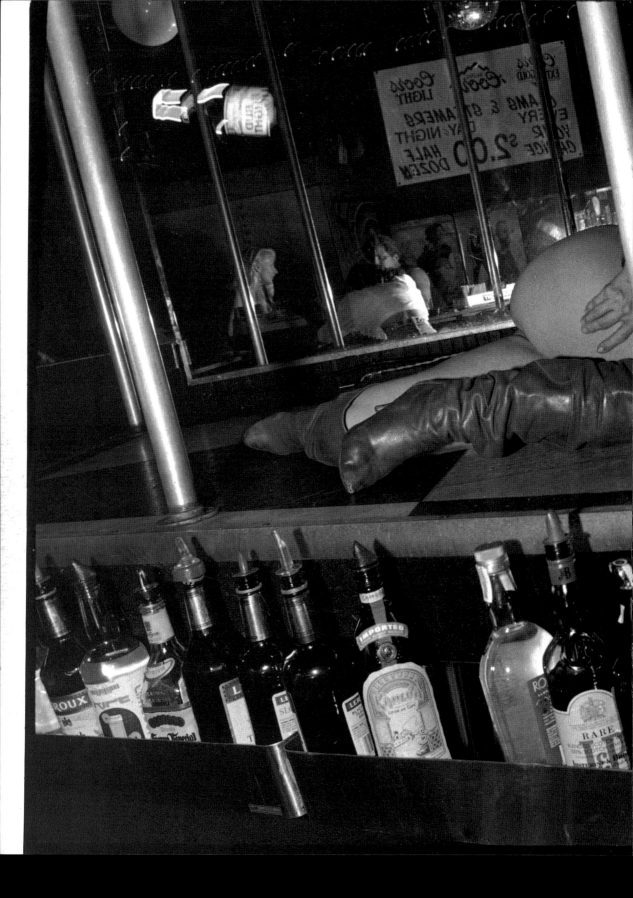

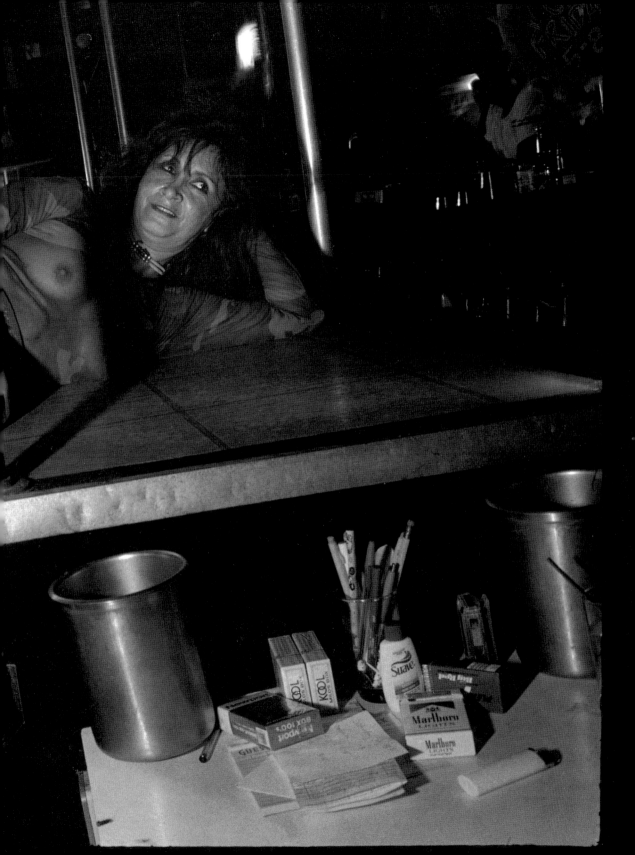

Hunts Point, the Bronx

DOING IT

Of all sex workers, it is the prostitute who stands as the archetypal figure—the ultimate object of romanticization, revulsion, and scorn. Within what is commonly described as prostitution, there is a vast divergence of experience: At one end of the business are high-class call girls who are kept for $500,000 a year or more; at the other are homeless street prostitutes who get $5 for a blow job. Yet all of these women are similarly branded with the mystical title of "whore."

Even within the sex industry, workers who perform prostitution—those who actually engage in physical sex acts with their clients—occupy a special place at the bottom of a professional hierarchy. Many women who work in the porn, S/M, or go-go worlds are quick to separate themselves from prostitutes. They may pose or perform, they say, but they would never actually have sex for money. The same goes for the people who run these businesses. They are not pimps, they insist, and their establishments are far from brothels.

But for Rebecca Rand, a well-known Minneapolis madam, such distinctions are disingenuous. "They keep everything real clean," she says of the high-class strip clubs. "And they say, 'We're legal. We're not whores.' No. You just get the men all worked up, and they come down to the sauna. You're the warm-up act. If you can make $300 or $400 without turning a trick, that's what you do. Then the guys will have to go down the street where the girl maybe isn't that gorgeous and doesn't dance that well, and spend their last $100."

The distinctions made between prostitutes and other kinds of sex workers may also be, to a great extent, fictional. As Hennessey insists, much of the real money at the go-go clubs is made by dancers doing prostitution on the side. "During the day, we're talking about the lunch-hour crowd, Wall Street executives who come in to see some tits and ass," she says. "But the money is being made at night. You know the old phrase—the freaks come out at night. They transform. It's dark. The sun's going down. They can lie: 'I am detained at the office—a late meeting.' That kind of crap. They all say there is no sex. Bullshit.

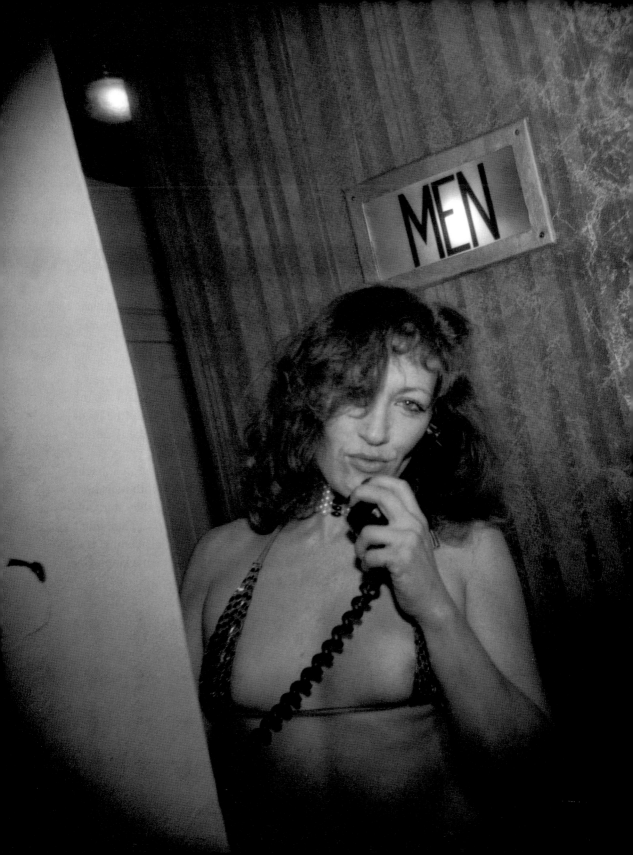

Bullshit. The bottom line is how many can you fucky-sucky. The freaks come out at night. That's when you make the money, in the corner in the dark…under the table yanking on his dick, smiling in his face."

SIDE WORK

Despite their assertion that go-go is only a bit of "good clean fun," many strip-club owners tolerate—or even encourage—prostitution (or "side work," as the dancers call it): a blow job or a hand job outside in the parking lot, or a quick one in the back room. According to former go-go manager Marty, many of the dancers sell sex on the side, and the clubs often take a cut. "There was a place where the customer would lay the money out on the bar, the bartender would take it. She would place it on the register or whatever, and about five minutes later the guy would go in the back room where the girl was waiting. Or the guy could have $40 sitting under his bottle, and leave it as a tip.…Now, if there's a cop in there, how's the cop going to bust her for prostitution? He doesn't see the money change hands with the girl.…Even if there was sex going on, [the owners] are going to say, 'What's wrong with that? Hey, I own this place. I can let sex go on in my establishment as long as it's not prostitution.'"

Marty says that some club owners also take a cut from prostitution at bachelor parties. "That's easy money. All cash. And you can get away with it; as long as the cash register at the bar isn't open, you can't get busted.…So they start collecting money two or three weeks before the thing is to come off. They don't want any money changing hands at the time when something is happening. It is the same thing with the girl. If she is gonna go blow the guy in the back, the guy will never give the girl the money. He'll give it to someone else."

While many dancers keep prostitution as an occasional and hidden sideline, a few do just the opposite. Dakota uses go-go to meet men, and then turns tricks. She lives with her two young children and her boyfriend; when they get stoned, it turns him on to hear about her work. She drinks and does drugs, and says that is what basically gets her through the day. She says she was abused by her father when she was a small child, and has been having sex—giving boys blow jobs, for example—since she was eight years old.

According to Dakota, "Most of the men who pay for sex are submissive. Many of the men I date are married and their wives are very normal. When they're with you, they want to bring toys into the bedroom. Put them inside you. Dildos. They want you to wear stockings and leather.…But you know what, once they come, they don't want anything. And I have one guy that just wants to eat me." Dakota tries to get $300 an hour for prostitution, but will take $100 an hour if she really needs the money. Her hour starts from the moment the date picks her up. In a good night she makes $600.

Dakota sometimes works bachelor parties. At these parties, "if you don't do side work, that's when they all get mad, because they want it. My girlfriend gives the blow jobs. I do the sex.…I don't like to give blow jobs. It grosses me out.…I don't want to smell his balls! It smells like foot odor shit! I been with a lot of women, and even if a girl don't clean and she's got an odor, she don't smell like no dirty feet!…What I do is I bring lubricated rubbers, so I have an excuse: 'Oh, sorry, I don't suck lubricated rubbers.' "

Dakota will do intercourse at a bachelor party for $50. She says she prefers to be entered from behind because it's more comfortable. "And another thing. I do not kiss them. Never. I don't want them to put their lips on me.…I don't want them to smear my makeup all over my face. 'Cause for the next guy I got to put my makeup on all over again. And what if he has bad breath or something?…

"When you're in the room with them, you tell them the rules. You say, 'Listen. You don't kiss me, you don't touch me anywhere I tell you not to, and you got ten minutes. Ten minutes for $50. You don't like it, get out. Next!'

"A lot of prostitutes, when they have sex, they don't come. They don't have orgasms. But I do, every time.…They could use a rubber dick. I couldn't when I was young. I had to go to therapy. I went from nothing to too much, you know?"

Dakota says that one way she copes with her work is by drinking. "[Before] I started drinking, I was a whole different person," she says. "But let me tell you, when you do a bachelor party and there's four guys, you get drunk." She also must separate the person she is at work from the person she is outside of work. "Even my boyfriend will tell you, on my way to work, I can't talk to anybody, I can't hear nobody. On the way to work, I tune everybody out.…It's like I'm going into character. I don't even speak in the car. All I do is blast the music real loud, and get into the feeling of being sexy and horny."

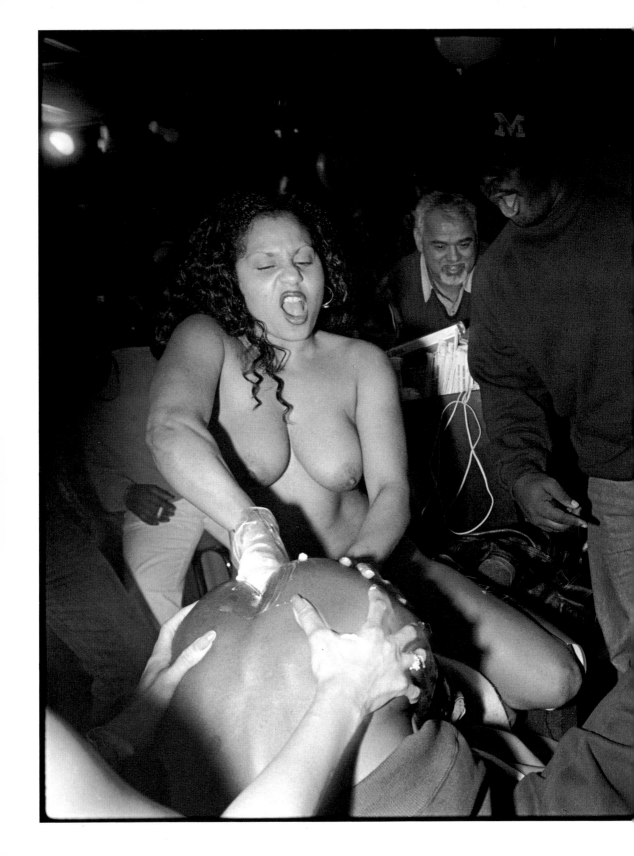

Ivory. birthday party. New Jersey

Dynomite handing out business cards, birthday party, New Jersey

Asked whether she enjoys the work, Dakota says, "Yes more than no. Usually I don't do it if I don't think I'm going to enjoy it. But I find a lot of different kinds of men attractive. I'm not the type of person who just likes one type of man. If he's a little overweight, so what? He's a man." She always protects herself by using condoms. "I buy my own rubbers. I always buy new ones. Never have any sitting around. And I ask them if they have a large penis, and then I use extra large rubbers. And if the rubber's not fitting him right, I won't do him. I won't do him if I can see he's bulging out of it."

Dakota also protects herself against customers who might get the wrong idea. "I always tell them, 'Listen, we ain't falling in love, OK? This ain't about love.' I always tell them, 'This ain't about love, it's about money.'"

THE AMERICAN SEX SCENE

While much prostitution is initiated at strip clubs and other venues, some of it still takes place in brothels. By one count, there are 150 houses of prostitution in New York City—a far cry from the 1,250 in existence at the start of the century. Few of these resemble the traditional brothel. The more upscale types are town houses or apartments where a few prostitutes are present and available at any given time, and the split between the house and the prostitute is about 50/50. In the notorious immigrant brothels, often found in more downscale neighborhoods, payment to the women is at the whim of the house—and often amounts to nothing more than room, board, and (sometimes involuntary) "protection." "What passes for a brothel is very different" than it used to be, according to psychologist Mary Nolan. "At the present time, the brothels are third world—Koreans, South Americans, Taiwanese, increasingly African, Filipinos. Some of these women come over of their own accord, but many end up in some form of indentured slavery." Prostitutes are more likely to work out of their own apartments, and can make arrangements for "dates" through an escort service. There is no way of telling how many women engage in this kind of freelance, entrepreneurial prostitution.

Bob Richter, himself a long-time client of the sex industry, is publisher of *The American Sex Scene*, a guidebook to brothels, escort services, and other commercial sex spots in New York City. He gives his own unobjective rundown of prostitution services available in the city. "You have places here that bring down $1.3 million. There are other places, maybe two girls together, and all they do is pay the rent. They don't want a bunch of guys coming through the door. So they put an ad in a magazine. And this way they get customers, keep a couple of regulars, and make enough to pay the rent and buy groceries. They can work on word of mouth....

"There are no pimps inside the houses. In most cases the houses are run by madams who used to be girls. There is nothing organized in the houses. The Mafia is not in the houses. Most men don't like [to own] whorehouses. They've got daughters, wives. Also there's not enough money in it. In New York ten years ago there were chains of them. One guy had seven places. Now most have just one....There are maybe 50 in-call establishments, with only five of them male-owned. Twenty-five percent of the escort services are run by men. There is less capital involved in an escort service. You can run one out of your house.

"There are the Oriental massage parlors, $140. They get you in and jerk you off. They used to be fantastic. They are controlled by the Chinese mob. There are some older girls who have learned to do things with their hands. You wouldn't want a blow job from one of them. She probably would never be able to do as good as she could with her hands....

"The peep show has lost its popularity. The buddy window, glory hole. You could go in and the girl would follow. Slide up the Plexiglas and give you a hand job. She had vaseline all over her hands, and I'm saying, 'Am I going to get this all over my pants?' So I can't even get off. I mean, it's better than getting poked in the eye with a stick, but it's really not great. And then I know a girl. All she does is cuddle guys."

Just as the settings for prostitution vary, the pimp, too, changes costume. Many sex workers will say they now are more independent, less apt to be dependent on the pimp for work—but in fact the pimp, in some form, is never far away. On the street, he is more apt to be called a boyfriend, hanging out to make sure his girl is safe. For the independent dancers the pimp will be an agent, often a woman, who sets up bachelor parties, charging $700, and paying each woman—who agrees in advance to perform a little side work—$100 to $150.

Pimps manage the saunas, where they rent rooms to the women in franchise-style setups. And in high-priced circles, pimps are sometimes the drug suppliers to the upper class, tacking a prostitute's services onto a large sale as a bonus.

MASSAGE PARLOR
MADAM

Having been a madam for 20 years, Rebecca Rand knows the business inside out. Rand is a mom-and-pop-store pimp who, if she had instead started a socially acceptable business, probably would have been celebrated as a genius. Hers is the working-class, no-frills fuckery.

Rand grew up in a small town in southern Minnesota where her parents worked all their lives in a canning factory. After high school, she got married and had a child, and then, during the 1960s, she revolted, divorced, and moved to Minneapolis, where she enrolled at the University of Minnesota. She had no way of supporting herself, and took a job in a sauna, giving massages for $8. The sauna got $5, and the masseuse kept $3. For $20, a customer could get the works: "I had to get buckets of hot water and bring them in the room and lather this guy up with shaving cream and give him a hard massage, and then wring towels out in scalding hot water, dry him off completely, then put powder on him and do this fingertip massage—all of which took and hour and a half. It was an hour and a half of really hard work, and sweat would be pouring off your brow."

Rand began working alone in a St. Paul sauna that was located in a back room behind a laundromat. "I was there alone and I was broke. I was getting $3 a massage—$25 on a really good day. This was in the early 1970s. Guys were always asking for sex. When you did a fingertip massage you weren't supposed to touch his genitals but come as close as you could without touching them. Which generally gives them an erection, which is what it is designed to do, so they will ask for another one on the thought that if they buy enough massages, they'll get some sex or something....

"Finally there was this guy, a big fat guy, a plumber, and he had this $100

bill and he said 'It will only take a minute. $100 a minute. I promise I won't take more than a minute.' I kept thinking about this minute stuff. It would be terrible getting caught, but how can you get caught in a minute? So finally, OK. I fucked him. And it took less than a minute! God, that seemed like an easy $100, easier than slaving away on the massages. It's like everything else. After the first one it came easier....So when the other guys would come in, I kind of said yes to whatever, if they wanted to get laid or a blow job. That was the two things they wanted.

"I didn't know anything about the business. I didn't know any prostitutes. So I took whatever they gave me....And see, a lot of them would beg me. And there was some guilt. I felt responsible for their hard-ons. I should do something about them. He's going, 'Oh please, oh please,' and you need money and it seems like an obvious and natural thing to do."

Some men tried to cheat Rand, claiming they had paid less than they really had for the previous time, and taking advantage of the fact that she really did not remember what she had charged them. To straighten things out, Rand set rates: $50 to get laid, $25 for a blow job, $15 for a hand job. Soon she dropped the low-paying, tedious massages altogether. Instead, she and her girlfriend concentrated on fucking the customers, and everyone began asking for them. Eventually the owners dropped out, and sold the saunas to Rand for $10,000 each. At the age of 26 she owned two whorehouse-saunas in the Twin Cities.

Rand developed a considerable knowledge of the business. "I worked all the time, and I really knew what everyone spent. They spent depending on the sexual services they got. And they tend to get the same. Guys who get blow jobs get blow jobs. They rarely get blow jobs one day and then get laid some other day. Because I was working all the time I knew everybody. I put in all these hours so it was kind of hard to cheat me."

Rand says she couldn't keep track of what the different prostitutes and customers were doing behind closed doors, so she ended up streamlining the system: charging the customer a set price for the room, and leaving the prostitute to set her own rates for what went on inside. She ran her whorehouses like this for 20 years.

The first time Rebecca Rand was arrested, in 1982, she was placed on probation, which she ignored and went right back to work. Arrested for violating probation, she was released from an overcrowded jail to a halfway house.

During the day she worked for a psychologist, from whose office she continued to run her saunas. During the 1980s Rand's case became a high-profile one in the Twin Cities, where an anti-pornography movement was in full swing, and where shutting her down became a popular preoccupation with the police and district attorney's office. During the latter part of the 1980s she was convicted under racketeering statutes and given a five-year sentence. She served six months in jail, was fined $200,000, and had all her property confiscated. Rand is now on probation for 20 years, and if she violates it she will serve five years in jail. The IRS also launched a case against her for failing to pay withholding taxes on 60 employees over three years.

Looking back on her life as a madam, Rand says, "It's not for everybody. But for some people it's a fine job, and those people should be left to do it." As for a prostitute's ability to have her own personal relationship at the end of a long day, Rand says, "If you're not physically tired, it's not going to matter....After all, it doesn't matter if you are physically exhausted from building a road or physically exhausted from having sex."

Massage parlors offering sex became popular with the return of Vietnam War veterans, who had experienced the massage parlors of Southeast Asia. They remain a major setting for prostitution, especially in working-class and middle-class areas. Usually, the owners receive money up-front for the massage, and workers are left to cut their own deals with clients in the back rooms.

"The massage itself was $40," recalls one dancer who worked briefly in a massage parlor, "and the proprietors got the whole $40." Without the sexual services, the masseuse would make nothing. But these services had to be tactfully arranged.

"So the doorbell would ring, and the system was that the girls would take turns. One would hide, and the other one would go to the door and say 'Hello, sir, how are you? $40 for a massage.' Just a massage. If the man would ask if there were any extras, you'd have to say no, because he might be a cop. But of course, those who were part of the customer base wouldn't ask, they'd go into the room. If they're regular customers it's an easy thing. If they're new customers, a lot of times they would try to go into the room and ask if there are extras, and we would say no, no. While they are clothed we can't discuss that stuff. What you have to do is to give them a massage....

"So you go away and the man takes off his clothes. You come back in and ask if he wants Swedish or shiatsu. Of course, I didn't know a damn thing about shiatsu. I remember asking the boss what shiatsu was, and he said, 'Oh, you know, you just sort of do it hard.' So whenever they said they wanted a shiatsu massage we'd just lay on the pressure. Every once in a while we'd have a customer who wanted a real shiatsu massage, so I'd try to pretend I knew about the pressure points. Most of the time it was Swedish, which is light pressure all over the body. We'd do it with [them on] their bellies first....As they're lying there, if they're not regular customers, they'd discuss what they want. The basic is what we call the manual release....They're on their stomach and they're getting excited. You're tickling their butt. Usually by the time they flip over they're hard. Sometimes, if they're regular customers, you'll take your clothes off while you're doing it. You'll have already discussed it. The rates are $20 for the manual release, $30 for the manual release with top off, $40 for manual release with top and bottom off....

"Every now and then, once in a blue moon, if there was a blow job with a condom that would be $50. Once in a yellow moon, there would be the man with a $100 bill blowing in the wind and I would be broke, and about 15 times I broke down for that, and a few times I broke down for $80. Each time they wanted their money's worth, and they'd say, 'I want to make sure I can come twice.' And I'd say, 'You bet.' Because they'd only come once, and they'd say, 'You know, you just took so much out of me!' And I'd say, 'Oh, OK.' Sometimes they'd tip.

"Average days I would say there were two or three men. I didn't make that much money a day. I'd walk off with $100 to $150 a day. I averaged $500 to $700 a week, and I read my book most of the time, between customers."

IN THE LIFE

Everyone who has worked in prostitution has a story to tell about the first time he or she took money for sex. For Ramona, it was a way to pay back a cop's wife whose car she had smashed up in an accident, and later, to supplement her mechanic's salary in the Air Force.

Ramona grew up an Army brat in California, and attended Catholic schools. The boys at school used to make fun of her, she says, because she was so ugly.

In high school, she began hanging out with surfers and cutting school. After she graduated, she remained in California and worked for an insurance company, and made a meager living. When she got into a car accident and was sued by the other party, her financial situation became really desperate. When a co-worker described how she supplemented her income by working for an escort service, Ramona decided she would try it. Since she was already going on dates just to get a free meal, and getting drunk and stoned and having sex with men anyway, she figured she might as well charge for it. And she didn't quite consider the work prostitution. "Let's call it escorting," she says. The difference is that "prostitutes aren't in the phone book. Escort—it's with massage. It's in the phone book. In the business personals."

Ramona signed up with her co-worker's escort service, and was sent out on a first call to a man suffering from emphysema. "I was sacred to death, because I thought, 'How am I going to do this?' It was a wheezy geezy guy. They told me it was going to be an easy call. And I thought, 'Well, what's that mean? I won't have to screw him? He comes quick? Or what?'

"So I went to this guy, he paid me $200 an hour, and he was like, on an oxygen machine, in a big huge house, and he said to me, 'I know you're new, and don't worry, because I can't even get out of this bed, my thing don't even work no more, but I still want to look and fantasize.'...So I'm like, taking my clothes off and I'm scared....And then, right before I left, he says, 'Oh, come over here.' And he pats me on the butt and goes, 'You know what, honey?' He goes, 'You can make a lot of money in this job, but don't do it too long. I can tell you're not the type.' I stood there with goose bumps all over me."

When Ramona joined the Air Force Reserve, she continued with the lucrative escort work because it paid $200 an hour, minus a $45 agency fee. "I thought to myself, 'God, the Air Force is paying me $12 a day. I mean, sure they're teaching me something, but God, who wants to get greasy when I can just, like, lay there....

"I tried to work only maybe two or three calls a week. I worked from nine at night to five in the morning, and I worked on Sunday, Monday, and Tuesday. Because the Friday and Saturday calls were usually a lot of people who were partying and they wanted to get down. But the Sunday, Monday, and Tuesday calls were mainly guys who were just all coked out of their minds, rich, and just wanted somebody naked." One man wanted seven girls at a time, and one wealthy

businessman rubbed butter all over Ramona's body and then sprinkled it with coke and licked it off.

While anything could go for the clients, the escort service had strict rules for its workers. "Number one," Ramona says, "you had to wear a dress. You couldn't wear pants. No short-sleeve blouses. If you went out to a call looking like a hooker, they would get real pissed off. And if you went there drunk or on dope they'd get real pissed off. And they'd have people checking up on you. They had dress code! I mean, the Air Force dress code was nothing compared to the escort service dress code."

Ramona went on active duty in the Air Force, but still took some escort calls. Then came her arrest. It took place at a motel, she recalls, and there didn't seem anything unusual about the trick to begin with. "He was in his underwear. And he was kind of cute and nice and everything.…I was in a real good mood that day, and I'm telling him, 'The only reason I'm on this call is because I wanted to get something special for my dad's birthday, so I thought, shit, another extra couple hundred bucks.'…The guy, he says, 'Are you going to give me head?' And I go, 'Well, uh, whatever you want.'

"And then that's when this other guy pops out from nowhere. The door flew open, and this guy's got a gun pointed at my head. I mean, like, whoa! Like, SWAT team! I mean, this guy was dressed like a commando—like a terrorist fighter! This guy's got the full flak jacket on. Right, like, 'Dude, I'm in my underwear, you know, I'm not gonna kill you.'

"This was way over. I mean, he thought he was Starsky and Hutch.…And some idiot behind him has got a camera with one of those big light bulbs that go, 'Poof,' like from the forties, right? And he's blinding me, and I'm like, 'Who the fuck are you? Where are the cops?'

"They immediately took me to jail.…They wouldn't let me go into the bathroom and put my clothes on by myself. I go, 'Look! You ain't paying for it, you ain't gonna watch me!' And I asked for my wallet back, and the cop goes, 'This is evidence.' I go, 'Fuck you! I have money in my wallet.' I bailed myself out, $100 bucks. I got out just in time, too—I had to borrow a uniform."

Ramona managed to keep her arrest—and her work—a secret from the Air Force. She refused customers from the nearby Air Force base where she worked. But once her escort service did receive a complaint from a client who said his penis burned after being with Ramona. This, she says, was because she had to

race from her military job to the trick, and didn't get all the jet fighter lubricant off her hands.

Later, in order to learn to fly, Ramona began exchanging sexual favors with a major who piloted a tanker. She would have sex with the officer every chance she could get—in the secret briefing rooms, or at 40,000 feet in the tanker's bathroom. In return, the pilot would let her fly the plane—usually when the co-pilot was passed out drunk.

Jack is a suburban college student and a part-time male prostitute for women. "I'm 22, from the suburbs. Irish Catholic background, went to all-boys Catholic high school. My mom's a teacher, my father's an ex-cop."

For Jack, being a whore was a good way to make spending money for his college social life. "Where else can you make money? I also teach tennis.… That's some money, but a college student is—you know, you're scrounging for money. You can't afford to be going out every night and keep asking your parents. I know guys who spend $2,000 to $3,000 a semester just on drinking alone, not including, say, someone who smokes pot or something. Campus food is usually pretty bad so you order out. You know, it's just expensive."

With some friends, Jack started up an escort service that provides young men for women. "Usually two guys will go. One guy will drive just to make sure nothing happens and sit outside just in case.…First call we got was a woman in Westchester. She was a 41-year-old lawyer and she was just tired of being with older men and she wanted a younger guy. I guess she wanted to enjoy the difference between an older guy sexually and a younger guy. So that was, like, our first client. She paid $180, plus she paid for the room."

Jack believes that his business is different from the usual gigolo scene. "We're like the kids next door, I think. If you came out of your house and saw me walking my dog in the street, I don't think you'd ever think.…It makes me pretty nervous."

The idea of the service, he says, "is not exactly sexual.…It's companionship more than anything.…There's one woman who just wanted to talk to the guy. Another guy just helped this girl study. They didn't have sex. The guys are pretty personable. They know how to talk to women and stuff. We like girls. We all like women. The main thing is we like being with different women. Men are generally different when it come to sex, anyway."

Jack says he and his partners have learned a lot about women from being in the business for just a few months. "There are a lot more lonely women out there than what you actually think....I always thought women might be comparable sexually. I knew a lot of girls who go and sleep around, girls I was friends with who loved to have sex. But [now] I think women, they want more....

"When you meet women out, they put up more of a front and they act a certain way when you meet them. When you're doing it this way it's a lot more personable, and you actually find them a lot more caring than you usually think most women are. A lot less harsh, not as bitchy, and, you know, more of a relaxed atmosphere than when you go out with them."

Jack is thinking about expanding the business and setting up a nude cleaning service. He says that so far, the customers are satisfied. "The one woman that was 41, she wants another one. But she said the first guy wore her out. She said it was a lot different than older guys. She thought it would be a lot more like a sensual experience than it was. So we told her it was our first time, really. It needs to be maybe a little slower, a little more loving. With a little more foreplay. It's hard to tell. We have to be worried about whether the woman is a cop and stuff. You know, you don't go to training for this. You just pick it up."

Like Jack, Steven started doing sex for money while he was in college. "I came out in a small town in Pennsylvania, when I was 16," Steven explains. "When you're 16 and you're coming out, especially in a small town, you kind of get passed around. The way you socially network, through what turns out to be a very large crowd of older gay men, is kind of prostitutional all by itself. You very quickly discover that men want to placate you either to protect their identities in a small town or take on a paternal role with you to make you feel comfortable so that you will sleep with them. So they'll buy you drinks, take you to dinner, and take on a Sugar Daddy role. And even guys my age—I'm 27—were adopting that sort of role with me because it was very safe to do it that way. There's just no emotional involvement with children, anyway."

Later on, at college in Philadelphia, Steven became a part-time prostitute. "There was an escort agency that I started working for when I was there. It was my freshman year. I was 19 years old....You could do in-call or out-call. They had a crappy little apartment on Spruce Street, the social equivalent of [New York City's] Christopher Street, to take in-calls to, where they charged $125 an

hour. You keep half that and tips. Of course, they stipulated you are not obligated to do anything with the client. But it's pretty obvious. Like Elmer isn't taking an hour out of busy day at the stock exchange to chat about the weather. It was pretty dreadful....

"It just got really, really toxic. It felt gross. These were usually clients who were getting you in the middle of the day. It felt dreadful because they are real, real pragmatic. There's no casual conversation about it whatsoever. It's just, 'Oh, hi. I'm Al. So let's get started.' There's no social accoutrements to it whatsoever. It's just very simple and quick. This is a client who has to get back to the office.

"When the escort agency described you they would usually inflate the stats a little bit. They added about an inch or so to some of mine. Not that I needed that, thank you. But they would say, 'He measures in at...' They had about 20 guys working for them. And it was so funny, because they would describe you as 'Greek, active/passive; French, active/passive'—French being blow jobs and Greek being fucking. There was penetration if the client wanted penetration.... I was only Greek active when I was working for them. I really didn't like the idea of strangers fucking me. Wouldn't mind going down on somebody, but only if I was really into them. So it was usually, like, they lay there. 'OK, baby. Do me.' Then clean up and go home. That works. That worked out just fine. Not a whole lot of intimacy in that."

Since Steven was a student, he only went out "on a couple of calls a week," making about $200 a week. "Just enough," he says, "to slack off on a part-time job." During the summer Steven went home, got a part-time job packing groceries, and picked up spare cash cruising in an alley between the town's two main streets, the focus of the town's gay scene. Men "would drive around and look for sex all night....I used to go out after I would clock off at the grocery store. Usually I would stop off at a bar on the way, where I knew I could get a pitcher—where they would serve me—and get myself half-hammered so it wasn't such an unattractive idea. I'd just stay out there until I'd had my fill of it all. Just about anyone who is looking for sex has $20 in his pocket and he'll pay for it if he needs to. It was usually blow jobs in the front seats of cars." Afterwards, Steven would ride his bike home.

"When I was tricking out of the alley it was money," Steven says. "It wasn't like real sex. I found most of these guys to be substandard partners. When I was working for the escort agency it was worse than substandard. It was vile. It was

a rhythmic thumping that would get this guy off so I could get dressed and leave. I walked around in a daze after my first call with them. I just felt so filthy. I went home and I showered and showered and showered. 'Out, out, damned spot.' It was dreadful. I just wanted to be cleansed of it. There was no way to get away from it. There was no sultry sound track. Blondie was not playing in the background. Richard Gere was nowhere in the picture. It was not *American Gigolo*. It was a bad idea."

After a time, Steven opened "Philadelphia's first and only erotic shaving service," which he later moved to New York. The services offered are "à la carte," and the total price depends on what the customer wants shaved. "If somebody wants, like, their balls shaved and their crotch trimmed, that's about $30 to $35. If somebody wants their ass shaved, their balls shaved, and their pubes trimmed, that's $50. If somebody wanted a total body shave that's $100. And it ranges in-between. There are different prices for different things. Some of them actually tip….It's only out-call. We come to them. The equipment consists of disposable blades, shaving cream, clippers. There's no overhead. All profit.

"You have to touch somebody to shave them. And they get aroused. But nobody's paying for release. What they are paying for is to be shaved. There is never a charge for release, because it's either 'No thank you' or 'Hey, no charge.' It depends on how much you're into the client. I never had a client tip for release. Generally if there was going to be a release it was because I was really into the client. Some of these guys have really fabulous bodies. And they want to have all the hair taken off to show it off better. Somebody like that is somebody you really do want to roll around with—granted they are still paying to be shaved."

Steven says that he still enjoys having group sex at the handful of gay sex clubs in New York, but he anticipates his hustle shifting to new ground. "Gay men are very ageist….The best bet older men have of getting laid is going to bars where younger men go….I don't expect when I'm 40 or 50 to have sex with people my own age. I'll probably start to want to have sex with men who are younger. I'm hoping I will go gracefully….There's that expression 'everyone pays.' As you grow older you find yourself inclined to placate the discrepancies of younger men.

"The guy I am dating is 36. He lives in a beautiful house. He's a lawyer. He's a really great guy. But frankly—this sounds shallow, but, oh well—if he were not as wealthy as he is, I wouldn't probably have stayed with him this long. We've

only been dating for a couple of months really, but the things that keep me around are largely financial. I've had better sex with better-looking guys who I find more interesting. But the fact of the matter is, my boyfriend has a really beautiful half-million-dollar condo and I have a house that I share in New Jersey. It saves me the hassle of having to commute and it keeps him happy when I stay at his place. Sometimes you just wonder. Everyone pays in one way or the other."

OCCUPATIONAL HAZARDS

Many prostitutes speak of the considerable psychological toll taken by their work. One young dancer says that she deals with crossing the line into prostitution by denying that she is really doing it. Although she admits that she has, on occasion, performed hand jobs, blow jobs, and intercourse, she does not consider herself to have been a prostitute. She describes how she separates herself from her own experience: "The situation is this: You're going to make a lot of money in a short period of time. What you want to do is to try to make it not much of an experience at all. Obviously, it's not going to be pleasant. There is nothing about any man that is going to make it pleasant for you.…What you want is for it to be as uneventful and unexperiential as possible. So hopefully you don't want him to come too hard. You don't want him to touch you too intimately. You don't want him to smell. You don't want him to fall in love with you. You don't want him to talk too dirty and ask you for your feedback. You don't want him to ask you about your fantasies. You just want to lie there while a clinical function is performed so that you can get through it, and get it over with, and get your money. You try to think of ways to make it go quickly, tightening your muscles or playing with his balls or something. You may talk dirty to make them come, but you don't want to talk about yourself unless you think it's going to make them come faster.…

"Now, as for the actual experience itself, you could describe it as, like going to a gynecologist. You are having something performed on your body and you'd like it to get over with. You certainly don't enjoy it, but you don't want it to hurt.

So something is happening to you. You are going to get money at the end of it. You think about that. The most you want to do is to have it be quick and friendly and easy and not much of an experience at all."

As for particulars, "You don't use a condom with hand jobs, because unless you have sores it's pretty unlikely you'll catch anything. You can wash up right after. With a hand job, you try to do it vigorously. Some men like it hard, some like it soft. Once you figure out what they like you can usually do it pretty quickly. And you consider that you're performing a function, just like any job. You're not involved. Your hand is going back and forth…just like you were sewing something on an old-fashioned sewing machine.

"The blow job is the same thing. You are performing a function with your mouth. It's a mechanical function. As long as there is a condom there it doesn't touch you, endanger you, or do anything to you. You're just performing a function with your mouth. You just try to do it good so the guy comes quickly and you can get the cash and say goodbye. The same with having sex. As long as he's wearing a condom you can justify you're not having sex. Because it's not like any part of his body really touched you. You were protected, and it helps enable you to deny the fact it really ever happened."

Some prostitutes say that in addition to enduring their own emotional burdens, they are expected to act as "social workers" to their customers. Cynthia Connors, who now runs a computer business and volunteers for the advocacy group PONY (Prostitutes of New York), describes her experiences as a teenaged prostitute: "I was a very bad prostitute. See, I believed that prostitution involved exchanging sex for money. Wrong. It involves exchanging perfunctory sex followed by a great deal of psychological hand-holding, and a kind of psychology and nursing care. Basically you're a social worker.…

"I had very few encounters where it was simply a straight exchange of sex for money.…That was what was so hard about the job. It was exhausting. I felt so badly for these people.

"What I've come to decide is that in this society men are not allowed to say they have problems, and not allowed to go to social workers, not allowed to go to psychiatrists. It is manly, however, to go to the peeps, to go to visit a prostitute, and so those people are forced to become their educators in sex and become their marriage counselors, and also become their psychologists.

"To this day I still am in shock....I was too young to understand how ridiculous this was....But I would love to find some of these men who used to be my regular clients and say, 'I was a 13-year-old heroin-addicted little street kid. Why did you think I should be your marriage counselor? Why did you try to impress me so?'"

Even Annie Sprinkle, who maintains a positive view of her work in the sex industry, speaks of the high emotional costs of prostitution. "On some level," she says, "I felt like I was really doing important things, you know, really important things. I was the hooker with the heart of gold. I felt a lot of love for the people, and I got a lot of love back. I have a low self-image. So they fulfilled my image of myself. It's so intricate and complex and there are so many different levels....

"But basically, I can't do it any more. I can't do regular prostitution on a full-time basis because, well, you have to have enormous patience, enormous energy. You have to care about them—at least I do. I don't care about them that much any more....And you have to have a lot of compassion. And you have to put up with an enormous amount of shit. You have to put up with the worst assholes that no one else will go near. So that's a hell of a hard job. So I paid my karmic debt. I did my part. I can't do it any more. It's time to leave it to the young girls. Or there are some who are just made for it. Women who are just totally cut out for the business and will be in it their whole lives. It just fits their needs perfectly and they fit the customer's needs perfectly."

Prostitution work also has high physical costs—chief among them the threat of HIV infection. According to a July 15, 1994, article in *Science* magazine by Peter Aggleton, Kevin O'Reilly, Gary Slutkin, and Peter Davies, the danger of contracting AIDS seems to have had little influence on destitute people engaged in prostitution, especially those whose activities are controlled by pimps or brothels. Because they live on the margins and outside the law, they are beyond reach of most social workers. Many sex workers are poor and unhealthy to begin with, have few options for changing their way of making a living, and do not have access to the kind of information and social services available to the rest of the population. "Economic necessity," the authors write, "is...one of the main reasons why individuals engage in sex work, and the greater that economic burden, the less able the individual is to insist on safer sex."

Dr. Joyce Wallace, who has run an outreach and HIV-prevention program among street prostitutes in New York City, found in one survey of 1,592 women prostitutes that only one in six prostitutes used condoms. About 75 percent of the prostitutes she talked to said they gave "mostly oral" sex (only 12 percent said they had intercourse). Over 40 percent of the women used drugs—mostly crack, which can cause blisters and cracks in the gums and mouth. And over one-third of these women were infected with the human immunodeficiency virus. By 1995 Wallace reported the rate of HIV among street prostitutes had dropped somewhat, to 21 percent—a result, she believes, of condom distribution programs and stepped-up state efforts to house HIV-positive homeless people. Despite the prevalence of HIV and AIDS among street prostitutes, many of their customers—by one report, over half—say they never use condoms.

THE STREET

The lives of the women who work on the street are usually drastically different from the lives of women who work through brothels, massage parlors, and escort services. In New York alone there are thought to be as many as 5,000 street prostitutes—many of them homeless, some with children, drug addicted, and infected with HIV or dying of AIDS.

Women of different backgrounds come together on the street. There are women who grew up in the projects and have lived on and off the street since they were little kids. There are women who grew up in nice middle-class suburban communities who pay for their drug habits by turning tricks; women who once worked through escort services or inside houses; women who followed a boyfriend to a new town and went into the streets to pay for his and her own drugs. Some lead straight lives by day, and secretly work the streets at night to help support their children. They are all ages, all nationalities, and all races.

Allen Street is a main street on the Lower East Side of New York, on the edge of Chinatown. On an average afternoon, it is clogged with double-parked trucks, forklifts, and handcarts. The area is also a "stroll" for prostitutes. Men come to Allen Street in the early morning to pick up a whore for a blow job before going to the office. Businessmen from out of town, college students on a

lark, Hasidic Jews from Brooklyn or the suburbs, and regulars from New Jersey drop by for sex. Some men who cruise Allen Street want to fuck in the back seats of their big cars, and the prostitutes take them down to large open lots near the East River. Others go under the expressways or bridges for a quick blow job.

The prostitutes who work the Allen Street stroll live cheek by jowl with the Chinese limo drivers who park there, addicts who support themselves ripping off stores, homeless men who live in tents under the nearby bridge. The cost of sex here is pegged to the price of drugs, sold from little bodegas and controlled by the Chinese. Heroin is cheap and the drug of choice.

Charlotte has been on and off heroin for several years. When she is on, she often works the Allen Street stroll. In her late 20s, Charlotte grew up in privileged circumstances in the West Village and attended private schools. She revolted, started a band, and began working in Times Square, where she had a moment of fame when her picture was plastered up over a peep show. She says that she prefers prostitution to performing. "I felt like a piece of meat in front of all these people when I was dancing. And then I started thinking of doing it in a guiltless, shameless way. In an honest way. You're up there in front of hundreds of people. It's better to be up in front of one person in a private way.…

"People will pay for me, you know," she says of her work as a prostitute. "I'm not a slut. I get paid. I won't have sex with anyone unless I get paid. That's how screwed up my mind is."

Of the Allen Street stroll, Charlotte says, "It's better here in the morning. There are cars. A lot of businessmen. People coming into the city, stopping for a trick on the way to the office. See, 12th Street [another stroll for prostitutes] is very residential, so you have all these normal people going to work around there and stuff. And they're really trying to get rid of the hookers there. They can't. The whores aren't bad, though. It's the crack dealers."

Sometimes Charlotte stays with her friend Jenny, who shares a crammed and dimly lit apartment in a boarded-up Lower East Side walk-up with her husband and couple of other addicts. One afternoon, in Jenny's apartment, the two women concentrate on getting high, cooking up the heroin and preparing the syringes over the blare of a television set in the corner.

As they make their preparations, Charlotte talks about her friendship with Jenny. "Jenny is one of the only two people who I've lived with who has never screwed me over. She's a real friend. She's shown me real love. It's very, very

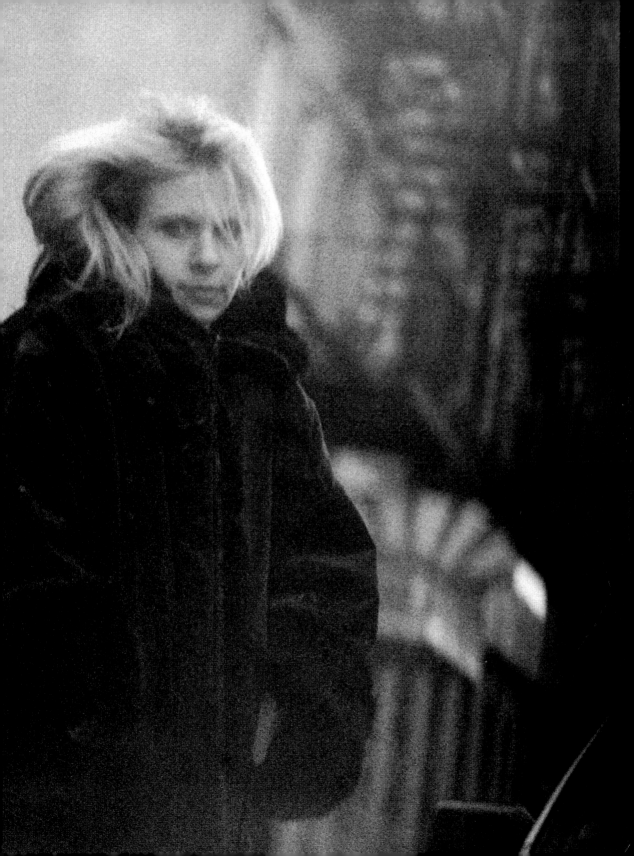

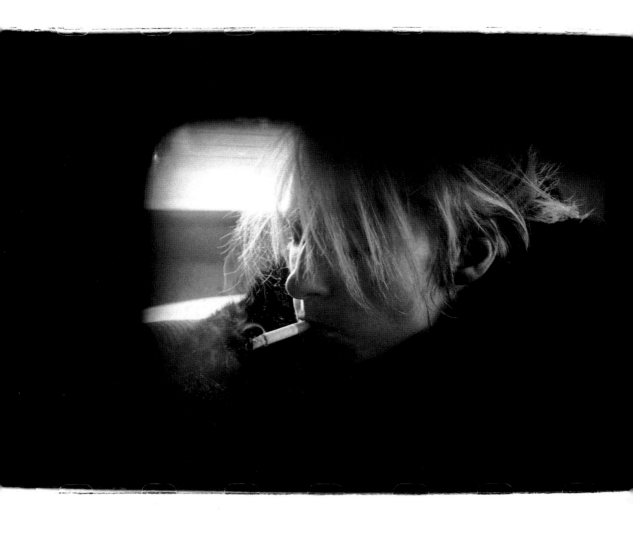

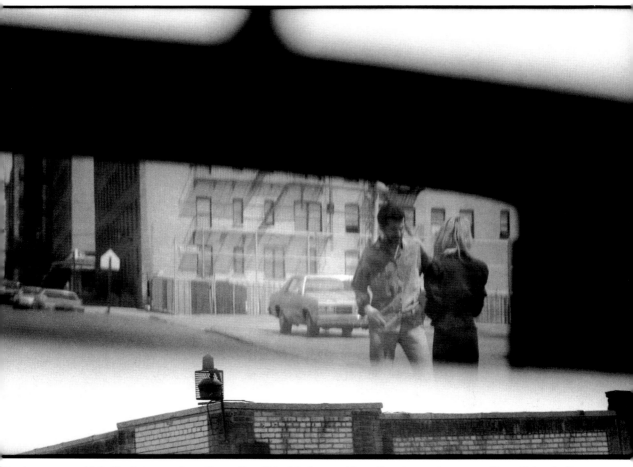

Previous page and left, Charlotte, prostitute, Lower East Side, Manhattan. *Above*, Prostitute and customer, Hunts Point, the Bronx

hard to find in this world. You know, the hookers will steal from hookers. So in this house you are among a very rare few people who haven't lost their dignity or morals. And who've come from good breeding."

"I'm from Seattle," Jenny says. "I came up here around 12 years ago with my husband. I left him and I came here. I have been around the area for eight years. [I started hooking] when I was 17 in Seattle. I worked in the houses. I never worked on the street until I came here. [I used to work in houses] here, too, until I started shooting up and stuff. Now I've got tracks on me. They don't take people like that. I used to work in the leisure spas before they closed them down for tax evasion. I used to make $600 a day. Then I got in an accident and lost my teeth. I used to be a model....I used to have a bridge going across, and I happened to get in the way of a fight and it came out, and I didn't do anything about it....

"Usually I come out at nighttime," she says, "like around 10 o'clock. When it gets light there are kids going to school, and I don't want to be around that. The police have been really clamping down lately, and I went to jail three times in a week. They are doing it because of the people in the apartment buildings. They are starting a lot of shit. They are going to work and the kids are going to school. They don't want to see it. When they see hookers they see drug dealers."

"Yeah," says Charlotte. "Like in different states the price of drugs will be the same price as a trick. It goes hand in hand. In Boston a bag of heroin is $25 and a trick is $25."

"Yeah. In Seattle it's $25," Jenny adds. "It's a big difference from what I used to do. I used to see a date for $100. Now I go for $20. It's a big difference working on the street than in a house. If I have to I will go for $10."

"Depending," says Charlotte. "If you know the person. If they're regulars....A lot of the girls, they undersell themselves."

"The price of a trick has gone down since I first started going out there because of all the girls out there using crack," Jenny says. "We used to go for $20 for a blow job, but now the girls out there are making it bad. Because of crack they go for $5. The guy is normally used to paying $20. Now the girls get talked down to $5."

"The guy will say, 'I can get it from another girl for $5,'" Charlotte says. "And a lot of times they'll leave and go."

On the television, Geraldo [Rivera] is interviewing a group of smiling call

girls, who talk about how much they make and how much they like the business.

"I don't stay out that long," Jenny says. "I get my $20 and go and get high. Five, six, seven a night. It depends. Sometimes I'll just do one."

All sorts of customers get women on the Allen Street stroll. "Everyone," says Jenny. "Like from [she names a well-known record company]. Those people were in a limo and they gang-banged a girl, raped a girl. Executives."

Charlotte says that a lot of yuppies come down looking for prostitutes. "Quite a few. I've got one of them who started shooting up cocaine through a nurse. He could be in an L.L. Bean catalogue. He would give me a couple hundred dollars at the end, but he would pay for all the drugs while we would shoot up and get high."

Few of the customers, Jenny says, come from the Lower East Side. "They live away from here. They live in Brooklyn. They are family people, married family people."

"And these screwed up little girls are giving AIDS to these guys, who are bringing it to their wives," Charlotte says.

"A lot of the guys don't use a rubber," Jenny adds. "I won't go without."

"Right, exactly," says Charlotte. "You don't need the money that bad. I'll tell you something, like with someone I know. She went with this limo driver. And later he was looking for her. And we got in this conversation. And he told me how he had sex with her. And he had sex without a condom. I said to him, 'You know she's got AIDS, right?' And he said, 'No, I didn't know.' I said, 'Can't you tell she's sick?' He goes, 'No, I thought she was just slender.'"

"I lost a lot of weight," Jenny says. "I'm usually 130 pounds." She says that she is HIV positive, but she is not sick. "I feel fine. I lost a lot of weight. But that's from coke. And depression. I'm doing all this. Once I get my teeth fixed I'll feel better.…"

Jenny says that most of the women who work on Allen Street are from out of town. There are black, white, and Latina women. Their average age is about 25. "A lot of them have boyfriends," says Jenny. "Not pimps. Boyfriends. Like Lisa. She can't go nowhere without him. He stands there until she gets a date."

"Most of the hookers don't have homes," she continues. "They don't have places to live. They live out there on the street.…Some of the time they sleep on the benches on Allen Street. In the winter they just go in the subway, or they try to find a hallway."

Charlotte with Jenny in her apartment, Lower East Side

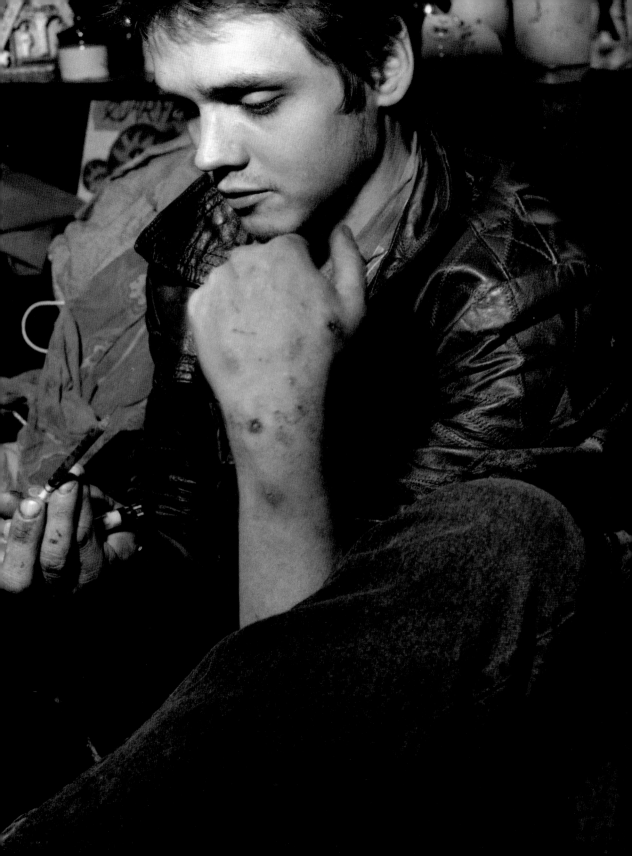

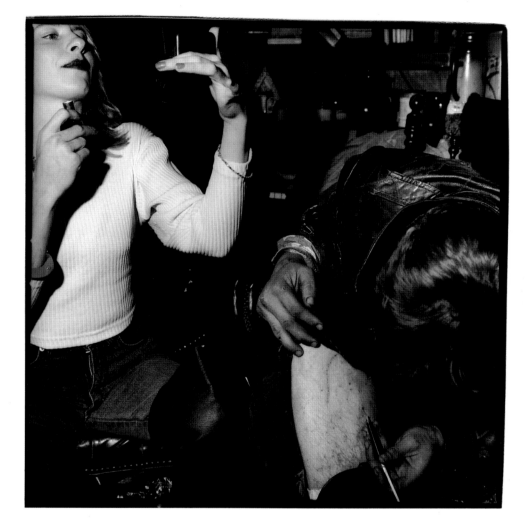

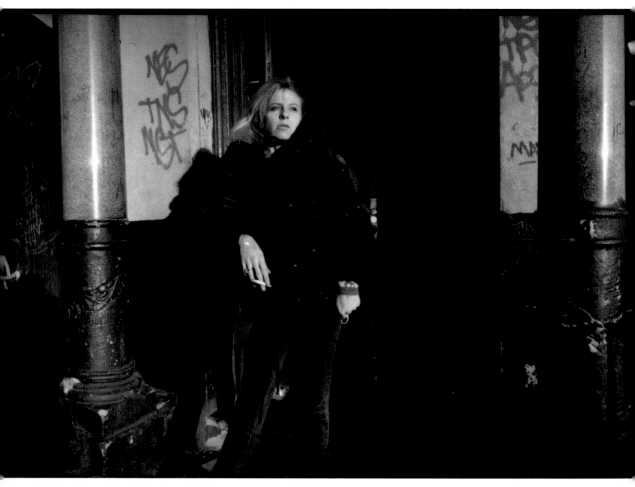

Charlotte, Lower East Side. *Opposite*, Greenwich Village, Manhattan

Charlotte says some of the hookers survive by robbing their tricks. "A lot of girls around here are masterful pickpockets. Me and this girl, it was Friday night and we're both down and out. We were sitting on our asses right down on Delancey and Eldridge streets, right by a dumpster. And this drunk Chinese guy walked up to us and started talking to her. And like, she's a master pickpocket, really incredible. The guy saw me. He wanted me, but I put him back to her....She takes him around the corner, you know, hardly even does the trick with him at all. They were done, like, two minutes. She had felt down in his crotch. She pulled out a roll of 20s. She comes back around the corner and says, 'Let's get out of here.' And this guy [we had robbed] comes running after her and grabs her purse. I got a cab, and I we got in and took off. We had like $300, $400. But how do you get something out of a guy's crotch? She is the best I ever saw....

"I have [robbed tricks], like, a couple of times, depending on the situation. If the person's screwed you over or it's too good to be true. But in general with tricks, we see them again. They're regulars."

The cops "don't usually bother you," Jenny says. "Except recently....They took me and the guy in. They were in a cab. They watched me keep going into the cars. They followed me to the parking lot. They waited about five minutes. We had gotten started and everything. They came in and said, 'Get out of the car.' And I was honest with them because they don't like you to lie to them. Well, I told them we were starting. I was getting the rubber on, you know. They started to let us go, but they couldn't. Whatever. They took us to jail and we got out with time served. I was in about eight hours. And he came and got me again." Sometimes they have sex with the police. "Occasionally," says Jenny. "Occasionally you do."

"You're glad to, though," Charlotte says. "I had one violent one once. More like a rape. Another cop was trying to get the girls to turn each other in."

"So far as the sex," Jenny says, "I don't enjoy it at all. But as far as the people, I meet a lot of people I become friends with. I just consider them as friends. I'm like a psychologist, you know. You have to talk to each one, and treat each one different, you know. Most of them are lonely and they want to tell you their problems. They are lonely and they need a friend. That's why people I get close to, I don't ask them for the money first. I get it at the end."

"Because they don't want to feel like a trick," Charlotte says.

"You know," says Jenny, "they need a hug."

"A nonbusiness-like approach," Charlotte adds. "That's how I work too. That's why we're so lucky."

"I've been hurt so much," says Jenny. "I was raped by my stepfather when I was a child. You think about stuff like that. And my landlord, he tried to rape me when I was a little girl. He chased me around the room. Most of the girls out there have been abused one time or another by men."

"The only relationship I could consider right now would be with a woman. Not because of sexual preference, but because of all my experiences with men…" Charlotte says. "I didn't get really abused until I got out there on the stroll. But you and me, Jenny, we're two of the strong, lucky ones who have gotten over that little innocent hump where you first start and could get killed really easy. We know how to survive out there."

"You can tell in your gut," says Charlotte, "when a man pulls up in a car, whether he is dangerous or not." Yet one of Charlotte's customers was the Lower East Side's own "ripper," Joel Rifkin, convicted in 1995 for killing several prostitutes. It is not clear why she, unlike other women, lived to tell about it.

"Some of them, the regulars, you never know when they might go off on you," Jenny says. "A guy who had class, he pulled a knife on me, and made me have sex with him."

"Tina, this Vietnamese girl, was found in different pieces," Charlotte says. "People think you are having fun, you know."

FIVE DOLLARS

Workers say that it isn't easy to get out of the prostitution business once you're in it. Sandra, who works on the street under the expressway near Brooklyn's Bush Terminal, puts it this way: "I've not only worked out here in the street, but I have also worked in agencies. I've worked from my house. You sit in the house and wait for the phones to ring. But, see, once you're a street worker, you can never just go sit, wait for the phone to ring. You can never go back.…

"Even though there's fear, even though it's scary—you never know if you're going to get locked up or one of these kids is going to knock the rest of your teeth out or break every bone in your body—for some reason, there's just something, that once you get used to coming out here and doing it, you can't go back.

I don't know why, but you just can't. You can never hold a regular job once you know how to make money out in the street. You feel like you're being used."

At Bush Terminal the women work the streets from pimps' or boyfriends' vans, or crouch in the doorways of rundown buildings. They sometimes live in old truck bodies, scrounging for food amidst the garbage. Their "dates" come down off the Brooklyn-Queens Expressway, which runs above the neighborhood, on their way home to New Jersey or Long Island for a fast, cheap blow job.

"I get a dollar a minute out here," Sandra says. "Even a quick blow job for 10 minutes is a dollar a minute and up....That's the absolutely lowest, and you only do that when the cops are coming or there are no dates out here and it's really bad. Otherwise it's $15 for a regular blow job. But right now, the cops scared all my customers away and I can't make no money."

"This is a very risky life," Hennessey says. "We're talking about street life, man....There's no holds barred. It's about compromising, how much, and sometimes $5 is a whole lot, because you've sold yourself to the goddamn devil man. $5 is a lot. Can you imagine $5 for some ass? It's unbelievable....

"Here she is overweight, snaggle-toothed, skunky. But it's a hole. He wants to bury his rod in the mud, like a dog. Like a damn dog. It's disgusting. And you're looking at this stuff, and saying, 'I bathe twice a day. I remembered to put on my cologne. I brushed my teeth. I have all of my dental work. I look good. I have a nice costume. I have a pair of shoes. I don't smell. I have my fabulous perfume on that I paid $65 an ounce for. I look goddamn good, and he goes to that shit!' He's got a suit. He's got a profession. We're not talking about a skeezer man. We're talking about a man in a suit. And you say to yourself, 'Where does the insanity end?'

"HIV? They don't care. In fact, they'll pay you more if you don't use a condom. They want to come in your mouth. They want to put the dick in your pussy: 'I don't want a condom,' he says. 'But wait a minute,' she says, 'I just told you I had AIDS.' 'I don't believe you,' he says. 'You look healthy to me. I'm sorry, but I think you're lying. Look, I'll pay you $50 extra. You look beautiful. You look clean. You don't smell.' The bitch is rotten inside. She's got AIDS. She's dying....

"He goes home, see, because he's already been excited by this tramp, this slut. His madonna is at home. She can't turn him on like this whore, this tramp,

this slut, this piece of shit. He didn't even have to pay much for it. He's got six fucking figures every week on a paycheck. He's paying you $5. He's having free sex. He's getting his dick sucked by a tramp. He knows where to go every week.

"He'll go home with all the fantasies. She just went down on his dick, on the sidewalk, in the dark. In the meat-packing district, in the street. Boy! That's a fantasy. Right there off the Hudson River. 'Wow! And I work on Wall Street. This is a movie! I'm on a sidewalk. In a doorway. My dick sucked by a tramp on her fucking knees. God!' Boom. He comes. He can't fucking believe it. He's in the fucking soup....In a doorway on 14th Street. Hey man, that's an orgasm in itself. I see it. Their eyes light up. And all they're paying for it is $5."

Prostitutes, Bush Terminal, Brooklyn. *Opposite*, Sandra, homeless prostitute, Bush Terminal

Community worker with prostitute, Brooklyn

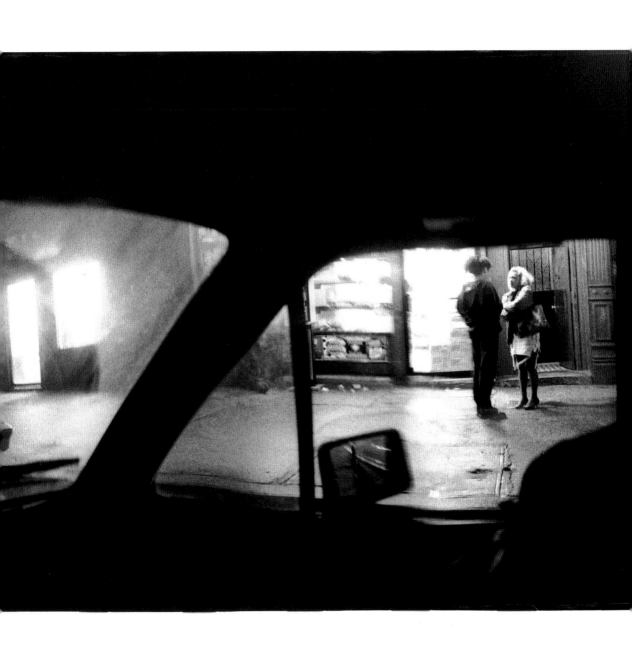

Left, Under the Williamsburg Bridge, Brooklyn. Opposite, Medical worker informs prostitute that she is HIV positive.

Greenpoint, Brooklyn

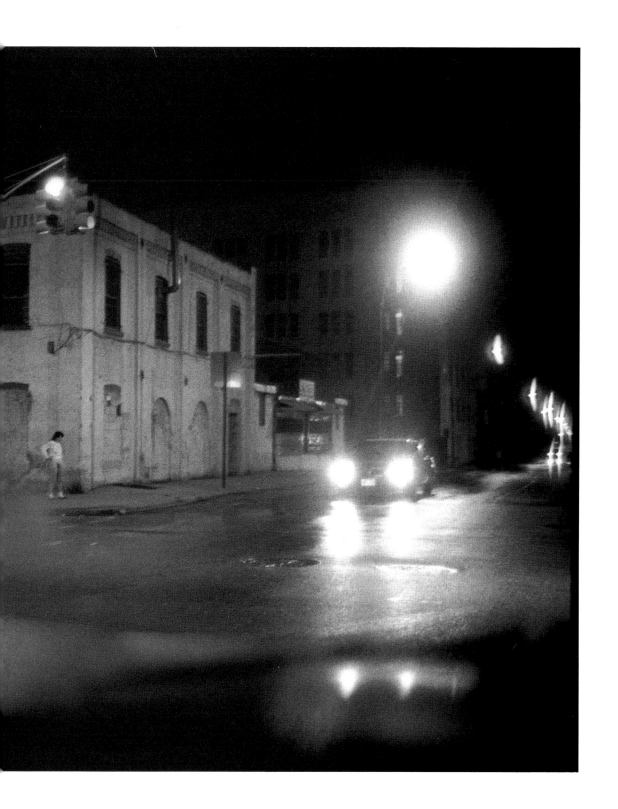

SYLVIA PLACHY is staff photographer for *The Village Voice*. Her first book, *Unguided Tour* (Aperture), won the International Center of Photography Infinity Award for Best Publication of 1990, and was named Best Monograph that year by the Maine Photographic Workshops. Her photographs have appeared in *Newsweek, Artforum, The New York Times Magazine, Grand Street, Wired, Doubletake,* and *Tatler,* among many other national and international publications. Her work is in the collections of The Museum of Modern Art and The Metropolitan Museum of Art in New York, the San Francisco Museum of Modern Art, the International Museum of Photography at George Eastman House in Rochester, and the Bibliothèque Nationale in Paris, and she has had solo exhibitions at the Minneapolis Institute of Art, the Whitney Museum of American Art and the Palladium in New York, and at venues in Tokyo, Manchester, Arles, Esztergom and Vancouver. Plachy is a recipient of the Guggenheim Fellowship award. Her weekly photographic column, "Unguided Tour," appeared in the *Voice* from 1982 to 1993. She currently contributes a column, "Signs and Relics," to *Metropolis* magazine. Plachy was born in Budapest, and lives in New York City.

JAMES RIDGEWAY is Washington correspondent for *The Village Voice.* He is the author of fifteen books, including *The Closed Corporation: American Universities in Crisis, The Politics of Ecology,* and, most recently, *The Haiti Files: Decoding the Crisis* and *Blood in the Face: The Ku Klux Klan, Aryan Nations, Nazi Skinheads, and the Rise of a New White Culture.* Ridgeway co-directed the companion film *Blood in the Face,* as well as *Feed,* a documentary on the 1992 presidential campaign. His writing has appeared in *Harper's, The New Republic, The Nation, The Economist, Ramparts, The New York Times Magazine, Details, Parade,* and other magazines and newspapers worldwide. He lives in Washington, D.C.

RED LIGHT: INSIDE THE SEX INDUSTRY

BY SYLVIA PLACHY AND JAMES RIDGEWAY

————

RESEARCH ASSOCIATE: SUSAN WALSH

TEXT EDITOR: JEAN CASELLA

DESIGN ASSOCIATE: FRANCESCA RICHER

SEPARATIONS AND PRINTING: PALACE PRESS INTERNATIONAL

Published in the United States by powerHouse Books

powerHouse Books is a division of powerHouse Cultural Entertainment, Inc.
635 East Ninth Street, #19, New York, New York 10009-4705
telephone 212-982-3154, fax 212-982-2171

First edition, 1996

Library of Congress Catalog Card Number: 95-73242

ISBN 1-57687-000-6

Distribution in the U.S. and Canada by D.A.P./Distributed Art Publishers
636 Broadway, 12th Floor, New York, New York 10012
telephone 212-471-5119, fax 212-673-2887

10 9 8 7 6 5 4 3 2 1

Printed and bound in Hong Kong

A slipcased, limited edition of this book with a signed gelatin silver print is available upon inquiry;
please contact the publisher. (Limited Edition ISBN 1-57687-001-4)

BOOK DESIGN BY YOLANDA CUOMO/NYC